More Praise for
Hollywood's Eve

"*Hollywood's Eve* is an extraordinarily felicitous meeting of subject and biographer. Let other writers worship at the banal altar of L.A. Thanatos; Anolik's Eve is the fearless beating heart of L.A. Eros, and her inimitable voice comes alive in Anolik's own lovingly warm and penetrating celebration of Babitz's magnificent beauty, wildness, and art."

—Elizabeth Frank, Pulitzer Prize–winning author of *Cheat and Charmer*

"The first injectable biography."

—James Wolcott, *Vanity Fair* columnist and author of *Lucking Out*

"There's no better way to look at Hollywood in that magic decade, the 1970s, than through Eve Babitz's eyes. Eve knew everyone, slept with everyone, used, amused, and abused everyone. And then there's Eve herself: a cult figure turned into a legend in Anolik's electrifying book. This is a portrait as mysterious, maddening—and seductive—as its subject."

—Peter Biskind, author of *Easy Riders, Raging Bulls*

"Lili Anolik's love letter to Eve Babitz is as probing and intelligent as it is outrageously fun, swirling with secrets and gossip, celebrity and art, feminism and literature and tragedy and sex and sex and sex. A glorious trip through the looking glass of a golden-age L.A., *Hollywood's Eve* makes the case for Babitz as chronicler and muse of an era even as it paints an unsparing picture of its lost illusions."

—Joe Hagan, author of *Sticky Fingers: The Life and Times of Jann Wenner and* Rolling Stone *Magazine*

HOLLYWOOD'S EVE

★

Eve Babitz and the Secret History of L.A.

★

LILI ANOLIK

SCRIBNER

New York Toronto London Sydney New Delhi

Scribner
An Imprint of Simon & Schuster, Inc.
1230 Avenue of the Americas
New York, NY 10020

First Scribner hardcover edition January 2019

SCRIBNER and design are registered trademarks of The Gale Group, Inc.,
used under license by Simon & Schuster, Inc., the publisher of this work.

For information about special discounts for bulk purchases,
please contact Simon & Schuster Special Sales at
1-866-506-1949 or business@simonandschuster.com.

The Simon & Schuster Speakers Bureau can bring authors to your
live event. For more information or to book an event contact the
Simon & Schuster Speakers Bureau at 1-866-248-3049 or visit our
website at www.simonspeakers.com.

Interior design by Jill Putorti 9 2 1

Manufactured in the United States of America

10 9 8 7 6 5 4 3 2 1

Library of Congress Control Number: 2018035881

ISBN 978-1-5011-2579-9
ISBN 978-1-5011-2581-2 (ebook)

To Mirandi, Laurie, and Paul

The pure products of America
go crazy
——WILLIAM CARLOS WILLIAMS

In L.A. when someone gets corrupt,
it always takes place out by the pool.
——EVE BABITZ

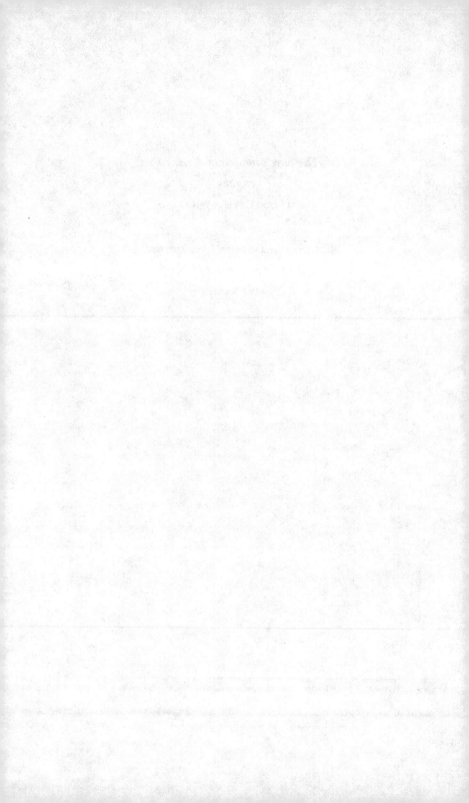

A Note, Slipped to the Reader

Hollywood's Eve isn't a biography—at least not in the traditional sense. It won't attempt to impose narrative structure and logic on life, which is (mostly) incoherent and irrational, lived moment-by-moment and instinctively rather than by grand design and purposefully; or to provide explanations, which (mostly) dull and diminish; or to reach conclusions, which are (mostly) hollow and false. In other words, it doesn't believe, or expect you to, that facts, dates, timelines, firsthand accounts, verifiable sources tell the tale.

Here's what *Hollywood's Eve* is: a biography in the non-traditional sense; a case history as well as a cultural; a critical appreciation; a sociological study; a psychological commentary; a noir-style mystery; a memoir in disguise; and a philosophical investigation as contrary, speculative, and unresolved as its subject. Here's what *Hollywood's Eve* is above all else: a

love story. The lover, me. The love object, Eve Babitz, the louche, wayward, headlong, hidden genius of Los Angeles.

A book can be infatuated—hopelessly, helplessly, heedlessly—same as a person. I'm telling you this not as a way of asking for allowances, but for understanding. In the following pages, things might get a little heated, a little weird, a little out of hand. Now you know why.

C'est Sheik

★

Imagine, for a second, this:

It's 1959. You're sixteen, a junior at Hollywood High. It's that dead time between classes and you're in the girls' room, sharing a cigarette with Sally, not her real name but what you'll call her when you write about her years later in *Rolling Stone*. Sally, who's already been through the wringer at Twentieth Century–Fox, signed to a contract and then summarily dropped because she bleached her hair a glowing, white-heat shade of blond (Marilyn Monroe's exactly) the night before her first day of work, blowing her chance at the very moment she took it, as, unbeknownst to her, the studio's plan was to turn her into the next Jean Seberg, the fresh-faced beauty plucked out of Iowa and obscurity to play Otto Preminger's Joan of Arc. Sally, who finds mornings so onerous she has to chase fifteen milligrams of Dexamyl with four cups of coffee just to drag herself to homeroom. Sally, who is rich and surly and sex-savvy and who has been adopted by a group of twenty-somethings from her acting class, the Thunderbird Girls, knockouts all in blue eye shadow and cinch-waist cocktail dresses, cruising around town in—what else?—Thunderbird convertibles, spending

1

their evenings on the Sunset Strip, letting Lenny Bruce steal their best lines, their weekends in Palm Springs, making ring-a-ding-ding with Frank Sinatra. Sally, who saved you from the Deltas and the other sororities that ruled the school. Sally, who is your best friend.

The company you keep is fast, just your speed as it so happens. No woof-woof among sex kittens you. Not with your perfect skin and teeth, hair the color of vanilla ice cream, secondary sexual characteristics that are second to none. Last year, you went to a party you weren't supposed to go to. An adult male and the right type of wrong, a big-beef dreamboat galoot, exactly what you'd had in mind when you snuck out of the house, told you he'd give you a ride. You jumped at the offer. But as soon as you confessed your age, fourteen, he pulled the car to the side of the road. "Don't let guys pick you up like this, kid, you might get hurt," he said, undercutting this gruff piece of fatherly advice by laying a five-alarm kiss on you. He drove off without telling you his name. A few months passed and there was your white knight in black and white, on the front page of every newspaper in town. He'd had a run-in with another fourteen-year-old girl, only this encounter ended in penetration: her knife in his gut. Johnny Stompanato, Mickey Cohen henchman, dead at the hands of the daughter of his inamorata, Lana Turner. Bad luck for Johnny but a good sign for you. You caught the eye of the infidel who stormed the temple of MGM's love goddess nightly.

That might not make you a movie star yourself. It does put you in the same firmament as one, though.

And you've got more than your looks going for you. What about your pedigree? Your dad, Sol, Jewish, Brooklyn-born, is first violinist for the Twentieth Century–Fox Orchestra. First violinist for the Los Angeles Philharmonic, too. He and a cellist once came to blows over the proper way to play the dotted notes in Bach. Your mom, Mae, a Cajun Catholic from southeast Texas, is an artist, her medium quill and ink. Also, parties. She's famous for her beauty and charm, her chignon with the rose in it, her chiles rellenos, the chiles just hot enough. Your godfather is the composer Igor Stravinsky. He's been slipping you glasses of Scotch under the table since you turned thirteen, and his wife, the peerlessly elegant Vera, taught you how to eat caviar.

Your house, on the corner of Cheremoya and Chula Vista at the foot of the Hollywood Hills, is packed so full of musicians there's barely room for their instruments: Fats Waller and Stuff Smith, Joseph Szigeti and Marilyn Horne. There are tales of picnics along the L.A. River with Charlie Chaplin and Paulette Goddard, Greta Garbo, Bertrand Russell, the Huxleys. On a family vacation to Santa Fe, Sol took a detour, drove to the middle of nowhere, so you could see the painter Georgia O'Keeffe, tall, ancient, flinty-eyed, for yourself. You liked the handsome boy who sat at her feet and rubbed them; you didn't like the chow dogs who barked at you. The two Kenneths, Rexroth and

Patchen, deliver readings in your living room. But poetry bores you blind, so you ask Lucy Herrmann, wife of Bernard—Uncle Benny to you—in the midst of writing the score for Hitchcock's *Psycho*, which Sol will perform, his violin shrieking as Anthony Perkins yanks back that shower curtain, to tell you stories upstairs. Arnold Schoenberg just laughs when you and your sister Mirandi get stuck together with bubble gum during the premiere of his latest piece at the Ojai Music Festival.

And then there's your brains. You're never not reading: Dickens, Trollope, Woolf, Proust. Plus, you're good at school, even if your spelling is of the experimentalist variety—no slave to form you—and your notebook filled with doodles of Frederick's of Hollywood models instead of actual notes. You still have little intention of letting your college counselor talk you into applying to UCLA. Not when Stravinsky gave you your name. (Could he, by the way, have made a cannier choice? *Eve* is the most emblematic of designations, and rife with cultural and allegorical significance, suggesting guileless innocence and lethal knowledge at once. You're it. Or maybe it's you.) Not when Edward James, the art collector, another friend of your parents', and for whom Salvador Dalí created the *Lobster Telephone*, told you that your beauty surpassed that of the Marquis de Sade's great-granddaughter. Not when your purse contains cigarettes, lipstick, a bottle opener, a copy of *The Pure and the Impure*, property of the Hollywood

4

Branch Library, and two matchboxes, one in which you keep your matches, the other, from the Akron store and large, in which you keep your diaphragm. And certainly not when "adventuress" is your ambition and the only thing UCLA can think to do with its girl students is turn them into "educators." LACC, the local junior college, seems the better option. Answer yes to the question "Do you speak English?" and you're in. And anyway, it's a whole lot easier to park there than at UCLA.

The bell tolls and you take a final drag on your cigarette. As you turn to flick the butt out the window, you're confronted by the same sight you're confronted by every day excepting weekends and holidays: the fifty-foot-tall mural of Rudolph Valentino, the exquisite Latin androgyne with the almond-shaped eyes and pouty-lipped mouth in the role that drove the 1921 moviegoing public into a state of rapture, of frenzy, of insanity—the Sheik, Hollywood High's mascot. The giant close-up, painted on the school's main building, depicts him in wind-blown headdress and romantic profile, gazing moodily past the track and football field, out into the distance. Perhaps at Paramount Pictures, a few blocks away on Melrose. Perhaps at Persia's desert splendor, oceans away on the other side of the world.

This reproduction of the silent-screen icon, crude as it is, corny as it is, transfixes you. You can't look away. Now don't forget. You've got that schizophrenic background. On the

one hand, you have your family, representing the East Coast, Europe, high culture. On the other hand, you have your context, Los Angeles, California: Roadside Beach and pineapple snow cones; the Luau in Beverly Hills, where you and Sally buy Vicious Virgins—two kinds of brandy, five kinds of rum, a splash of lemonade, and a gardenia floating on top—with your fake IDs, bat your lashes, also fake, at men twice your age; Marilyn Monroe and Jane Russell in matching cleavages and clashing polka dots, pressing their palms into the wet cement in front of Grauman's Chinese Theatre as you, in the fourth grade and on your way home from swim class, watch with eyes stinging from chlorine and smog. And if that weren't enough, you're possessed of a naturally romantic disposition. Consequently, the melodrama of the image before you, larger-than-life, large, in fact, as the movies, grips and beguiles you, its allure so potent, so resilient, so abiding as to be deathless. Literally. (After Valentino was felled by a ruptured ulcer at thirty-one, a number of women, a few men, as well, claimed to have received beyond-the-grave communiqués.) The longer you stare, the more susceptible you become to its dark fascination, its trashy-profound glamour.

And then, just like that, your imagination is captured, your tastes formed. Even if you don't think much of the movies or the people who make them, your sensibility—instincts, too—from this moment on will, in essence, be cinematic. Hollywood,

with its appeal to the irrational and the unreal, its provocation of desire and volatility, its worship of sex and spectacle, will forevermore be your touchstone and guiding light. For better or worse, its ethos is your ethos, its values your values. Henceforth, when you look at Sally, you won't see a mixed-up kid, already damaged, and who'll bring nothing but trouble to those close to her, sure, though mostly to herself. You'll see a starlet. The kind of magical creature who turns everyone into a bystander, a spectator, a *fan*. To you, high school is the set of a movie, an extravaganza with a sky's-the-limit budget, a gaudy locale, and legions of luscious background players. But then, if it isn't the set of a movie, why be there?

You're Eve Babitz, future muse and artist, observed and observer, chronicler of scenes, stealer of them, too; and you're poised to enter a new decade.

Marilyn Est Morte!

★

It's generally reckoned that it was the 1950s in this country well into the 1960s, all the way until November 22, 1963, when that magic bullet took out JFK. For Los Angeles, however, the end came sooner, on August 5, 1962, when Marilyn Monroe took herself out with Nembutal. Eve got word the following day

from the headline on a newspaper in France, where her family was living as Sol completed his baroque musicology research. Her favorite movie star, the one with whom she most passionately identified, had OD'd while she hung around cafés, smoking smelly French cigarettes and bemoaning the shortness of the *jeunes hommes* even as she chased them. She was angry with herself for not being there. "I felt I could have saved her. . . . Marilyn kept putting herself in other people's hands, believed them. They let her think that she was just a shitty Hollywood actress and Arthur Miller was a brilliant genius." But Eve knew something others did not. Eve knew the truth: that Monroe wasn't shitty or even an actress, though Monroe was a performer and beyond compare (did anyone, before or since, male or female, dramatize to greater or more moving effect what it means to be a star?), that Monroe was an artist, same as Georgia O'Keeffe. Better than O'Keeffe, in fact, because Monroe was an artist who was also a work of art.

Monroe's suicide pushed Eve to the brink of a nervous breakdown. ("Well, I've never been too stable.") Deciding it was time to go home, she placed a call to her boyfriend, Brian Hutton. Hutton was an actor, though, fortunately for him, former, since Eve didn't truck with actors who weren't Brando—"Sally and I watched *One-Eyed Jacks* three times in a row at the Pix Theater on Hollywood Boulevard, the credits rolled and we didn't get up from our seats, just stayed and

stayed"—from New York, and twenty-eight. He was also married. He immediately wired her $500 for a plane ticket.

It was the fall of 1963. More than a year had passed since Eve's continental adventures. No longer was she riding shotgun with the Thunderbird Girls. They weren't, as she'd initially thought, an alternative to the Deltas, they were a "souped-up version" of—a sorority in all but name. And anyway, she preferred traveling solo: "In grammar there is a noun and there are adjectives. Adjectives modify the noun, they alter it and cramp its style. I didn't want to be a [Thunderbird Girl]. I just wanted to be a girl."

And she'd gotten herself a new boyfriend, art curator Walter Hopps. Not that she'd dropped the old. She and Hutton, a liar and charming and very funny, which seemed like overkill considering how good-looking he was, would be on and off for years. Hopps, same as Hutton, was significantly older, thirty-one to her twenty. And Hopps, same as Hutton, had a wife.

A word on Eve and married men: Eve's parents were, as far as she was concerned, "one of the most gorgeous couples ever established here on earth, even in Hollywood." Sol and Mae started out crazy about each other and stayed crazy for forty-plus years, until Sol's death in the early eighties. Lau-

rie Pepper, Eve's first cousin though more like a second sister, the third Babitz girl, recalls, "Sol and Mae were always taking these naps—you know, *naps* with quotes around it—in the middle of the afternoon. Mae had a gigantic dresser, and it was filled with lace nighties and sexy underwear. And there was pornography in their bedroom, racy drawings with captions in foreign languages. Eve and Mirandi and I snooped, naturally." But when Sol and Mae met, Mae already had a husband, Pancho, an Italian, the maître d' at the famed Sunset Strip nightclub, Ciro's. Sol had to have her, though, and they began an affair. (Eve: "I don't think my mother thought of it as cheating. She felt like she was in a European situation.") Mae, pregnant with Sol's baby, Eve—Mirandi would come along three years later—told Pancho she was leaving him. To soften the blow, Sol offered to pay for Pancho's analysis. Which is to say, Eve both revered matrimony and believed it wasn't something to be taken altogether seriously. If it didn't bother the men that they were breaking their vows, it didn't bother her, was her policy. And she never slept with a friend's love or ex-love, no matter how cute he was, how good the drugs he was holding. Honor among thieves, etc.

Now back to Hopps. Hopps, a fourth-generation Californian, grew up in Eagle Rock, the son, grandson, and great-grandson of doctors. He was fitted for his first stethoscope

while still in diapers. And, when it was time for college, he obligingly enrolled in premed classes at Stanford and UCLA. It was his art history classes, though, that compelled him. And in 1957, he cofounded, right on La Cienega Boulevard, the Ferus Gallery, a move that required nerve. And faith.

According to Eve, L.A. was, at that time, "a hick town" as far as art went. She wrote, "If you judged it by the L.A. County Museum, or by its nowheresville galleries, or by its public philanthropies like the Huntington Library . . . the place was hopeless. It was so impossible that the L.A. County Museum didn't admit any art from Los Angeles. . . . My mother once picketed the place with her friend Vera Stravinsky, just to call the museum's attention to the fact that nobody from L.A. was inside." Ferus, in contrast, would make it a point to exhibit local artists. Its first show was of Boyle Heights' own Wallace Berman, and resulted in a bust by the vice squad—"Okay, where's the dirty stuff?"—Berman led away in handcuffs a few days after the opening (the "dirty stuff" in question was actually a drawing by artist-occultist Marjorie Cameron, but Berman took the heat), and the gallery temporarily closed by order of the police department.

The scandal didn't hurt Hopps's standing any with L.A. art patrons, an easily scandalized bunch. Maybe because in his navy-blue Brooks Brothers suits, his starched white shirts, his dark-framed glasses, he looked like the doctor he never

became and incapable of an un-straight-arrow thought or deed. Wrote Eve of Hopps, "It was as though someone from the other side, the public side of L.A., had materialized on . . . our side, the side of weirdness, messiness, and art." L.A. artists Billy Al Bengston, Ed Moses, Kenny Price, Larry Bell, and Ed Ruscha would have their first solo shows at Ferus. Andy Warhol, a New York artist geographically but an L.A. artist spiritually, as well—those Campbell's soup cans, all thirty-two mouth-watering flavors.

In 1962, Hopps left Ferus in the hands of partner Irving Blum in order to accept the position of director of the Pasadena Art Museum. His September show, *New Paintings of Common Objects*, featuring Roy Lichtenstein, Ed Ruscha, Joe Goode, and Andy Warhol, among others, was the first pop-art exhibition in the U.S., beating out New York, still under the sway of the abstract expressionists, by nearly six months.

And Hopps was getting ready to turn the art world on its ear again. Hopps had convinced the great dadaist-surrealist Marcel Duchamp, who'd forsaken art back in 1921 to devote himself exclusively to the game of chess, to allow a museum that nobody had ever heard of in a town that was famous for a Jan and Dean song in which it was synonymous with the word *square*—"the little old lady from Pasadenaaaaaa!"—only not yet, not for another year, so was famous for nothing but the Rose Bowl, worse than nothing, to host his first retrospective.

Though Duchamp's best-known work was a painting, *Nude Descending a Staircase, No. 2*, it was the *Fountain*, the urinal he'd flipped over and signed, that had, to quote critic Peter Schjeldahl, "opened a trapdoor at the bottom of Western feeling and thought." In short, Duchamp was the original pop artist, the one who'd started it all. Suddenly, old was the new new, and Los Angeles, not even in the race art-wise, was ahead of the pack by a full length, two lengths, three. The shift had begun: the cultural wasteland was about to become the cultural center.

Of course the cultural wasteland talk was always so much hot air. Geniuses aren't dumb. To those with established reputations in the arts, the movie industry meant easy money, which was why L.A. was geniuses galore, as Eve knew better than anybody, since all she had to do was walk from her living room to her kitchen and she'd trip over three of them at least. The world was about to find out, though, and she wouldn't be there to utter a single "I told you so." She'd been left off the invite list for the party for the show's private opening. Hopps was notoriously absentminded. This oversight, however, was deliberate. What happened was this: his wife, Shirley, was supposed to be out of town, then she wasn't.

So Eve stayed home with her parents the night of October 7, flinging herself prostrate across the furniture, refusing dinner, or at least partaking of it less heartily than was her custom, getting annoyed with her father when, provoked by

one of her many deep sighs into asking, "What's wrong?," was satisfied with her response of, "Oh, nothing," and went back to tuning his violin.

Eve was right to sulk. The party wasn't at all the usual slop-pot, slapdash, beatniky L.A. art affair, people wearing whatever clothes they'd thrown over their bathing suits, drinking cheap Chablis out of plastic cups, wandering from gallery to gallery. (Monday-night art walks, they were called.) It was high style and high gloss and altogether ultra super-duper, black ties and pink champagne, a band, held in the ballroom of the elegant old Hotel Green. Guests included movie stars (Dennis Hopper), and the children of movie stars (Hopper's wife, Brooke Hayward, daughter of Margaret Sullavan), and underground movie stars (Taylor Mead), and people played by movie stars (Beatrice Wood, the ceramist and the real Catherine—the Jeanne Moreau role—in Truffaut's *Jules and Jim*), as well as L.A. artists (Ruscha, Bengston, Bell), and non-L.A. artists (Richard Hamilton, Claes Oldenburg, Andy Warhol, who was in L.A. for the first time for his Elvis Presley–Elizabeth Taylor show at Ferus and who'd get sick on that pink champagne), and assorted society types. And, naturally, the guest of honor, Marcel Duchamp, his wife, Teeny, former wife of Pierre Matisse, the art dealer and youngest son of Henri,

on his arm. Oh, and Mirandi Babitz, the date of the *Time* magazine photographer covering the event, Julian Wasser.

Eve hugged her pillow that night and cursed her faithless lover. "I was only twenty, and there wasn't a way I could really get to Walter. But I decided that if I could ever wreak any havoc in his life, I would."

Eve proved as good as her word. She was holding a glass of wine, standing in front of *Nude Descending a Staircase* at the opening—the *public* opening—held several days later when Wasser made his approach. Their conversation, according to her screenplay, "Portrait of the Artist as a Young Slut," optioned but never produced, went something like this:

Wasser unhooked the Nikon from around his neck. Without looking at Eve, he said, "I'm going to take a picture of Duchamp and a girl. You want to be the girl?"

"Okay."

Wasser popped open the camera, replaced old film with new. "Playing chess."

After a beat, Eve said, "Oh, right, because that's what he gave up art for."

Wasser kept his eyes on the film as he pulled it taut. "And naked. You, not him."

After another beat, Eve said, "Oh, right, because—" She gestured to the painting.

"Still in?"

"Still in."

At last Wasser looked at her, bared his teeth in a grin. "Great. Then we're all set."

"Have you told Duchamp about this?"

"As the French would say, no."

"Don't you think you'd better? What if he doesn't like it?"

Wasser, Nikon back around his neck, started to walk off, on the job again. "He'll like it."

"What makes you so sure?"

"He's a man, isn't he?" Wasser threw these words over his shoulder, then disappeared into the crowd.

Eve drained her glass of wine in a single swallow.*

Wasser had a reputation for being one of the most exciting photographers on the scene. He also had a reputation for having a reputation. Says Eve, "I met Julian through a friend of mine from LACC, Marva Hannon. Jewish girls were just starting to

* Eve has told this story both orally and in writing many—many as in many, many—times. Though the major details remain constant, the minor change: what Wasser said to her, for example, or where she was standing when he said it. I could have gone with any number of versions. I went with this one for no better reason than because I like it best.

get their noses done, and Marva was the first. Whatever Marva did was the height of style. Marva told me Julian took the most marvelous pictures. You know, naked pictures that you could show guys. She met him when she was at Beverly Hills High. He had an apartment across the street and was always trying to think of ways to get girls to take their clothes off." Laurie Pepper, a conquest of Wasser's in the late sixties, remembers a Seconal tablet "appearing like a magician's rabbit in his hand" after sex; a drawer full of toothbrushes, "individually wrapped," in the bathroom; and "candy bars for the Beverly Hills High girls in the fridge, but you can't say *that*!"* And this: "Julian was terrifically kind and friendly, and he gave great head along with great conversation. I admired him. I was a professional photographer, too, then, but I wasn't making a living. I thought he was an artist, and, oh, wow."

Wasser had his pick of young lovelies. He chose Eve. "She had a very classic female body," he says. More classic even than usual. Eve: "My breasts were big normally. For the first and only time in my life, though, I was taking birth-control pills. My breasts blew up. I couldn't get into any of my dresses they were so huge, and I thought they should be photographed, documented. For posterity."

A few days later, Wasser, in his shiny toy of a car, a Ford

* Laurie changed her mind. I can say it.

Fairlane convertible, white, picked up Eve bright and early at her parents' house. She'd left the public opening on a cloud and hadn't come down. The more she thought about Wasser's idea, the more she liked it. *Nude Descending a Staircase* would become *Nude Sitting at a Chessboard*—how brilliant. The more she liked her role in it, too, the only one worth having: the starring. This would, in fact, be the most Hollywood thing she'd ever done, including writing her number on the palm of Tony Santoro, boyfriend of Mamie Van Doren, when she met him at Roadside Beach on the day she and Sally ditched school to work on their tans. What could be more Hollywood than posing for dirty pictures? It was practically a local rite of passage, the de rigueur desperate act of the camera-ready cutie, flat broke, wolf howling at the door. Even for Monroe. *Especially* for Monroe. (Admitting she was the golden girl and wet dream in the Golden Dreams calendar did as much for Monroe's career as any movie and brought her public love besides.) Except Eve wouldn't be baring all to make money. She'd be doing it to make mischief. And art. She'd out-Marilyn Marilyn.

But suddenly Eve wasn't on that cloud, had lost her footing and was careening toward earth. Maybe this wasn't such a hot idea after all. Maybe this was just Wasser getting yet another girl out of her clothes and in front of his camera. Maybe only a

fool wouldn't have known she was about to be played for a fool. At least there was still time to call it off.

Just as she started to open her mouth, though, Wasser turned to her. His tone accusatory, "You aren't going to chicken out, are you?"

Not trusting her voice, she shook her head.

Minutes later they arrived at the Pasadena Art Museum. After exchanging her blouse and skirt for a smock, she sat miserably at the chessboard Wasser had dragged to the center of the room and chain-smoked, waited for Duchamp to appear, for the lights to be set up. At last, everybody was accounted for and all arranged. Wasser gave the signal. Eve rose, her mother's advice ringing in one ear: *Never put anything in writing or a photo*; her father's in the other: *Take his queen*.

She dropped the smock.

Eve and Duchamp were in the middle of their third game and engrossed. Hopps entered, stopped short. The gum he was chewing fell from his mouth.

Eve, who understood when the moment called for sardonic insolence, said, "Hello, Walter," barely looking up from the board.

Duchamp inclined his head in a slight bow. *"Bonjour."*

Hopps just stood there, staring, until Wasser said, "Walter, do you mind? We're working here."

Hopps, making apologetic noises, backed out the door.

Eve Babitz and Marcel Duchamp play chess in the Pasadena Art Museum, 1963

In the resulting photograph, Eve and Duchamp sit at a chessboard. Duchamp's hand is raised, his wrist cocked, in anticipation of his next move. Eve, legs crossed at the ankle, chin propped on her palm, waits for him to make it. She might have something on—the radio, for example, or Chanel No. 5. You wouldn't know it from looking at her, though. Not that Duchamp, his sangfroid as immaculate as his suit, is. He has eyes only for the game. Willful obliviousness is essential here. If Duchamp or Eve acknowledge her state in any way—if

he leers or smirks, if she betrays the faintest hint of nerves or self-consciousness—she'll be truly exposed, no longer nude, a classically accepted form of beauty, but naked; art will have become cheesecake, and that will be that. It's a walk across a high wire, net-less. Yet both Duchamp and Eve reach the other side, and without stumbling or flinching or even breaking a sweat. Their mutual aplomb carries the day.

Eve has certainly progressed since Hollywood High. No more is she content to be a mere looker-on, part of the audience. She's ready for her close-up now. Yet—and here's the kicker—she refuses to take it. Wasser's finger clicked and clicked that morning. And in most of the shots he captured, her features were visible. She chose a shot in which they were not (Wasser, a rogue but also a gentleman, granted her final say), and, in so doing, turned an extroverted gesture into an introverted one, a demand for attention into a plea for privacy, stardom into anonymity. The photo was thus a fulfillment of her paradoxical desire: to reveal herself to the world so a single person would see.

What else the photo was: her chance to be Marilyn Monroe. Eve, in Wasser's rendering, was the American Dream made lush, nubile flesh, as if sprung fully blown from the imagination of the European aesthete, lean as a blade, dry as a bone, opposite her, as Monroe, in *The Seven Year Itch* (1955), was the Girl, a gorgeous ninny bringing Tom Ewell's midlife crisis to climax. In other words, both Eve and Monroe were exploitable sex

objects. Only Eve was a sex object who was, too, a sex subject, meaning she exploited herself every bit as ruthlessly as either of the men exploited her. She wasn't just model and muse, passive and pliable, but artist and instigator, wicked and subversive. Says Eve in a voice cool, even deadpan, "Walter thought he was running the show, and I finally got to run something."

Posing with Duchamp did for Eve what she hoped it would. It allowed her to get even with Hopps. Get one up on, in fact. Yes, he'd achieved the impossible by landing the retrospective. It's her image, however, that's associated with it. In effect, she upstaged him, stole the occasion right out from under his nose, so high in the air it didn't twitch to the foul deed going on below.

And the photo, a lark and a prank and a bit of fun, a self-dare and a self-double-dog-dare, became famous ("Every artist on the planet knows it," says Wasser), as well as an emblem of the era, appearing in promotional catalogs and advertisements for *Pacific Standard Time*, the sprawling, grand-scale series of exhibitions in 2011–12 that commemorated the birth of the L.A. art scene. Which is to say, the birth of the pop-art scene. And what is pop but the coupling of dadaism and surrealism, embodied by Duchamp, the dada of dadaism, the sir of surrealism, with Hollywood, embodied by Eve, her sultry splendor laid bare and made available to our most delirious erotic fantasies? And adhering to the picture is something of the evocative poignancy of pictures of our parents together

before they had us; it invokes the same nostalgia, a nostalgia so strong it amounts to an ache, by showing us a time and place from which we are and always have been exiled.

Eve had come of age.

"What Are Tits For?" *

★

And now for Eve's groupie period, which, by the time she was getting checkmated by Duchamp (well, he was a chess master), she was already deep into. First, though, a bit on the term *groupie*, just then coming into vogue. It wasn't one of distinction or affection, obviously. Groupies saw themselves as muses, capable of inspiring artistic and commercial achievement; the rest of the world saw them as bimbos, capable of inspiring erections and nothing else. They never got the joke, which is that they were the joke. Another way of saying they were the starlets of a new generation.

Within Eve's groupie period were two distinct phases, and the first phase can't rightly be characterized as *groupie* since, during it, she ran around with artists, and groupies, at least in the early days, were a perk lavished strictly on musicians,

* A rhetorical question, posed by Eve, in casual conversation.

specifically on rock 'n' roll musicians. So, technically, it was an ur-groupie phase. And in it, Eve set a pattern she'd follow for the rest of her life: stay in one place, get around.

The place was Barney's Beanery, a "wreck of a West Hollywood chili joint," where she met Hopps. (And, incidentally, where Sol took Mae on their first date.) Barney's was not just a place. It was a scene, meaning a place + enchantment. The source of enchantment was the place itself, but also Eve, a fantasist at heart, her imagination possessed of a vitality, raw and raging, for which reality was no match. Suddenly the spot Eve was standing on began to glitter and glimmer and, in a flash, transformed into an earthly paradise and the sweetest of dreams, a locus of madcap and mayhem and romantic possibility. She wrote, "I have always loved scenes, bars where people come in and out in various degrees of . . . despair, gossip, and brilliance, and the scene at Barney's was . . . fabulous." No doubt it was. But seen through Eve's ecstatic eyes, it was more than fabulous, was irresistible. "LACC was the closest I ever got to college, and I dropped out of LACC for Barney's. After Barney's, I couldn't see the point."

Barney's was on Santa Monica Boulevard, a stone's throw from La Cienega and Ferus, and where all the artists drank. Says folksinger Judy Henske, "Barney's was outré, but not really. Let me put it this way, if you were part of the Jane

Fonda crowd, Barney's was outré. The people who hung out with Jane Fonda thought they were hip, but they were movie people, and how can movie people be hip? They can't. And Barney's was hip. It was the inside of the inside. Eve was on it, and so was I."

Barney's was where all the artists picked up girls, too. Eve, more often than not. Eve, if she didn't pick them up first. (Laurie: "Evie was dressing to go out one night, her boobs properly elevated and all that. And Mae looked at Eve and said in her sideways way, 'You do know that a guy will hump a tree, don't you?'") Art critic Dave Hickey: "I knew Eve through Barney's, and I knew people she knew, but we did not chat. She never had interest in guys she wasn't going to fuck." And, according to Henske, a little ditty was composed in Eve's honor/dishonor: "Eve Bah-bitz / With the great big tits."

A bit more on the term *groupie*, particularly as it pertains to Eve, who used it, to the exclusion of almost all others, when describing her young-woman self. It's not that she was unaware of the built-in sneer, it's that she was unfazed by the built-in sneer. Maybe because the sneer only looked as if it was directed at her. Groupie wasn't Eve's identity, no matter how frequently or gleefully she claimed it as such. It was her disguise, and good enough that many were fooled. Her giddiness, wide-eyed and all-out, her enthusiasm, not just vivid, incandescent, always made her seem slightly bananas.

And if you didn't catch her darting asides, her observations that sounded dumb when you first heard them, so smart you couldn't believe it when you thought about them later, you'd take her for a daffy ding-a-ling, a nitwit nymphet, Eve Bahbitz with the great big tits. Which is what Larry Bell, for example, did: "Eve was a funny, goofy kid who pushed her way onto the scene. I never paid too much attention to her." And Billy Al Bengston: "I liked Eve, but I didn't like being around her. She was always trying to get in your pants."

Others, however, did not. Ed Ruscha, for example: "Eve was our Kiki of Montparnasse." And sculptor Peter Alexander: "I'd see Eve around town, playing her game. She had those—well, let's just call them attributes. I'd go up to her and say, 'Oh, Eve, can I get a squeeze? Come on, give me a hug.' And she'd give me one, and it would be great. Even if she acted like a groupie, though, she never was. Groupies are passive, bounce off whoever they're around. And she was so much of a personality—bright, a multitude of talents, and confrontational. God, confrontational! Her opinions were immutable. It wasn't, 'I think it is.' It was, 'It is.' And you applaud that. You've got to."

Passing herself off as a groupie allowed Eve to infiltrate, edge into territory from which she'd otherwise have been barred. "It was the only way I could hang out with the artists at Barney's Beanery." Where she belonged since she was an artist, too—pen

and ink and watercolor—though, in fact, her true medium was as yet to be determined. Says Hickey, "Men artists are very, very welcoming of women artists who are ugly, but if they happen to be beautiful and sexy, the men hate them. A lot of those guys were scared of Eve. Most guys don't deal well with erotic charisma. Ed [Ruscha] does. Ed loves beautiful women and he's not afraid of them."

So Eve traded sex and sexuality for access, except it wasn't that simple because she also traded sex and sexuality for sex and sexuality. The Ferus artists were a talented bunch, and she cottoned to this early. A pretty one, too—"artists who looked like movie stars"—which didn't escape her attention either. Eve might not have known what kind of artist she was at this point, but her aesthetic gaze was already finely honed, and honing in. On Ed Ruscha ("the cutest"), Kenneth Price ("maybe cuter"), Ron Cooper ("cute too in a Toshiro Mifune way"). And on Dennis Hopper, an artist who looked like a movie star and was, only she had the sense to keep her distance. ("I loved Dennis but he was too weird for me. He once kept me up all night telling me about a screenplay he was writing. *Easy Rider*. It was better than anything I could think of, so I hated it."). Hickey again: "Here's what Eve wanted— to be one of the boys and to get with the boys." How lucky for her then that these were not mutually incompatible goals.

Not yet, at least.

Lucky Little Lady from the City of Lights

★

On February 9, 1964, the Beatles appeared on *The Ed Sullivan Show* and, in Eve's words, "changed It All." Only It didn't change. Not for her. Not right away.

She spent a few more years as an artist (using as a studio the bungalow behind Sol and Mae's house, where she also slept) and an artist's moll (was one of Ed Ruscha's *Five 1965 Girlfriends*). She lived briefly, very, with Ron Cooper. Cooper: "Eve decided she wanted to move in with me. I wasn't convinced this was a good idea. I'm not going to tell you what she did to convince me, but convince me she did. I drove over to her parents' place in my 1954 Ford station wagon and packed up her stuff. We went back to my loft downtown. She stayed a couple weeks, then she told me she'd had enough." During the day, she was at the *L.A. Free Press*, an underground paper, working as a receptionist. ("I learned how to type because my mother said I should.") During the night, she was at Barney's. ("The floor was covered in sawdust and the chili cost ¢35 and it was everything that was new and terrific and exciting.")

It isn't that Eve was unaware of rock 'n' roll as a phenomenon. It's that she was unpersuaded by it. Until January 1966. "I was not culturally deprived, okay? My father had the same

hat size as Albert Einstein. He got a Fulbright grant, a Ford grant, and then another Fulbright grant. He was this genius violinist and musicologist, and the only rock 'n' roll record he allowed in the house was Chuck Berry. And when I first heard the Grateful Dead and Jefferson Airplane and the Byrds—I mean, I didn't think they could play. Then David Crosby took me to see the harmonica player Paul Butterfield at a club on Sunset called the Trip. I couldn't believe it. Paul was so good and his band was so good."

And so Eve's ur-groupie phase gives way, at last, to her groupie groupie phase. "Up until then, I'd thought of the Sunset Strip as older. You know, as a place for Bing Crosby and people like that. But then came rock 'n' roll. And I was so in love with Paul Butterfield. I wore all these weird outfits and fake eyelashes out to here and went to see him everywhere. Nothing I did worked. Well, it turned out he only liked square girls. I found this out later when I was at a bar with my friend Lucille, and I was wearing this tweed suit that my mother had made. He walked in and saw me and said, 'Eve, you look wonderful!' So I guess I was on the wrong track."

With Paul Butterfield maybe, but not with Jim Morrison, on whom her ever-roving eye would also alight in early '66. Eve wrote a piece about the Doors' frontman for *Esquire* in 1991, timed to the release of the Oliver Stone biopic of the band. Her description of their initial encounter: "[It] took place . . . at a

now-forgotten club just down on the Strip called the London Fog. . . . There were only about seven people in the room. . . . [I] propositioned him in three minutes, even *before* he so much as opened his mouth to sing. . . . 'Take me home,' I demurely offered when we were introduced." He'd oblige, though not until the next night. It was worth the wait. "His skin was so white . . . [his mouth was] so edible."

Eve thrilled to Morrison the heartthrob, an object of desire so supreme he was also an object of art: "Michelangelo's *David*, only with blue eyes." Morrison the artist provoked another reaction entirely: "The Doors were embarrassing, like their name. . . . It was so corny naming yourself after something Aldous Huxley wrote. . . . Even [Jim's] voice was embarrassing, sounding so sudden and personal and uttering such hogwash. . . . If [he] had lived in another era, he would have had a schoolteacher wife to support him while he sat at home writing 'brilliant' poetry." It was Morrison's girlfriend, Pamela Courson—erratic, aggressive, violent, sexual, nasty—who was rock 'n' roll. Wrote Eve, "[Pamela] had guns, took heroin, and was fearless in every situation. Socially she didn't care, emotionally she was shockproof. . . . [She was someone with] a heart embroidered on her pants over the place where her anus would be." In short, all the things Jim pretended to be, Pamela was.

(Something I should probably have the good taste to leave

out, but here goes: When I first opened the March 1991 issue of *Esquire* that I'd purchased on eBay, saw Eve, in its pages, make sport of Morrison's intelligence and sensibility, his posturing and pretention—calling his poetry "brilliant" rather than brilliant was an especially brutal and welcome touch—I almost wept with relief. The piece was the second-to-last thing of hers I read, and it would have been the very last except her *Fiorucci* book couldn't be had for less than $2,000 on Amazon, and I wasn't in the mood to stick up a bank. Morrison loomed large in Eve's private mythology. Public, as well. She used a song he wrote as the title of one of her books and referenced him in nearly all. I was scared, is what it came down to. Was afraid of finding out that she regarded him as an existential hero and symbol of brooding, youthful fatalism, the Arthur Rimbaud of her time. The idea that she had even the slightest bit in common with the girls in college who irritated me most, the preeningly sensitive arty ones, a retro "Young Lion" poster invariably, inevitably, tacked to their dorm room walls, made my stomach twist, go watery. My love for her was pure, without irony or qualification, and I wanted to keep it that way. Which is why I ducked the *Esquire* piece for so long. And, yes, my feelings were unreasonable, but they lay beyond reason, and I was at their mercy. Morrison, to me, was just such an appalling figure. Mawkish and moist, striving to be taken seriously and therefore impossible to take seriously—a joke, basi-

cally. Final point, and then I'll move on: the renewal of faith in Eve that I experienced while reading "Jim Morrison Is Dead and Living in Hollywood" wasn't an isolated incident, would become a recurring theme in our relationship.)

And yet, though Eve rejected Morrison, she didn't, couldn't, not fully anyway. When they first got together, he was twenty-two and newly slender, having dropped thirty pounds after a summer of LSD—"a mud lark . . . [who woke] up a prince." He had, until the drinking and drugging left him bloated and ravaged, remarkable beauty, and beauty made Eve reverent. He had, too, remarkable fame, which did likewise, fame being to Eve what money was to F. Scott Fitzgerald. The very famous are different from you and me, she believes, have about them a gorgeousness, a romance, a theatricality, an air of boundless possibility and promise. She wrote, "[People] don't know what it was to suddenly possess the power to fuck every single person you even idly fancied, they don't know the physical glamour of *that*—back when rock 'n' roll was in flower."

But aesthetics were only part of it. Between Eve and Morrison was an emotional pull. Morrison *got* to Eve. At least some aspect of him did—his mournfulness, his incomprehension, his sweetness, his grace. (Her portrait of him is extraordinary, utterly unsentimental yet deeply moving. The tenderness she feels for him sneaks up on you as you read it, as, I suspect, it did on her

as she wrote it.) "[Jim] wasn't cool, but I still loved him. . . . I couldn't be mean to him. . . . He knew in his worst blackouts to put my diaphragm in and take my contact lenses out. . . . [And] something about him began to seem great compared to everything else that was going on." And her impulse was to protect him from Stone, a director who "[didn't] even like [beauty]" and whose movies were "always about horrible men doing awful stuff." Morrison might have been a poseur, but he was also the real thing: a genuine phony. Kind of like Hollywood.

A few weeks later, on March 6, 1966, Eve moved to New York. "I decided to spend a year there, even though I didn't want to. Why? To complete my education." She worked as the office manager of a counterculture newspaper called the *East Village Other*, the type of publication that featured doctored photos of Lyndon Johnson with his head in the toilet; comics by R. Crumb; inscrutable sex ads ("Dominant iguana seeks submissive zebra"). John Wilcock, *EVO*'s editor in chief, met Eve when she was at the *L.A. Free Press*. He couldn't get over her. Wrote Eve, "[He] talked about me so much that some girl who got around started calling me 'Wondercunt' before I'd even shown up, I was so famous."

Her first task was to throw an April Fools' Ball. Says Eve, "It was held at some place on Bleecker and it was so packed I

couldn't move. I was on acid. The Fugs played. A group that staged happenings, Fluxus, was there. Yoko Ono was part of Fluxus, so she was there, too. Her job was to make crepe-paper streamers and then toss them all around. It was a den of iniquity, but the streamers made it look like a high school gym on prom night."

Playboy had a Playmate of the Month, *EVO* a Slum Goddess. Eve: "The Slum Goddess title was nothing, it wasn't anything, it was something fat men with cigars came up with, but I had to have it. There was this girl Robin, and Robin was supposed to be Slum Goddess for that issue. She was prettier than I was and she wore peacock earrings. She should've won, only I did. She'd get me back, though. She'd steal one of my boyfriends."

Eve spent a lot of time with Andy Warhol. "The first time I saw Andy it was at the opening of his second Ferus show [September 30, 1963] and he was standing next to this Elvis that was silver and, like, twelve feet tall." Eve and Warhol took to each other immediately. "Andy complimented me on my tan. He said, 'With that tan you can do anything. Anything you do goes perfectly.' And I thought his work was great. I got it immediately. When I was in New York, we used to meet at Bickford's. We both ordered the English muffins."

Eve spent a lot of time, as well, with Timothy Leary, the pied piper of LSD, though that was a less happy association. Says Eve, "New York is hot in the summer, so I got a boyfriend

who had air-conditioning. Ralph Metzner. Ralph was part of Timothy Leary's team. I hated Tim. He was an alcoholic, and he always ordered everybody around as soon as he walked into a room. He made me type all his lectures, and he couldn't write. He loved speed and gave it to everybody. I love speed, too, but it was still too high a price to pay, typing up all those goddamned lectures of his. Ralph was the brilliant one, and everybody loved him better than Tim, and so did I. And so did Robin. Ralph's the boyfriend of mine she stole."

Metzner remembers the breakup slightly differently: "At the time Eve and I were together, I was using the *I Ching*. In one of our lovers' discussions around the issue of 'where is this relationship going,' we decided to consult it. The main pronouncement was 'The maiden is powerful. One should not marry such a maiden.' I interpreted that to mean we should discontinue our relationship. Eve, understandably, was pissed. But the oracle was right. The maiden *was* powerful. So that's why we split. The other girl had nothing to do with it. She didn't come until later. Oh, but Eve was a babe then. Gorgeous, just gorgeous!"

While in New York, Eve would also: introduce Frank Zappa to Salvador Dalí ("We drank Chartreuse"); get busted by G. Gordon Liddy, soon-to-be mastermind of the Watergate break-in ("Actually, it was Tim Leary who got busted, but I was there. It was at that estate of his—Millbrook, that mansion

with the Buddhas all over the place. I don't know why the cops didn't bust me, too. Maybe they thought I was cute"); testify, along with Walter Bowart, *EVO*'s publisher, about the ameliorative effects of LSD and other narcotics before a Senate committee that included Teddy Kennedy ("They asked me how many people I knew used marijuana, and I said, 'Everybody I know uses it except my grandmother.' Afterward, a reporter from the *New York Times* wanted to know why I hadn't turned my grandmother on, and I said, 'Because she's high already' "); become a secretary on Madison Avenue ("Walter Bowart said I was embezzling. But I didn't know how much I was supposed to be paid, so I took as much as I thought I deserved. I guess it was too much. He had to find me another job uptown. I worked for a guy who was an ad salesman for magazines. I hated it. I hated being put on hold"); and attend an exhibition of the artist Joseph Cornell.

It was the last that had a significant impact. Eve: "Walter [Hopps] told me to go. It was at some teeny gallery. I went with my friend Carol. Carol looked just like me except she was black. We were both on acid. I looked at Joseph Cornell's collages and I looked at Joseph Cornell's boxes, and it was just, like, 'Oh.' I'd always considered myself a prodigy at art and drawing. I thought I was good and my mother, who was good, thought I was good, and those were the only two opinions I cared about. But what Joseph Cornell was

doing was so beyond anything I'd ever seen or even thought of. Afterward I went out and bought all these magazines to make my collages. Which is when I started doing art madly." That Eve should have received Cornell as a revelation isn't so surprising. His work is homespun and pie-faced and Americana, and, at the same time, sophisticated and European and surrealist, each box a private reverie or fantasy. A private movie theater, as well. Cornell was an idolater of Hollywood. He made box tributes to Lauren Bacall, Greta Garbo, Hedy Lamarr, and—of course, naturally—Marilyn Monroe. *Custodian II (Silent Dedication to M.M.)*, featuring a fragment of a constellation chart, a chunk of driftwood, and a gold ring with a chain, is one of his most mysterious, romantic, and moving pieces.

Eve stayed in New York a year to the day, leaving on March 5, 1967. She put a duffel bag of her magazines for collages ("the main part of my life being centered around collages") on a bus, and herself on a plane. She barely even told anybody she was going, so eager was she to be gone. It wasn't so much that she hated the city as that she was temperamentally incompatible with the city. She wrote, "There are no spaces between the words [in New York], it's one of the charms of the place. Certain things don't have to be thought about carefully because you're always being pushed from behind. It's like a tunnel where there's no sky."

★ ★ ★

When Eve returned to L.A., she did the same things she was doing before she left, but she was different. "I was renting my own apartment on Formosa. That's where I was when a friend called and told me Paul Butterfield was playing in Huntington Beach. I'd finally got my license, but driving the freeway made my hair white. I could do side streets, though, so I borrowed my mother's car and drove down. Nobody was in the audience except Stephen Stills [of Buffalo Springfield]. The rest of the band had gone, and Stephen needed a ride home. I said, 'I'll give you one if you let me do the art for your new record.' He said, 'Okay.' I was thinking business, weird as it seems."

And so, from the only pictures of the band she could find, a spread in the fan magazine *Teen Set*—"Win a Dream Date with Buffalo Neil!"—Eve created a Joseph Cornell–style collage. It became the now-iconic cover of *Buffalo Springfield Again*. Eve: "I also bought one of those little Brownie cameras and started bringing it with me everywhere. I figured photos would be another way to get the record companies to pay me. What I'd do was print the pictures in sepia and then hand-color them so they looked like they'd been taken thirty years before. That's how I liked things to look—old, out of the past."

As an album-cover designer and photographer, Eve was part

of the rock 'n' roll scene in a way she hadn't been, was a legiti-mate player. Later she'd shrug off this career, laughingly refer to it as "a hoax." What she really was, she claimed, was "a slave to skinny boys with long hair who sang and played guitar" pos-ing as a cool-eyed professional—a groupie-plus, basically, her designer-photographer guise providing her with both a front and an alibi, as well as an all-access backstage pass. Because I've read her books and talked to her and talked to those off whom she cadged jobs during this period, however, I know the truth. She was serious about her art. Says John Van Hamersveld, art director of Capitol Records when he first met Eve in 1967, "She came into my office. She had her collages and her Buffalo Springfield album with her. Her reputation was as a preda-tor. And she chased me around my desk a few times, asked me on dates. But that was just Eve playing around. Work is what she wanted from me. She was looking to get hired." A thing about Eve I've learned: though she never lies, she's not always to be believed. And I'm inclined to put more trust in this line of hers—"Become art, not decoration"—the closest she ever came to articulating an ethical code, or, for that matter, giving advice.

Eve had a hungry heart. She wrote, "I was twenty-three and a daughter of Hollywood, alive with groupie fervor, want-ing to fuck my way through rock 'n' roll and drink tequila and take uppers and downers, keeping joints rolled and lit, a regular customer at the clap clinic, a groupie prowling the

Sunset Strip, prowling the nights of summer." So eagerly does Eve court corruption, so exuberantly does she participate in her degradation, so merrily does she roll along the path of sin, that she's incorruptible, undegradable, and beyond reproach. (Has there ever been a less jaded debauchee?) She's naughty, certainly, but bad, never. Is an innocent no matter how depraved her conduct. A lewd angel.

The Sunset Strip had, by the mid-sixties, become the place where youth and beauty, talent and ambition—art and commerce, too—met. A point of collision that was also a point of explosion. And of orgasm. In other words, the Sunset Strip, in West Hollywood,* had become Hollywood. As Eve was the first to recognize: "I was already much further into HOLLY-WOOD than most of my parents' friends. It was like all they ever knew was the movies about Hollywood whereas to me the Sunset Strip was ten times more immediate than a movie. Plus, it was alive."

Eve wasn't interested in having a boyfriend. But boy*friends*, ah, now that was a different story. Her romances were fleeting, casual, legion. In one of her books, a conversation is recounted. It's between Eve, though called "Sophie" or "I," and her cousin

* West Hollywood was not officially incorporated until 1984. But I have on excellent authority—Eve's—that West Hollywood was always called West Hollywood by natives, so I'm going to call it that, too.

Laurie, though called "my cousin Ophelia" or "she." (Eve's books, while frequently billed as fiction—"novel," "confessional novel," "stories"—are not. Says Eve, "Everything I wrote was memoir or essay or whatever you want to call it. It was one hundred percent nonfiction. I just changed the names. Why? So I wouldn't get sued!" Mirandi corroborates, "I was Eve's first reader, always. She'd hand something to me and say, 'Who's going to kill me if I write this?' ") From *L.A. Woman*:

> "But you know so many men," Ophelia said, "isn't there even one for you?"
>
> "They're all adjectives," I said, "they all make me feel modified; even a word like *girlfriend* gives me this feeling I've just been cut in half. I'd rather just be a car, not a blue car or a big one, than sit there the rest of my life being stuck with some adjective."

Eve is saying a lot of words here, but really she's only saying four: *Don't tread on me*. (She's also using the words, near exact, that she used when explaining why she couldn't be a Thunderbird Girl.) It's an extraordinarily aggressive statement, for a woman especially, even if the language it's delivered in is groping, unsure. She wanted sexual freedom, yes, a genuine possibility for the first time in history, thanks to advances

in medicine and science. Biology no longer called the shots. Wrote Eve, "Stuff like jealousy and outrage and sexual horror tactics like that . . . now suddenly didn't stand a chance because [I wasn't] going to get pregnant, die of syphilis." What she truly wanted, though, was freedom in general, sexual freedom, dreamy and cat's meow as it was, just a stand-in for something larger. She believed in the myth of the open range, had the cowboy's ethos: no borders, no fences. Certainly no little woman or little man tying her down or, worse, up in a wedding knot. "My secret ambition has always been to be a spinster," she wrote, and when there was still plenty of time to change her mind, except she never did. The idea of answering to somebody or explaining herself, of another person having rights over her, a say in what she did, was, to her, abhorrent and not to be countenanced.

Yet during this period, she did enter into a relationship with a man that was passionate, perilous, mutually dependent, and all-consuming. Says Eve, "It was around the time of the Monterey Pop Festival [June 1967]. I'd just turned twenty-four, and I had this boyfriend, Peter Pilafian. He played electric violin for the Mamas and the Papas, and he was their road manager and unbelievably cute. Before he was with me, he was with Rusty Gilliam. Rusty was the sister of Michelle Phillips [one of the Mamas in the Mamas and the Papas, later an actress]. Rusty was just as beautiful as Michelle, only more realistic. She

and Peter had a couple of kids together. Anyway, I'd stayed over his place, and we were in bed, and it was seven in the morning, and, would you believe it, in walks Earl McGrath."

Who's Afraid of Earl McGrath?

★

Before I get to Earl McGrath and Eve, Earl McGrath and me. Cross out the "afraid of" in my little subheading there and you have the question I posed, for several years, to anyone who seemed even remotely capable of providing an answer, though not to Earl McGrath himself since he denied my multiple interview requests. And once that answer came and it failed to satisfy me—and it failed to satisfy me no matter how detailed or juicy it was—I let go with a second question. Feeling my cool, disinterested journalist façade cracking, revealing the curiosity, hot and naked, underneath, I'd lean in and say, "No, but I mean, really, who *is* he?" And while McGrath died in early 2016, my questions did not. I kept asking them, just changed the "is" to "was." (Also, the "*is*" to "*was*.") The way other people collected baseball cards and postage stamps, I collected information on McGrath, who from here on out I'm going to call Earl, which I wouldn't normally presume to do as we weren't acquaintances, never mind friends, but obsession has its privileges.

"In every young man's life there is an Eve Babitz. It is usu-
ally Eve Babitz." That, as far as I'm concerned, is the best thing
anybody has said about Eve ever. It's an insult, yes, but it's also
Oscar Wilde, and therefore a compliment, and none higher.
I saw it on the inside flap of Eve's first book, and though it's
attributed to Anonymous, Anonymous, I later found out, was
Earl, and that's when my fascination began. I started bumping
into him in other places—all chic, all glamorous, all in—as well.
There he was in Joan Didion's monumental *The White Album*
(Simon & Schuster, 1979), a co-dedicatee. Then a friend lent
me his copy of *Within the Context of No Context*, George W. S.
Trow's book-length essay on television and its discontents,
which contained a profile, originally published in the *New
Yorker* in 1978, of Ahmet Ertegun, cofounder and president of
Atlantic Records. At Ertegun's side, boxing out a pre–David
Geffen David Geffen, was Earl. And then, a few weeks after
Earl died, I was researching a piece on Andy Warhol and Andy
Warhol's 1965 Girl of the Year, Edie Sedgwick, and received a
message from Frederick Eberstadt, a photographer and society
figure who'd known both. He needed to reschedule the day of
our interview. "Earl's memorial service has been postponed to
let the smart set at Jerry Hall's wedding to Rupert Murdoch
fly across the Atlantic, including the bride and groom," he
wrote. He assumed I'd know that "Earl" was Earl, and I did

know, but why did I know? Another way of asking, Who's Earl McGrath?

Eve's answer now: "Oh, Earl was fabulous. He was from Superior, Wisconsin, or some crazy place like that. He read Proust when he was sixteen and it changed his life. He ran Bobby Kennedy's career, that was his original thing. Then he was head of production for Twentieth Century–Fox. He came to Hollywood to write screenplays. He had a penthouse at the Chateau Marmont, but I didn't know that until later. For a while he was in charge of record companies. He had an art gallery in L.A. and one in New York. Earl gave Steve Martin his 'I'm a Little Teapot' routine. He was Joan Didion's best friend. Also Harrison Ford's. He had one hundred and thirty-seven godchildren. His wife was an Italian countess and her father ran off with the chauffeur. He made the best chicken salad." Not only is this answer wildly, extravagantly interesting, so interesting, in fact, that my brain keeps short-circuiting from attempting to pursue multiple trains of thought at once, it's almost all true. (I can find no mention of Earl in any biography of Robert Kennedy. According to Peter Pilafian, it was a suite Earl rented at the Chateau Marmont, the notorious Sunset Boulevard hotel—"If you must get into trouble, do it at the Marmont," advised studio boss Harry Cohn in 1939—not a penthouse. And Eve rounded up on the godchildren; the offi-

cial count at Earl's death was twenty-four.) And yet, it isn't the one I want. It's Eve's answer *then*, in the late sixties and early seventies, when she and Earl were a daily presence in each other's lives, that I'm after. Tough luck for me since I can't get it.

Or can I?

Janet Malcolm in *The Silent Woman*, her meditation on the art—and the con—of biography, which reads like a cross between a Kafka short story and a Patricia Highsmith psychological thriller, wrote, "Letters are the great fixative of experience. Time erodes feeling. Time creates indifference. Letters prove to us that we once cared. They are the fossils of feeling. This is why biographers prize them so: they are biography's only conduit to unmediated experience." I don't have Eve's letters to Earl, if ever she wrote any. But I do have *Sex and Rage*, which she did write, and in the mid-to-late seventies, when her emotions had not yet cooled or healed, were still burning, still raw. It's an intimate book, and immediate. And rereading it, knowing Eve now as I do, and having the keys to the characters, feels excitingly, shamefully forbidden. As if I've snuck into her bedroom, am snouting around in her underwear drawer, dropping crumbs in the pages of her diary.

Earl is a central character in *Sex and Rage*. He's called Max; Eve, Jacaranda. Jacaranda first encounters Max when he pays an early-morning visit to Gilbert, the handsome young man with whom Jacaranda is sleeping: "[Max] emerged out of the

Jaguar like a tall drink of water, like Cooper in *Morocco*; all he needed was a palm frond and a straw fan and he'd be complete." He doesn't stay long, the duration of a single cigarette. And as he leaves, having knocked Jacaranda dead with his simple style—"every move he made was like spring water, clear and salt-free"—his complicated charm—"a sort of seamless wicked, sarcastic, teasing temperament"—he invites her to a party. Delighted, she wonders what she'll wear "now that everything was going to be perfect." This is, unmistakably, the language of infatuation, no matter that Jacaranda intuits immediately that Max is gay. And the infatuation appears to be very much mutual. Max looks at her "as though at last he'd found her and now they had nothing else to do but spend the rest of their lives discovering the mysteries of each other's perfections."

Jacaranda's feelings intensify when she observes Max in a social setting, his natural element: "He smelled like a birthday party for small children." As a host, he's peerless, an artist. She recognizes this instantly, appreciates it as only a fellow artist can: "There was something special about [his] parties. . . . Within the first few moments after [the guests had] arrived, they'd be drenched in [his] delight with them and everything would become smooth and golden, and soon . . . the whole place would ascend to heaven." And the spectacle of him practicing his art hypnotizes her, puts her in a childlike, trancelike

calm: "Max's penthouse had filled up and people were sitting everywhere, humming and purring, a tight golden roll running through the air. . . . [Max] never let the ball drop for a moment, and was always ducking in and out of silences, laughing at how brilliantly things were going. . . . Gilbert was standing, leaning against the same wall that Jacaranda leaned against, and the two of them had been watching in smooth dreamy pleasure for nearly twenty minutes, not saying a word to each other."

And apparently Earl's parties *were* something else. Says Michelle Phillips, "If you went to Earl's, you were going to a party that you knew would be staffed and stuffed with the most beautiful, interesting people you could find. Always, always, the most fuckable people." Adds Ron Cooper, "Earl was an incredible cat. He knew everybody in the world. He was the Gertrude Stein of our era. He had a salon like Stein. I met Jasper Johns through him, Robert Rauschenberg, Andy Warhol, Jann Wenner and Dennis Hopper, Jack Nicholson— oh, just an amazing roster of people."

But it wasn't the gaudy glitter of celebrity that so dazzled Eve. It was all that brilliance assembled in one place, on one scene (shades of her parents' house in the forties and fifties), a magician—Earl—passing his hand over it and bringing it to life. Dave Hickey: "What Eve found at Earl's is, I think, what Warhol and a lot of us found at Max's [Kansas City, a New York nightclub]. Now, Max's was a bunch of low-end

social climbers and psychotics and drug addicts, but it had an elevator to the penthouse. Get there and you might get to go to Baby Jane's. It's where the money and the fame was, the silver bowls of cocaine on glass tables."

Yet while most of Earl's friends were indeed known, they were not famous, at least not in the way of a Warhol or a Wenner or a Nicholson. From *Sex and Rage*: "They were . . . the names you read in *W* and on lists at weddings in *Vogue* or *Queen*, only instead of being in black-and-white, they were in color and moved. . . . [The women] were never quite in the mood for Los Angeles and often got tired in one day of Rodeo Drive and shopping. . . . The men all wanted to become movie producers. . . . Jacaranda thought of [them] living on a drifting, opulent barge where peacock fans stroked the warm river air and time moved differently from the time of everyplace else." In other words, they were the jet set, considerably less stimulating company. Though, as it turns out, that isn't entirely true. Not for Earl and Eve, anyway.

Eve mentioned the transfiguring effect reading Proust had on a young Earl, this upstart from the provinces, son of a short-order cook who would grow up to become the man who knew privately nearly all the great public figures of his day. For much of his youth and slightly beyond, Proust flitted around the bon ton, squandering his time on endlessly trivial pursuits and unrelievedly fatuous people. (Fop was Proust's

mask in the same way that groupie was Eve's.) Only he was actually investing his time, and wisely, and those pursuits and people were essential, providing him with both education and preparation, as well as material, enough to last him the rest of his life. And just as Proust is rumored to have looked at an empty-headed duchess and seen the embodiment of several centuries' worth of duchesses, so Eve imagined Earl looked at some overdressed socialite twit too rich and bored to push her voice past her teeth and saw a modern version of the Duchesse de Guermantes. His vision, she believed, had an extra dimension, was capable not merely of perception, not even merely of extra-perception, i.e., a special keenness, but of extrasensory perception: it discerned the past in the present, ghosts walking among the living.

Eve was quick to pick up on Earl's powers because she possessed them herself. She must've felt he'd been made for her—the playmate of her dreams. And between the two of them existed a sympathy so perfect it verged on the uncanny: "[Jacaranda] felt very, very close to [Max] and heard him breathing and saw exactly what he saw and knew exactly why he did things and understood everything without a hitch." They were one being.

Earl had other friends, too, a smaller, cozier set, "the handful of people he took up with . . . in Los Angeles." The handful: Eve, obviously; Michelle Phillips and Peter Pilafian; Ann Marshall, daughter of thirties leading man Herbert Marshall, and

Phillips's best friend; artist Ron Cooper; Joan Didion and John Gregory Dunne, the couple having moved to L.A. from New York in 1964 to break into screenwriting; and Harrison Ford, before he was a movie star.

Says Phillips, "I didn't even know Harrison was an actor. I remember getting dragged to *Star Wars* at ten a.m. on a Saturday morning by my stepbrother, who'd done some animation for the movie. I was sitting there, watching the screen, and all of a sudden Harrison comes on and I gasped and said, 'That's my pot dealer!' " Says Eve, "Harrison carried his dope in a base-fiddle case, which he brought to Barney's." Ford was supplementing his dealing with a little carpentry. Though, in Eve's opinion, he should've stuck to dealing: "I don't think Harrison knew anything about architecture or engineering or anything like that. He built a deck for Joan and John, and John almost killed him because he never finished it." In *Vegas: A Memoir of a Dark Season*, Dunne wrote, "[W]hat had started as a two-month job . . . [stretched] into its sixth month and the construction account was four thousand dollars overdrawn. . . . I fired the contractor. 'Jesus, man, I understand,' he said. He was an out-of-work actor and his crew sniffed a lot of cocaine and when he left he unexpectedly gave me a soul-brother handshake, grabbing my thumb while I was left with an unimportant part of his little finger."

The thing about carpenters, though, is they really know how

to nail it. Says Eve, "Harrison could fuck. Nine people a day. It's a talent, loving nine people in one day. Warren [Beatty] could only do six. Earl was in love with Harrison. One time Earl and Harrison and I were taking acid at the beach in Malibu. And then I suddenly decided we had to go home because there were too many cops around, so we drove all the way back to Holly-wood. We stopped for breakfast at the Tropicana. Harrison started talking about working on a movie with—what's the name of Barbra Streisand's first husband? Elliott Gould? Harrison said he thought Elliott was a nice guy. Well, Earl stood up and threw all the dishes on the floor. It was weird. I mean, *weird*. He was jealous."

Though Earl was married to Countess Camilla Pecci-Blunt, a descendant of Pope Leo XIII, his preference was for men. Says Pilafian, "There was so much to like about Earl, so Harrison and I just sort of put up with his ridiculous advances." And yet, Earl's relationship with Eve was sexual, even if, technically, it was chaste. He stole her from Pilafian. That is, stole the object of affection of his object of affection. Or, rather, his objects, plural, of affection. (Eve engaged, too, in bouts of "clashes-by-night" sex with Ford, Earl's other crush.) The question becomes: why Eve? Why not, say, Joan Didion, with whom Earl was close before Eve and stayed close long after? My guess is because Eve, in spite of having "guys coming out [her] ears like streetcars," was, same as Earl, fundamentally

unattached, alone in the deepest sense. She was available in a way that Didion wasn't. And Didion didn't just have a husband, she had a reputation, as well. When Didion met Earl in 1962, her byline was already appearing in national magazines. Her first book, a novel, *Run River*, would come out a year later. And by 1968, with the publication of her second book, a collection of essays, *Slouching Towards Bethlehem*, she'd be famous. So Didion was protected twice over. Eve's position in the group was far less secure. She had nothing tangible or durable to rely on, only such delicate and fragrant qualities as an ability to captivate, a talent for amusing. She was there on the pleasure and whim of people better known and more powerful than she. Again, same as Earl.

Earl and Earl's scene absorbed much of Eve's energy, not to mention time (Cooper: "It seemed like at least three nights a week, Eve and I and Joan and John and Earl would have dinner, either at Joan and John's house, in their kitchen or their backyard, or at Eve's place, or at Earl's, or at my loft"), but not all. In 1968, she started hanging out at a folk club turned rock club called the Troubadour, a few blocks down from the Sunset Strip on Santa Monica Boulevard in West Hollywood. More specifically, at the Troubadour's bar, where, according to Eve, "the semen potential . . . was so intense it was enough

to get you pregnant just standing there." Says Dickie Davis, road manager of Buffalo Springfield, "Eve had a favorite table. It was in the corner. She'd say to me, 'Look around, Dickie. *This* is Paris in the 20s. *This* is café society. And sitting here, at this table, I can control the whole room.' "

Eve took photos of Troubadour regulars: singer-songwriter Gram Parsons, singer-songwriter Jackson Browne, singer-songwriter J. D. Souther, founding members of the Eagles Don Henley and Glenn Frey, banjo player and comic Steve Martin. Slept with all these guys, too (see: semen potential), except for Browne and Parsons, whose room at the Chateau Marmont she made it into, but whose bed never. They spent their afternoon together on the balcony, snorting pure cocaine imported from Germany and discussing the rhinestones in "The Diamond as Big as the Ritz"—even better than sex. Business was pleasure, and pleasure was business.

Eve continued to make her fine-art art, the Cornell-inspired collages, and a series of white Coca-Cola bottles, a variation on Warhol's *Green Coca-Cola Bottles*: "I took a bunch of glass Coke bottles and painted them white and then took two flowers and painted them white and stuck them inside the bottles. I was copying Andy. He was so brilliant." She didn't have a gallery, but that was okay. ("No, it didn't bother me. I thought I was too good for everyone. I was a

Max decided to arrange a meeting between Jacaranda and Etienne on the spur of the moment, one afternoon. . . . [He] asked if Jacaranda minded if he used her phone. "I would like you to meet a friend of mine. But I'm going to play a trick on him. Is that O.K. with you?" . . . She just waited, looking out the window at the smoggy afternoon, while Max dialed.

"Hello?" Max began, "You're *there*! . . . Listen, I want you to come over right away, it's important. . . . I met a woman in the supermarket. . . . Her husband is in [Phoenix]. So you've got to come at once. . . . She says she wants to meet you. She says she makes the best frozen potatoes au gratin in L.A." . . .

Twenty minutes later, a new beige Lincoln Continental pulled up sharply across the street. . . . Out of the Lincoln stepped one of the most powerful men in the world.

And Ertegun would become *the* most powerful man, in his world if not quite the, when, in 1971, he stole Mick Jagger and the Rolling Stones away from Decca Records. Yet while Ertegun was a suit and a shark, a killer by instinct as well as by trade, he was other things, too. He wrote lyrics for Ray Charles and the Drifters; launched Aretha Franklin; recorded, in addition to Sonny & Cher and the Allman Brothers and Led Zeppelin, John Coltrane and Charles Mingus and Ornette Coleman. From

snob, you see.") Eve continued to make, as well, her non-fine-art art, collages for *West*, the *L.A. Times'* Sunday magazine, accompanying pieces on topics such as Liza Minnelli and the L.A. pop music scene. And her album covers, for friends such as Noel Harrison (*Santa Monica Pier*) and the Byrds (*Untitled*), though she was more getting by as an album-cover artist than taking off. Her description of her life as a freelancer: "Some art director would say he loved [my work] in the morning and get drunk at lunch and call and change his mind before dinner. . . . In the free-lance art world [art directors] felt *they* were doing *me* a favor. . . . And maybe they were."

Still, she was able to pay her bills, and when she wasn't able to, she was able to find somebody who was. "I looked upon men, in those days, as people who'd never miss my incredibly reasonable fifty dollars for cabfare, which was much too cheap to make me feel like a hooker." Everything was casual, easy, there for the taking. And even though she was in her mid-twenties, her existence remained as footloose and improvisatory as that of a teenager. Years later she'd write, "Life . . . [in] West Hollywood during the 60s was one long rock 'n' roll."

A year or two into their friendship, Earl introduced Eve to Ahmet Ertegun, called Etienne Vasilly in *Sex and Rage*:

Sex and Rage: "Etienne had Magrittes in his living room . . . his wife was on the Ten Best Dressed list, he'd been everywhere, done everything, and spoke all these languages." Which is to say, Ertegun wasn't the usual cigar-chomping, money-grubbing music-mogul vulgarian; rather he was an impresario-potentate, the Monroe Stahr of rock 'n' roll. He clearly delighted in Earl's rascality and wit—Trow, in that *New Yorker* profile, described Earl as "the person, perhaps, with whom [Ertegun] was best able to relax"—Earl serving as a kind of courtier and companion. And Ertegun, in turn, looked after Earl. Earl's career was strange and implausible. That he had one at all, however, was due in large part to Ertegun, Ertegun hiring Earl to run Clean Records, an Atlantic subsidiary, and then Rolling Stones Records, also an Atlantic subsidiary.

But what Ertegun really hired Earl to do was run his social life. Earl's job was to know what Ertegun liked, and Earl, with his "quick gaming eye," knew Ertegun would like Eve. Stated plainly, Earl was Ertegun's procurer. And he was offering Eve to Ertegun. (That he didn't do so immediately, that he hesitated, is what interests me most. Did he have pangs? Scruples? Misgivings? Did he want to protect her? Keep her for himself? Or at least away from Ertegun?) It's irrelevant that the manner in which he offered her was playful and entirely un-coercive.

Eve didn't cry or balk or even give a moment's pause. She went along with it. Became the mistress of the married Erte-

gun. He was an attractive man, intelligent and worldly, and she felt more than respect for him, felt fondness. Yet there was about the relationship an unsavory quality. Maybe because it wasn't, properly speaking, a relationship, but an arrangement. Underneath the sophistication and suavity, the conversations about Marshall McLuhan and the bottles of French wine he had delivered to her apartment, a studio with two folding chairs and an upside-down orange crate for furniture, it was mercenary, transactional, brutal.

Recalls Mirandi, "Ahmet would call up Eve late at night, and she'd go over to the Beverly Hills Hotel. Ahmet always stayed in a bungalow, the same one, I think, set back among the palms. He always had the best drugs. Not just the best drugs, the best exotic drugs. He'd have things like opium. And there was room service all over the place, and champagne on ice. Evie loved all that. And she'd service him or whatever, and then she'd go home." Eve's version is different, but only slightly. From *Sex and Rage*: "The parties would last till 2 or 3 a.m. The girls would tempt Etienne, and he'd choose one, perhaps a pretty little laughing blonde. . . . At about midnight, suddenly . . . Etienne would start spewing insults at the little blonde. Or, worse yet, forget her and start on some new woman. . . . Jacaranda, of course, being in love with Max, didn't care too much about Etienne's intentions. . . . Since [she] cared so little about what Etienne was doing, she usually wound up being the one with whom Eti-

enne slept. . . . She, Max, and Etienne would have a nightcap and discuss the evening, until one of them was sent home in a Rolls-Royce limousine—Max." It's ugly emotions that are being expressed and exchanged here, or, I suppose, not expressed and not exchanged. Eve sounds, for the first time, bored. As if the deadly torpor of the people she's surrounded herself with has, at last, infected her. Sounds, too, hard, cold, contemptuous of self and others. Sounds fallen.

Mirandi: "There would be times that we went to Earl's, after a show or a concert. I'd see the mix of people who were there, top music people, people like Mick Jagger. And I remember all of them talking around a table. They were half-cocked, drunk, and full of whatever. And the talk was so mean and mean-spirited. It would be directed at the girls, sometimes at Eve—these horrible put-downs. Most of the girls would just crumble. Not Eve. She'd figure out what the deal with you was and just go for the jugular. She'd say things that would cut you in half. And drugs like cocaine made her even more surly. So she'd give it right back to Ahmet. I worried she'd get slapped, but I think he liked it." Eve thought the same. She wrote, "As for Etienne, he seemed pleased with Jacaranda's bravado. . . . It pleased him to watch her drunkenly delude herself that she was sailing along, walking on water. [Her] kind of foolhardy determination made [his] eyes grow madly hot."

And it's when Eve started up with Ertegun that it ended

with Earl. "Somewhere along the way, Max's tender-hearted, gleeful mastery turned to tears of poison." So their love story had a surprise twist, and the twist was that their love story was—surprise!—a hate story. Did Eve loathe Earl for pimping her? Did Earl loathe Eve for allowing herself to be pimped?

Eve's romance with Earl wasn't the only thing going blooey. Joan Didion, from *The White Album*: "Many people I know in Los Angeles believe that the 60s ended abruptly on August 9, 1969, ended at the exact moment when word of the murders on Cielo Drive traveled like brushfire through the community." The murders Didion is referencing are, of course, that of model-actress Sharon Tate, eight months pregnant, and four others, by the followers of cult leader Charles Manson, at the house Tate shared with husband Roman Polanski on 10050 Cielo Drive. Says Eve, "The first time I saw Sharon was at the Café de Paris in Rome. It was 1961, the same year I saw the pope. I couldn't believe anyone was that beautiful."

Cielo Drive was a bloodbath and an atrocity and a horror. Not just death but death in the family. Michelle Phillips: "It was so sad and so revolting and it had happened to our friends. Roman and Sharon were close with all of us." And not just death in the family but death in the family at the hands of the family. Manson and his followers weren't out-

siders in Hollywood. They were part of the community that Didion mentioned. It was Eve's friend, Terry Melcher, son of Doris Day and producer of the Byrds's *Untitled*, who was the intended victim. (Manson, an aspiring singer-songwriter, was introduced to Melcher by Beach Boy Dennis Wilson, at whose house he and a few of his women had crashed for several months in the summer of '68, and he blamed Melcher when he failed to secure a recording contract. Melcher and Melcher's girlfriend, actress Candice Bergen, had been the tenants of Cielo Drive before Polanski and Tate.) Catherine Share, the Manson member known as Gypsy, went to school with Eve, first at Cheremoya Grammar, then at Le Conte Junior High, and finally at Hollywood High. Says Eve, "Cathy—that's what she was called then—was in the orchestra. And she had the locker next to mine in gym class. She was perfectly fine, except she was a little gullible." And Bobby Beausoleil, the Manson member known as Cupid, whose stabbing of musician Gary Hinman on July 27 had kicked off the killing spree, lived with Eve for a week in 1964. She wrote, "Bobby Beausoleil had romped with his dog in my house. He'd worn a sign that said 'I am Bummer Bob.' I let him stay but hadn't slept with him because anyone who called himself that, I figured, must have the clap. . . . He sent Christmas cards from Death Row." Cielo Drive looked like an act of random, senseless violence, but it wasn't. It was a Greek tragedy.

Didion was right: the sixties in L.A. were finished. The decade that began with the suicide of Marilyn Monroe ended with the murders of Sharon Tate, Jay Sebring, Wojtek Frykowski, Abigail Folger, and Steven Parent. Only it took Eve almost two years to realize it. "I was too stupid to know I was in the wrong place. Joan knew, but I didn't. She had to go through the horrible awakening of finding out that California was in dire straits. I never had to find out because I was too drunk and stoned."

If Eve missed the chimes at midnight, however, she caught the echo. On July 3, 1971, Jim Morrison overdosed, an event she connected with Charles Manson—"Jim looked like [Manson] in his obit picture in the *Los Angeles Times*"—as though Morrison and Manson, who looked like Morrison in *his* picture on the cover of *Rolling Stone* the year before, were two faces of the same phenomenon, or, rather, two faces that had merged into one: the rock star who dreamed of becoming a homicidal maniac, and the homicidal maniac who dreamed of becoming a rock star.

Eve wrote of the sixties, "We were all . . . under a spell of peace and love and LSD that we thought had changed the world." When Morrison's body was found in the bathroom of his apartment in Paris, the spell broke for her. Disenchantment set in. With the Troubadour scene: "I was getting too old to be a record album photographer. I was losing my groupie

touch and had begun telling rock 'n' roll stars I hated rock 'n' roll and nobody is that cute." More painfully, with the Earl scene: "[Max's friends] talked about the newest places to eat and the newest places to become slender. They talked about the very newest people, and then they talked about the very most fabulous oldest people. They talked about how 'boring' anyone was who behaved with the least bit less surface élan than Cole Porter. Anyone who was serious about something other than what color to do the hall was boring." And most painfully, with Earl himself: "It was only art anyway, Max's attitude seemed to say—a dismissal of all he'd been before— and suddenly he smelled like suitcases and dry cleaning, not a birthday for an eight-year-old at all."

Once a fantasy lover and soul mate, Earl was now a stranger and an enemy, and Eve was convinced he wanted to destroy her: "Jacaranda felt Max was truly dangerous because of her painting. She'd drawn and painted all her life: ladies with whips, bluebirds, clouds in the skies. But then one day Max paused, stood back . . . and said, 'Is that the blue you're using?' After that, [Jacaranda] just stopped painting."

And so did Eve.

So there you have it, the answer to the question, Who's afraid of Earl McGrath? Eve. Eve was afraid of Earl McGrath.

★　　★　　★

Before I conclude this section, which marks the end of Eve as a painter and a collagist, a note on "Is that the blue you're using?"—the words that wiped out Eve's artistic assurance, until that moment absolute. They were originally spoken by Earl. Obviously. I just quoted Eve quoting him. But Eve speaks them, as well, in other contexts. Several years ago, I asked Eve how come she'd never gone into the local business, movies, and written scripts in more than a half-assed, quick-buck way. She replied, "Because you show a Hollywood person your screenplay and the person asks, 'Is that the blue you're using?'" And then, more recently, when she and I were discussing the Duchamp retrospective, and I wondered aloud why Duchamp had really left the art world back in the twenties (a sudden and overwhelming passion for a board game struck me as a fake-out, a cover story), she said, with total surety, "Because some terrible person who was supposed to be his friend asked him, 'Is that the blue you're using?'"

So "Is that the blue you're using?" is, clearly, for Eve, shorthand for a type of remark that sounds benign but is not. Odorless, tasteless, lethal, it's a kind of rhetorical arsenic, invading and then annihilating the recipient's self-belief. She puts it in the mouths of people who radically and profoundly fail to understand how art is made, how an artist suffers to make it. Like the dumdum studio executive. Or of people who *pretend* to radically and profoundly fail to under-

stand how art is made, how an artist suffers to make it. Like Duchamp's insidious confrere. Like Earl.

Intuition tells me that Earl was jealous of Eve. The jealousy was sexual—he was jealous of the other men for sleeping with her, jealous of her for sleeping with the other men—but only in part. Mostly the jealousy was artistic. Earl resembled, in so many ways, a character in one of those sprawling nineteenth-century realist novels about lost illusions. A young person of humble origins with grand hopes and dreams is lured to the big city, where his hopes are dashed, his dreams crushed. Stendhal's *Le Rouge et le noir* or Dickens's *Great Expectations*. *À la recherche du temps perdu* by Proust and *The Great Gatsby* by F. Scott Fitzgerald, the American Proust, are the twentieth-century versions. While Earl, through a combination of deft timing and exquisite manipulation, had climbed the heights socially, there was to him a sadness—sensed rather than seen, guessed at rather than known—a disappointment, a melancholy, an ache. And Eve, who both sensed and guessed, was as drawn to his dark depths as she was to his radiant surface. Moreover, the two derived energy from the same sorts of situations and people, but only Eve was able to convert that energy into something beautiful. Or soon would be. (As a painter and collagist, she never quite made the grade. She would, though, in her next incarnation. And, in any case, she wasn't ever not trying. Art, beauty, transcendence—these were always the goals.)

Says the Proust-like narrator in *À la recherche du temps perdu*, "The essential, the only true book, though in the ordinary sense it does not have to be 'invented' by a great writer—for it exists already in each one of us—has to be translated by him. The function and the task of a writer are those of a translator." Translator is the function and task of any artist. And Earl couldn't translate. He was blocked, stalled, stymied. Proust also said, in a letter to a friend, that the social life in which he appeared so engrossed was merely "the apparent life," that "the real life [was] underneath all this," the real life meaning the artistic life. Earl's sin was in acting as if he believed the "apparent life" and the "real life" were the same, that being invited everywhere and having your invitations accepted by everyone was an end in and of itself, that a host-artist was an artist-artist, that, in essence, he had no hopes to dash, dreams to crush. Finally, he was a will-o'-the-wisp and a dilettante; a romantic who lacked the courage and conviction to make the leap of faith romanticism requires, and so a cynic; an elegant nonentity. Finally, he was impotent.

I guess it was sexual jealousy, after all.

Out of the Blue

★

Eve went from ingenue to bawd in the blink of an eye. By the time she and Earl were through in 1971, she'd lost her looks: "[I] gained weight and [my] legs were scuffed with alcoholic black-and-blue stains. . . . [My] beauty had long ago sunk into the sludge of gray-green no-sun pallor; the look with broken pink-eyed blood veins—of someone 'who drinks.' " Her way: "[I] wouldn't even risk blue paint anymore." And her mind: "All I took was speed, painkillers like Percodan and Demerol for fun, and painkillers like codeine and Fiorinal for cramps. And I never took downers, except if anyone happened to have any Quaaludes or Mogadons. Oh, and LSD or mushrooms or mescaline if it was a nice day." There's a term for this condition, and Eve coined it: *squalid overboogie*.

If this were the end of Eve's story, Eve wouldn't be a story. Eve would be a footnote. A minor figure of glamour in America's cultural history. A star groupie or a groupie turned semi-star. Basically, Eve would be Edie Sedgwick, so relentless a companion to celebrity that she became a bit of one herself, a few rays of spotlight spilling over onto her, making her luminous, too. Or, rather, Eve would be an alternative version of Edie Sedgwick: L.A. to Edie's New York; Marcel Duchamp and Jim Morrison to Edie's Andy Warhol and Bob Dylan; Jewish sexpot

to Edie's WASP gamine. Put slightly differently, Edie and Eve were opposites in ways that only revealed their essential sameness. (And their sameness *was* essential: born within a month of each other, within a hundred miles, and both Slum Goddesses to boot.) Like Edie, Eve was at the white-hot center of a red-hot scene, then banished. Upon which, Eve, like Edie, found her bloom faded. Became, like Edie, angry, bitter, resentful. And realized, like Edie, that she was less taking drugs than the drugs were taking her. Then, all of a sudden, divergence. Edie went left, Eve right. On November 16, 1971, Edie, age twenty-eight, died. She was in bed with the husband she'd picked up at a recent stint in the loony bin. Zonked from her meds and whatever else she'd ingested, she was unable to lift her head from the pillow, suffocated. An accident-suicide. It was during that very season, fall of '71, that Eve, age twenty-eight, came back from the dead. She resurrected herself as a writer.

Even before the divergence, though, there was a distinction, key, between Edie and Eve: while Edie and Eve both fucked stars, Edie was a star-fucker; Eve was not. How could she be? The stars she was fucking she was fucking when they were still earthbound, celestial ascension but a dream. Says Steve Martin, "Nobody was famous yet. Eve knew who the talented ones were." Again, it is Eve's artist's eye that set her apart. She saw beauty and value before others did. She went home with people or not home with people (behind the Troubadour was a favorite

trysting spot) for, I'm sure, many reasons: for the fun of it, for the thrill of it, for the hell of it. Never, though, for the prestige of it. In a funny way, her ego was too big for that sort of thinking.

Post-Earl, Eve cooled it—for her—on the controlled substances. The blowsiness receded, and she once again began to look "what her mother . . . referred to as 'your age, dear, eighteen.' " There was, too, a new guy in the picture, writer Dan Wakefield. Says David Freeman, also a writer, and a friend of Eve's, "Dan wasn't Eve's usual screwball behavior. He was a real person and very serious about what he did. He liked smart, interesting women, which Eve certainly was. That was a real love affair." Wakefield, thirty-nine, born in Indianapolis but living in New York and Boston since the early fifties, was a big-time journalist. The entire March 1968 issue of the *Atlantic* was devoted to his piece on the Vietnam War and the state of American politics. And his first novel, *Going All the Way*, had been a commercial and critical smash the year before, in 1970. He was riding high.

Wakefield: "I came to L.A. in 1971. The second week I was there, John and Sandy Gibson [publicists at Atlantic] fixed me up with Eve. She walked into the bar wearing the shortest skirt and the tightest sweater I'd ever seen, and when she smiled at me I knew the move to California was going to be everything I hoped it would be. I'd spend my days work-

ing at the Chateau Marmont, and at night I'd walk over to Eve's little place on Formosa. She was beautiful and tremendous fun. One night, an earthquake hit. The TV flew across the room, dishes and glasses broke. I jumped out of bed—off the mattress, to be specific—and started getting dressed. Eve simply looked up and said, 'What are you going to do, run to Boston?' So I took off my pants and went back to sleep. Eve was brilliant, but in an offbeat way. She liked to make pronouncements, and she convinced a lot of people of a lot of things. Did you know she was the one who put Steve Martin in that white suit?* And I remember her handing me a stack of books and saying, 'Read these. They're Proust with recipes.' It was M. F K. Fisher, the greatest food writer in the world. So a lot of those opinions of hers were shrewd. There were people, though, who were afraid of her. A guy I knew out there wouldn't go to a party if she was going. That's how brutally she'd cut him down. And once she banished me from her apartment for three days. I don't recall what I'd done— probably flirted with another woman in front of her. I was

* Wakefield didn't sound as if he was kidding when he told me this, but I still half thought he was. The white suit is as much a part of Martin's persona—at least Martin's early persona—as the prematurely gray hair. How could it have been anyone's idea but his own? "No, Dan's right," Eve said when I raised the subject with her. "That was me. There was this great French photographer, Henri Lartigue. He took pictures of Paris in the twenties. All his people wore white. I showed his photographs to Steve. 'You've got to look like this,' I said. He actually listened." It took me a while, but I finally got Martin on the phone. And he confirmed: the white suit was indeed all Eve.

used to seeing her every day and being shut out was painful. When she told me I could come back, and opened the door, I pulled her to me in a mad rush. I said, 'How could you have been so cruel?' She seemed gratified by my distress, and said, 'When a lover hurts you, you must really make him suffer.'"

Wakefield's reason for being in L.A. was a screenplay. But the reason was, in reality, an excuse. "Thanks to *Going All the Way*, I had some money for the first time in my life. I optioned a novella by a marvelous writer no one knows, Fanny Howe. It was called *Dump Gull*. I was trying to adapt it, but not very seriously. Mostly what I wanted was to have a good time. So I was in the movie business, sort of. But Eve was in the music business. And the music business then was what you think of as Hollywood—so extravagant, so lavish. The movie business was small-time compared to it. You don't do too many drugs if you're working on a movie because there's a lot at stake, and you have to be up early. I remember Eve taking me to a party for the release of a new album. It was on the side of a hill in this enormous tent. Beautiful girls in harem costumes were holding gold trays with perfectly rolled joints on them. It was unbelievable. Anyway, as far as I knew, Eve was an album-cover designer and a collage artist. I've always made it a point to never have a girlfriend who was a writer."

Wakefield's point became beside the point, though, when, a few months into the relationship, Eve showed him what

she'd been working on in secret: a piece about her alma mater, Hollywood High, entitled "The Sheik." ("Dan says I did it in secret? I don't think I've ever done anything in secret in my whole life. But maybe I did. Maybe I was afraid I wouldn't be able to pull it off.") Wakefield passed "The Sheik" on to his agent, Knox Burger. Wakefield: "Knox was very smart. He'd discovered Kurt Vonnegut when he was the fiction editor at *Collier's* magazine. And to be nice to me, he sent Eve a two-page, single-space letter telling her all the things she had to do to the piece to get it published, and he sent me a copy. So I went over to her place that night and said, 'What did you think of Knox's letter?' She put her hands on her hips in her particular way, then said, 'I hope Knox Burger burns in hell!' " And Eve, as self-confident and self-doubting a writer as she'd been an artist, meant it. "I'd already sent 'The Sheik' to Jim Goode at *Playboy* and he'd rejected it and told me what was wrong with it. I hate people who tell me what to do to improve my stuff. They get nowhere with me."

She then marched "The Sheik" over to Joan Didion, still her friend even if Earl no longer was. (Wakefield, coincidentally, was also close with the Didion-Dunnes, knew them from New York. Wakefield: "After Eve and I began dating, I called up Joan and John. I said to them, 'I've met this terrific girl.' I told them her name, and there was laughter. And then John said, 'Ah, yes, Eve Babitz, the dowager groupie.' ")

Says Eve, "Joan liked 'The Sheik,' thought it was a little tour de force. She was all the rage then. Grover [Lewis, an editor at *Rolling Stone*] asked her to write for him. She couldn't because of her contract with *Life*. She recommended me."

In September, Eve mailed the piece to Lewis. Two weeks later, she received a check. "The Sheik" would be published as a short story in a forthcoming issue. ("I thought it was an essay, but *Rolling Stone* saw it as fiction, and that was fine with me.") She could scarcely believe it: not only had her work been accepted, but her work had been accepted with ease and speed, and by a total stranger. She didn't have to make threats, as she did with Stephen Stills; or break out the sex appeal, as she did with John Van Hamersveld. More important, she didn't have to look to anybody else's example, not to Joseph Cornell's or Andy Warhol's, instead setting her own.

The experience was revelatory. Wrote Eve, "It was like something I heard somewhere when a person said, 'You know you're doing the right thing if you don't have to tap-dance.' " Lewis wasn't even asking for edits on "The Sheik," was taking it as is. Nor was *Rolling Stone* just any magazine. Started only four years before, in 1967, by Jann Wenner, it was the counterculture's bible, and one step ahead of hip. Among its contributors were Tom Wolfe, Lester Bangs, and Hunter S. Thompson, who would publish that November, in its pages, *Fear and Loathing in Las Vegas*.

Not among its contributors, however, was Dan Wakefield. *Rolling Stone* had, in fact, recently rejected a piece of Wakefield's, which is why, according to Eve, he split with her. " 'I'll see you on Johnny Carson.' That's what he said to me when he walked out the door." Years later she'd write a story, "Black Swans," about the breakup: "I knew everyone would be glad for me except the one man I actually loved. . . . Normal men aren't going to love anyone who looks forward to anything but them. And I couldn't help looking forward to being published."

And so we reach the point in Eve's tale where her desire to be one of the boys and her desire to get with the boys become irreconcilable, if only in her head. (Says Wakefield with a laugh, "She gave me the story. I read it and I thought, *That*'s what she thinks happened? No, no, no, no, no. Our year together was one of my favorite years, but I couldn't have lived through two of them. My God, the decadence! When I was with her, I tried every drug known to man. At least known to this man. And we were only ever going to be together for a year because I'd already accepted a teaching job at the University of Iowa. From Hollywood to Iowa City— boy, that was an extreme change.")

It was a drag about Wakefield. Still, the moment was a triumphant one for her, and it altered forever the course of her life. As she herself would marvel, "[I] was twenty-eight. It was time for [me] to O.D., not get published."

★　　★　　★

"The Sheik" is, as I said, about Hollywood High, and set
ten years after graduation, the narrator sitting at the bar of
the Troubadour, catching the scent of rain on the air, and,
for a moment, "the past appear[ed] in all its confusion and
doubt and pleasure, and [her] high school days surface[d]."
The piece is sad, tender, wistful, and passionately contradic-
tory: a romance, and enthralled with love without believing,
even for a second, that love is other than doomed; a rhapsody,
but a rhapsody on regret, decay, decline, ruin, so a rhapsody
that's also an elegy; a youthful promise made and a youthful
promise broken, and in nearly the same breath. Brightness
fades, beauty fouls, time passes, it tells us, such is the way of
the world. Nostalgia thus becomes, according to its logic, an
almost sacred duty, a species of keeping the faith, honoring
our losses. And the style of "The Sheik" matches the mood.
The writing has a lushness to it, a warmth, a kind of dole-
ful, sensual languor that is purely ravishing. Is closer, in fact,
to poetry or music than it is to prose, dependent as it is on
rhythm and tempo, melody and tone.

On the girls at Hollywood High:

The girls at our school . . . were extraordinarily beautiful.
And there were about 20 of them who separately would

cause you to let go of reason. Together—and they stayed pretty much together—they were the downfall of any serious attempt at school in the accepted sense, and everyone knew it. . . . The school was in constant chaos with whispers of their love affairs, their refusals to go along with anything that interrupted their games, scandals, tears, laughter. . . . These were the daughters of people who were beautiful, brave, and foolhardy, who had left their homes and traveled to movie dreams. In the Depression . . . people with brains went to New York and people with faces came West. After being born of parents who believed in physical beauty as a fact of power, and being born beautiful themselves, these girls were then raised in California, where statistically the children grow taller, have better teeth and are stronger than anywhere else in the country. When they reach the age of 15 and their beauty arrives, it's very exciting—like coming into an inheritance and, as with inheritances, it's fun to be around when they first come into the money and watch how they spend it and on what.

And on Carolyn, the top of the top twenty:

[Carolyn's] skin was dark and warm—flawless, clear with mauve cheeks like hidden roses. . . . Her hair was hazel or opalescent. . . . Her eyes were the brazen blue—the same

color—as the sky in back of the palm trees on the Palisades in summer. . . . She was a captive in the Sheik's harem, a stranger from the land beyond the sea who never learned to speak nor the purpose of speech, and it would have been more sensible if she'd been made a mute since occasionally she would unfold and stretch . . . her cupid-bow mouth would unsuccessfully try to suppress a yawn, and her tiny snow teeth would show—then she'd back up, sigh, and say, "Fuck, man, I wish today was Friday."

How not to read in rapt delight?

Eve gave two reasons for writing "The Sheik," one public, meaning she revealed it to her readers in a book, and the other private, meaning she revealed it to me over the phone.

I'll start with the private:

"So, Evie," I said, "what made you write it?"

Eve cracked something with her teeth, a hard something, something with a shell, maybe a pistachio, which she bought in bulk at Trader Joe's. "Rosalind Frank died."

"Who's Rosalind Frank?"

"Rosalind Frank was the most beautiful girl at Hollywood High, and the most beautiful girl at Hollywood High was the most beautiful girl in the world."

I waited for her to continue. When she didn't, I gave a nudge: "Well, what happened to Rosalind Frank?"

"She killed herself."

"How?"

"An overdose."

"All right. And?"

Eve took a drink, likely of coconut water, which she also bought in bulk at Trader Joe's. I gnawed impatiently on a cuticle as she washed down the pistachio or whatever it was. "And I thought the occasion shouldn't go unmarked."

I need to pause for a moment, tell you something. When I first read "The Sheik," I assumed Eve was exaggerating. She had to be. The school she's describing, never mind the girls in it, couldn't exist, not even in Hollywood, not even sixty years ago. And I've *seen* Hollywood High. I have one brother, younger, who went to USC for grad school, rented an apartment in West Hollywood. There was a two-year period during which I drove past Hollywood High semi-regularly. It isn't the kind of place that inspires romantic and fantastical thoughts, okay? You don't stop at the red on Sunset and Highland, catch it out of the corner of your eye, and start picturing flower-faced nubiles sitting in its classrooms, wilting of boredom, as a middle-aged teacher drones on about the significance of the green light in *The Great Gatsby* or how to solve for *x*, when they should be sipping Coca-Colas at

Schwab's, or the contemporary equivalent of, waiting for a genie in the form of a talent scout or casting director to make them rich and famous beyond their wildest imaginings. No, you're more likely to roll up the windows, fumble for the lock button. It looks run-down and tough and, frankly, scary.

Not that I thought Eve was consciously trying to deceive. She believed what she was saying. Anytime she recounted to me an episode in which she'd exhibited extreme sexual verve at a young age, I'd say, "But, Evie, how did you know to do that?," her reply would invariably be, "I went to Hollywood High." Like that explained everything. Because in her mind it did. Except her mind and reality weren't always a precise match. She was the type of person who saw things as they should be, not as they are. She was a dreamer, another way of saying she was an artist, and preoccupied with deeper truths. Only a fool would take her literally.

And then I began doing my research. Eve was technically the class of '61, though she completed her requirements a semester early, so was suspended between the classes of '60 and '61. In those two years alone was enough talent to fill the stables of an MGM or a Paramount. It's as if Hollywood High were both an American high school and an American high school as portrayed by Hollywood, i.e., an idealized version of an American high school, the teenagers played by actors, i.e., idealized versions of American teenagers. Not a pimple

or a pair of braces in sight. There was Tuesday Weld, shoot-
ing *Wild in the Country* with Elvis Presley and Hope Lange
(Eve, "Tuesday Weld was a rumor, as far I was concerned. I
never saw her at school"); Yvette Mimieux, already a head-
liner by 1960, co-lead, at eighteen, in the sci-fi classic *The
Time Machine* (Eve, "I knew Yvette was going to be a movie
star, even when she cut in front of me in the cafeteria. With
that face there was nothing else for her to be"); Linda Evans,
Mrs. John Derek before Bo took over the role, and *Dynasty*'s
Krystle Carrington; *Hart to Hart*'s Stefanie Powers; Barbara
Parkins, the bad girl in *Peyton Place*, the good girl in *Valley
of the Dolls*, released in 1967 and re-released in 1969 after the
death of Parkins's co-star Sharon Tate; television actress Car-
ole Wells. And a few years behind Eve, in the class of '63,
was her friend Mimsy Farmer, who'd have a film career, too,
if mostly in Europe. There were also the children of movie
stars: Dana Andrews's daughter, Kathy, for one. And Rosa-
lind Frank blew them all clean away.

It's not easy finding information on Rosalind. Near impos-
sible, in fact. She's not even in the 1961 Hollywood High year-
book (though neither, for that matter, is Eve). She is, however,
in another book, *Upper Cut*, a memoir by Carrie White, a
well-known L.A. hairstylist. Carrie was, like Rosalind, in the
Deltas—"the top sorority, absolutely the prettiest, cuntiest
girls in school," says Eve—and was Rosalind's best friend.

I wrote Carrie a message on Facebook and we met at the coffee shop at the Beverly Hills Hotel when I was in town a few weeks later. Carrie, pert, blond, slender, is the most girlish-looking seventy-two-year-old I've ever seen, a former *Playboy* Playmate, Miss July 1963. She's also a lively, funny talker. ("Oh, I was an alcoholic way before high school. The first time I was picked up for public drunkenness, I was nine. A police officer came up to me on the street and said, 'How old are you?' I said, 'I'm fine. How are you?' ") And her recollections of Hollywood High and Rosalind have the same shimmer as Eve's:

Let me tell you, Hollywood High was church. There was something almost spiritual about it. I'm not kidding. It was so beautiful—the trees, the quad, the girls. And, my God, the sororities. If you weren't in a sorority, it was, like, 'Do you exist? You're just an extra in our movie.' The Deltas were it. We were the rock stars and the beauty queens. We ran everything, including the teachers, who wanted to give up their degrees and date us. It seemed like all the girls in it were famous or about to be famous. Linda Evans was already at Paramount. I think Barbara Parkins had already been cast in *Peyton Place*. Years later Barbara and I were both at Sharon Tate's wedding to Roman Polanski in London. I did Sharon's hair. Stefanie Powers—she was called Taffy

Paul then—was discovered by Ann Sothern [actress and singer] in a Hollywood High musical. Even I got a contract with MGM. I was supposed to be the girl in an Elvis Presley movie called *Roustabout*, but then it fell through. And Roz was the best of us. Everybody in school knew who she was. *Everybody*. She was that glamorous. We were all like deer in headlights when we looked at her. She had these blue cat eyes, and this delicious skin that was always tan, a perfect straight nose, perfect lips, always with the Max Factor Essence of Pearl lipstick. She wore her hair like Veronica Lake, one strand sort of over her eye. And her clothes! The black dresses that tapered at the knee, black spaghetti-strap sheaths. She kept her diet pills—her Dexedrine—in this little gold box in her purse. I'd cover my awe, but most of the time I just couldn't get over her perfection. She seemed to have the script to life. All the boys were crazy about her. She didn't date high school boys, though. None of us did. We wanted to be grown up, in contact with the world. We dated men. I dated an actor named Danny Zephyros. He was a muscleman in the *Mae West Revue*. Then, to get over him, I dated another actor, Jack Nicholson. Jack was twenty-three or twenty-four then. He'd done one of those Roger Corman horror pictures, not much else yet, but he already had that smile and those eyebrows. He took me to an acting class and said, 'Okay, Carrie, your first acting job is to act eighteen.'

Roz was tortured over this married guy, I remember. Some music mogul. He'd call her at midnight and she'd go see him.

Carrie and I talked for more than three hours that morning. As I left her at the counter, taking the stairs to the lobby in bunches because time had flown and I was already twenty minutes late to my next appointment, my heart began to beat so hard and fast I could feel it in my throat, the tips of my fingers. I was experiencing one of those renewals-of-faith-in-Eve moments. She'd got it right again. No way could she have got it right again, but she'd got it right again.

A refusal to let the occasion go unmarked was, for Eve, a hereditary trait. Her mother, Mae Babitz, born Lily May Laviolette in Crowley, Louisiana, in 1911, was the daughter of a French Cajun teenager, Agnes, and the man who raped Agnes. Agnes was pressured by the church to marry her rapist, resisted, was excommunicated. She took Lily May and moved to Sour Lake, Texas, birthplace of Texaco, pitched a tent beside the oil rigs so that she and Lily May would have somewhere to sleep, and began cooking chili for roughnecks.

The Depression had just started when Lily May finished high school. She went to work for $4 a week at her mother's hot dog stand. Her days were spent fending off passes and collect-

ing nickel tips in the pink-checked uniform she made herself. Says Mirandi, "Mother was so close with Agnes. They were only sixteen years apart. Agnes had bad husbands. The worst was Joe Forman. He was a bootlegger and an alcoholic and a wife beater, and he was after Mother since she was very young. And I don't think Mother felt she could leave Agnes with him." The hell Lily May was trapped in was a particularly American kind: hard luck, hard times, mother love, self-destructive loyalty.

And then, five years later, deliverance. It came in two forms. A priest, who found Lily May a driver headed West, saving her train fare. And a gambler on whom Agnes decided to roll the dice. Mirandi: "Charlie Spillars became Agnes's next husband. Either he got rid of Joe or Joe just left. Charlie was always losing money, but he was an absolute sweetheart. He and Agnes adored each other. And I think that's what finally freed my mother."

Lily May arrived in Hollywood in 1934. She must've blinked her eyes, dried out from the Dust Bowl and the fluorescent Texas sun and the ugly, oil-reeking air. Maybe she also rubbed them because it would be hard to credit what they were seeing: palm trees, the leaves heavy, fleshy, swaying gracefully under a sky of blue both deep and soft; slanting, honeyed light spilling densely across the fronts of the buildings, horizontal rather than vertical and sleepy-looking, the cottages, wooden and A-frame or Spanish-style, white stucco with red-tile roofs;

trolleys moving people unhurriedly to and fro and back again on wide streets that still had, as she'd soon discover, long rural stretches, orange groves on either side; and, most thrillingly of all, in the near distance, above Bronson Canyon, on Mount Lee, the HOLLYWOODLAND sign, erected in 1923, an advertisement for a real estate development, and the site, the year before, of a spectacular suicide, a young woman named Peg Entwistle jumping off the *H* after failing to make it in motion pictures (Lily May had no interest in those, but she very much did in enchantment, the other local product). And as she stood there, breathing in the delicate scent of the jasmine blossoms, feeling the lazy, languid weight of the breeze—ocean, even though the Pacific was miles away—its touch on her face as gentle as a caress, she probably wondered if she wasn't dreaming or dead. Reality here simply wasn't real.

Lily May immediately dropped the *Lily*, along with the country accent, and changed regular old American *May* to the more exotic *Mae*. A whiz typist thanks to a class she'd taken at the Chenier Business School in Beaumont, she had no trouble finding work: as the receptionist at the office of Dr. Franklyn Thorpe, a prominent gynecologist. The job was unrelated to show business in any way, except through marriage. Thorpe's wife was actress Mary Astor. Two years after he hired Mae, Thorpe took a peek inside Astor's diary. The ink she used was plain brown, but the writing was gaudiest purple, espe-

cially when describing an affair with playwright George S. Kaufman. Thorpe promptly filed for divorce, and the custody battle between him and Astor over their daughter became the scandal of 1936. The diary was the star witness, the one whose testimony everybody had been dying to hear ever since Thorpe began leaking passages to newspapers: "[George] fits me perfectly . . . many exquisite moments . . . twenty—count them, diary, twenty."

Marital discord was something Mae knew plenty about. Her husband, the Italian with the Mexican name, Pancho, kept irregular hours. Maître d's at the city's most exclusive nightclub didn't come home until dawn, and Pancho often came home later than that because he believed having a wife was no reason not to also have a girlfriend. There were other problems, too. The big one: he wasn't what she wanted. So when in 1942 she met Sol, a not-quite-divorced New York violinist with an unshakable conviction that the Wagnerian style of playing Bach was wrong as wrong could be, and a cute William Powell gigolo mustache, plus an aunt who was under contract at RKO (it wasn't Sol's genius that landed him the job as a studio musician, it was Aunt Vera's connections), the timing and circumstances weren't as dire as might initially have been supposed. Mae, in this order: got pregnant, converted to Judaism, divorced Pancho, married Sol. And, a scant four months following the wedding, on May 13, 1943,

Sol and Mae Babitz, 1942

gave birth to Eve. And since Sol and Mae Babitz were those rare lucky someones for whom love actually worked out, they lived happily ever after.

Now, Mae was a woman of immense daring. She put it all on the line. Born into the situation she was, poverty and obscurity a near given, she pretty much had to. But she understood the value of what she'd won, was careful never to risk it. She'd been so close to having no kind of life at all.

(She was almost twenty-three when she escaped Sour Lake, twenty-nine when she found Sol.) Which is why she saw L.A. for what it was: a heart-stopping mixture of blue sky and green pasture and blue-green sea, and virtually untouched. She didn't need to lose Paradise to realize she was in it.

She even tried to save it. In 1958, Mae became one of the founders of the committee dedicated to rescuing Simon Rodia's Watts Towers from destruction. (She got Picasso to sign the petition.) In a letter to the *Los Angeles Times*, she'd write, "History's tallest structure ever built by a single person shall survive intact." And so it did.

Then there was her own art. A rage for newer, bigger, better swept through L.A. in the fifties. Buildings and houses from the turn of the century, elegant and majestic, were being torn down left and right, junked like old movie sets, to make way for monstrosities, bland and anonymous. Mae's method was, in her words, "to stay one step ahead of the smashing ball." Says Mirandi, "Mother used to bump into the man who ran the Cleveland Wrecking Company at sites. They became friends. He started calling her when he got a job. He'd tell her, 'We're going to be at such and such a place in three months.' She'd grab her card table and her folding chair, her pencils and pads, and go. Usually she'd take me and Evie with her. I'd bring my homework, and Evie would bring a book, and we'd just sort of hang out while she drew." Mae's sketches of the Hollywood

Hotel, the original Los Angeles High School, the Angels Flight Railway at Hill Street, are among the only records of these structures that exist. And to see her work in its entirety is to see a city that's vanished, a city that wasn't a city at all, but a drowsy Spanish outpost, the ghost town called Los Angeles that haunts the sleek, tense, ultramodern urban experience known as L.A.

Eve inherited her mother's eyes, no matter that they were the exact color and shape of her father's. Eyes that stayed bright, stayed devious, that always saw for the first time even when they saw for the thousandth. And what Eve did for Rosalind Frank was what Mae did for the Victorians on Figueroa. She made sure something remained. "The Sheik" is a record, a testament, a firsthand account of a natural phenomenon—a beauty so powerful it was a black hole, sucking up everything around it, including its possessor. It appears to have left Rosalind without character or ambition or even a distinct personality. If ever there was a shoo-in for movie stardom, she was it. It didn't happen, though. The reason: she was already a star in life. How could she be expected to audition, to hustle, to cope? Wrote Eve, "People took care of [Rosalind]. Usually, her sorority sisters, but if they weren't there, then anyone who was would automatically assume responsibility. It wasn't that she was retarded; it was just that she couldn't scrape up even a sliver of interest in the proceedings and couldn't see why she should, and no one else could think of a good enough reason,

either—at least, one that made sense when you looked at her."
In short, Rosalind was too much the thing to be the thing.
Hollywood High was her movie, and when the movie ended,
she was adrift, without an arc or a script to follow, supporting
actors to keep her from missing her cues or flubbing her lines,
a director to tell her where to stand or how to look. Her suicide
was a confession of her vacancy. She faded to black because she
couldn't think what else to do.

Which is to say, I accept that her death is the reason Eve
wrote "The Sheik." Or, rather, I accept it is *a* reason. In the
story, the narrator finds out that the Rosalind character OD'd
two months prior. In life, however—and this to me is a crucial
difference—Rosalind OD'd almost two *years* prior, in early
1970. Says Carrie White, "Roz was always in a heartbreak.
The man-trap business was the only thing she developed. So
if a man left, it just destroyed her. She came into my salon
one day. She was hysterical, was so freaked-out from all the
Dexedrine pills she was seeing spiders. I grabbed them from
her and said, 'You're still taking these rough-housers?' And
then I flushed them down the toilet. She lost it, ran out. Soon
after that, I got the call. Her family said it was an accidental
overdose, something to do with a miscarriage. I don't know.
There were mixed stories." So Eve had been sitting on this
knowledge for a while before she started feeding paper into
her typewriter. A more urgent impetus, therefore, must exist.

★ ★ ★

Now for the public reason. Eve gave it in her 1982 book, *L.A. Woman*. The Eve character is an artist-photographer, Jim Morrison her on-again, off-again lover. She calls him her "tar baby" and credits him as her inspiration. Or, I suppose, properly speaking, anti-inspiration:

> I was so mad at [Jim Morrison's] L.A., [Jim's Morrison's] Symptom of the Apocalypse attitude, that every picture I began to take was proof he was wrong—and they really *worked*. They were casual but in an obsessed kind of way since I wanted to make L.A. look as though even a child could see that the bungalows and palm trees were only bungalows and palm trees and not out to kill the rest of the world.

"The Sheik," so full of freshness and wonder, did precisely that, which is why I buy the above reason without qualification. Without qualification but *with* a substitution: swap out *Jim Morrison*, put in *Joan Didion*.

Eve's *Esquire* piece makes clear that she had great affection for Morrison, but little respect. It's highly doubtful, therefore, that any idea rattling around his pretty head would get her blood so boiling she'd feel the need to seek aesthetic revenge. She didn't take him seriously enough to pay him that com-

pliment. And besides, when she wrote "The Sheik" in 1971, Morrison was in a bad way: mired in troubles both legal and personal, physically deteriorating, spiritually depleted. After a disastrous concert in New Orleans on December 12, 1970, he'd stopped performing live. John Densmore, the Doors' drummer, from his memoir *Riders on the Storm*: "Jim wasn't even drunk, but his energy was fading. Later Ray [Manzarek, the Doors' keyboardist] remarked that during the set he saw all of Jim's psychic energy go out the top of his head. . . . I knew the band's public life was over. I saw a sad, old blues singer who'd been great once but couldn't get it up anymore." In other words, Morrison of 1971 was not Morrison of 1967, a figure of youth and beauty and potency, a modern-day Orpheus. He was fat, flaccid, loaded, going through the motions. A stricken man. And by July of that year he'd be a dead one. So the timing's off with him, same as it is with Rosalind.

How's this for timing? Didion, in 1970, when Eve was as intimately involved with Earl McGrath and his crowd as she'd ever be, published a novel, *Play It as It Lays*, about an actress named Maria Wyeth. Maria spends her days going everywhere, going nowhere, just driving the freeways, as her marriage and life fall apart: "Again and again [Maria] returned to an intricate stretch just south of the interchange where successful passage from the Hollywood onto the Harbor required a diagonal move across four lanes of traffic. On the afternoon

she finally did it without once braking or losing the beat on the radio she was exhilarated, and that night slept dreamlessly."

(What, by the way, I mean by "intimately involved": Eve, because of her association with Earl, is responsible, if inadvertently, for the ending of *Play It*. Says Eve, "Michelle Phillips told the best stories in town. I remember her once lying down on the floor of my apartment—I was having a dinner party, Joan and John were there, Earl was there—and telling that amazing story about her friend Tamar. [Tamar Hodel, twenty-six, decided to kill herself after a failed love affair. She asked a then seventeen-year-old Phillips to help. Phillips, believing it wasn't her place to tell Hodel, an adult, what to do, agreed. Hodel swallowed a bottle of Seconal. Phillips fell asleep beside Hodel in bed. Fortunately, friends came home in time to call an ambulance.] I guess Joan was listening." I phone Phillips, relay Eve's words to her. Phillips laughs. "Oh, yeah, Joan was listening. She called me up the next day and said, 'Is it all right if I use that story you told in the book I'm working on?' And I said, 'Go ahead, it's all yours.' " In *Play It*'s climactic scene, Maria cradles the married-but-homosexual producer, the Earl-like BZ, as he overdoses on Seconal. She falls asleep beside him in bed. Friends come home, though, unfortunately, not in time to call an ambulance.)

L.A., where the story's set, is presented as a twentieth-century Sodom and Gomorrah, fire and brimstone all it deserves, what it has coming. *Play It*, whatever your feelings

about it are, can't be dismissed, not the way Morrison's lyrics ("There's a killer on the road / His brain is squirmin' like a toad") and song titles ("Hello, I Love You") can. Interestingly, Didion, unlike Eve, wasn't inclined to dismiss Morrison. On the contrary, she was very much taken with him when she, in the spring of '68, attended a Doors recording session. She'd write about her time in the studio in *The White Album*, referring to his band, and without a hint of irony or sarcasm, as "missionaries of apocalyptic sex." It's difficult to imagine a description that would be more gratifying to its descriptee.

Play It is a literary achievement—the momentum building along with the dread; the pitch, high and fevered and trembling, sustained; the prose, pared down, charged, electric even—and its writer a serious talent. It was a sensation when it came out, an instant seminal Hollywood book, in spite of, or perhaps because of, its absolute contempt for everything Hollywood. In mood (dark) and vision (doomsday), it's close to another seminal Hollywood book, Nathanael West's 1939 *The Day of the Locust*, the central metaphor of which, a painting by the artist-protagonist entitled *The Burning of Los Angeles*, is made literal in the final scene: a crowd of starstruck fans turning into a foaming-mouthed mob, a movie premiere into an orgy of violence and destruction.

Now, look sharp because things are about to take a turn for the funky. Eve conflated Morrison and Didion. She also,

however, conflated Didion and West, and for essentially the same reasons. She loathed *The Day of the Locust*, like *Play It* a formidable work, yet one Eve had no problem sticking it to. In a very angry, very funny piece called "And West (né Weinstein) Is East Too" she wrote:

> All of the things that Nathanael West noticed are here. The old people dying, the ennui, the architecture and fat screenplay writers who think it's a tragedy when they can't get laid by the 14-year-old doxette in Gower Gulch, the same 14-year-old who'll ball the cowboys any old time. But if there had been someone, say, who wrote a book about New York, a nice, precise, short little novel in which New York was only described as ugly, horrendous and finally damned and that was the book everyone from elsewhere decided was the "best book about New York there ever was," people who grew up knowing why New York was beautiful would finally, right before dessert, throw their sherry across the table and yell, "I'll pick you up in a taxi, honey, and take you for a fucking guided tour, you blind jerk."

Alter a few of the specifics, and Eve could have been describing *Play It as It Lays*, and the dismal view it took of L.A., pretending to tell the whole truth about the city while telling a partial truth at best.

And here's Eve on West:

I think Nathanael West was a creep. Assuring his friends back at Dartmouth that even though he'd gone *to* Hollywood, he had not *gone* Hollywood. It's a little apologia for coming to the Coast for the money and having a winter where you didn't have to put tons of clothes on just to go out and buy a pack of cigarettes or a beer.

Alter fewer of the specifics and Eve could have been describing Didion, half of a literary couple that the charitably disposed might term "careerist," the uncharitably "two-faced." Didion and Dunne were Hollywood people from the mid-sixties until Dunne's death in 2003. Yet they always let it be known that they were only writing scripts so they could afford to write books, were East Coast intellectuals slumming, basically. They'd cash the studio checks while simultaneously distancing themselves from the resulting crummy movie—one or the other of them often writing a piece for a classy New York publication about the experience after it was over that struck an arch, insiderish tone—even reveling in the resulting crummy movie, as if the crumminess were further evidence of their superiority, proof that they'd sold nothing when they'd sold out. (Dunne would go so far as to write an entire book in such a vein, *Monster: Living Off the Big Screen*,

in which he detailed his and Didion's involvement with the 1996 Robert Redford–Michelle Pfeiffer clunker *Up Close & Personal*, alternately boasting and bemoaning.)

And yet Eve wasn't describing Didion or *Play It as It Lays*. And she wasn't calling Didion a "blind jerk" or accusing Didion of copping a "Symptom of the Apocalypse attitude." She'd go after West or Morrison instead. Or rather in lieu. She could express her feelings about Didion but only by proxy. Why?

In the fall of 2015, I spoke to Eve for a piece I was doing on Didion in Hollywood in the sixties and seventies. Eve, who loves and hates with a child's purity and holds nothing back,* was reticent, cagey. At least on certain topics. She'd talk to me, on the record, for example, about her memories of Didion's amphetamine use: "Joan and I connected. The drugs she was on, I was on. She looks like she'd take downers, but really she's a Hells Angel girl, white trash. I thought [she] was more in control than [the rest of us] were, but I reread *The White Album*. She didn't sound in control, did she?" She wouldn't talk to me, though, about Didion's work, even after I'd switched off my recorder. She'd say that Didion's books were "great"—every time, that word and no other—and then shut the conversation down.

* Once when were out at lunch, a woman—Eve's age—perfectly pleasant seeming, waved from a neighboring table. Eve didn't return the wave. I asked Eve who the woman was, and she said, eyes wide, voice grave, "That's my enemy." (Eve and the woman had, as it happened, shared a boyfriend forty years before.)

When my Didion piece appeared, I didn't send Eve a copy or breathe a word of it. What I wrote about Didion was respectful but tough, and I was sure Eve would be angry, think I'd elicited information from her under false pretenses. Tricked her, in essence. My hope was that she'd forget we'd ever done the interview, walk right past the issue on newsstands. And then my cell rang, her name flashing across the screen. I hit ACCEPT, a tight, sour ball of dread forming in the pit of my stomach. But before I could stammer out a hello, she crowed, "You did it! You killed Joan Didion! I'm so happy somebody killed her at last and it didn't have to be me!"

To be clear, I did not kill Joan Didion. I could not kill Joan Didion. No one could. She's too good. That, though, isn't the vital thing here. The vital thing is that Eve was overjoyed because she *believed* I killed Joan Didion. As the ball dissolved, I listened to her talk. And talk. It was as if she'd been under a curse, now lifted, and her tongue, unbewitched, was able to speak the truth: Didion had been the making of her, so she couldn't say a word against Didion. (Publicly discussing Didion's taste for uppers is not, in her mind, a betrayal since to her drugs are just things people do, no embarrassment or shame attached.) It was so duh-duh obvious that, for several seconds, I was rendered mute. Eve was *grateful*. That was the explanation. And if Eve had been anybody else, I'd have guessed it at once. Wouldn't have needed to guess,

would have assumed. In this case, however, it didn't even occur to me. Gratitude didn't seem like the kind of emotion Eve would entertain—too modest, too humble, too ordinary. But she did, and there you go.

So I have inside information and it backs up my theory: Eve started writing in reaction to Didion. (If I'd paid closer attention to the dedication pages of her first book, the one in which "The Sheik" appears, I'd have saved myself a lot of trouble: "And to the Didion-Dunnes for having to be who I'm not.") Didion was the tar baby, Morrison and West the decoy ducks. And you could argue—I *am* arguing—that Eve's entire literary career was a response to, nay, a rebuttal of, *Play It as It Lays*.

Eve didn't become a writer like that, out of nowhere. Not quite, anyway. There'd been an attempt, just the one, earlier.

In her late teens, while she was in Italy with Sol and Mae— "I lived in Rome for almost a year and the only word of Italian I learned was *cazzo* [slang term for *penis*]"—Eve began a novel, or, rather, a memoir masquerading as a novel, "Travel Broadens." "Travel Broadens" was *Daisy Miller*, except *Daisy Miller* turned on its head. Instead of the decadent Old World corrupting the innocent American girl, as happened in Henry James's tale, it was the other way around. (This plot summary, incidentally, is Eve's, not mine. I've got to rely on her memory, can't

consult my own since I've never read the book, all known copies having been lost.) Eve completed "Travel Broadens" at the tail end of '61, during a short trip back to L.A. Before rejoining her family, she sent a letter to Joseph Heller, then thirty-eight, who'd published, earlier that year, *Catch-22*, a landmark cultural event.

The letter, in its entirety:

Dear Joseph Heller,

I am a stacked eighteen-year-old blonde on Sunset Bou-
levard. I am also a writer.

Eve Babitz*

It was a provocative letter. As provocative a letter as the Wasser-Duchamp photo was a photo, and in exactly the same way—Eve once again playing for a celebrated artist and con-siderably older man the sexy, boobalicious girl while also kid-ding the idea of playing the sexy, boobalicious girl. Heller was

* This, I should confess, is only one version of the letter, and it isn't the first version I heard. The first version I heard was Nan Blitman's. Blitman, Eve's friend and former agent, recalled Eve describing the letter thusly: "Dear Mr. Heller, I'm sitting on a bench on Sunset Boulevard in a wet bathing suit. I've written a novel. I'm eighteen." As soon as I hung up with Blitman, I phoned Eve. Trying to tamp down my excitement, I asked her about the letter, but did not repeat Blitman's words out of fear of contaminating her memory. She gave me the version quoted above. (Eve, by the way, never volunteers information, no matter how relevant or useful. She's like one of those riddle-speaking figures in myths and fairy tales. She'll answer any question you ask, except you have to know exactly what question to ask, and how precisely to ask it. That's the trick and the challenge.) Afterward, though, I did quote Blitman's words to her, and she conceded that it could be Blitman who has it right. It's a pick-and-choose-type situation. And just because I picked and chose Eve's version doesn't mean you have to.

provoked. (This, by the bye, is one of those times when Eve and I had a But-Evie-how-did-you-know-to-do-that / I-went-to-Hollywood-High exchange.) Says Eve, "I heard back from Joe quickly. He wrote, 'Have you actually written anything?' So I mailed him one hundred and twenty-three pages, or however many pages I had, and he laughed his head off and gave them to Robert Gottlieb [the young editor at Simon & Schuster who'd discovered *Catch*]." It was an auspicious beginning, and that's where it ended. Eve: "Gottlieb said the book needed more. I didn't know what he meant by 'more,' and I didn't try to find out. I just thought, Uh-oh, and that was it."

Well, Is that the blue you're using? isn't the only way of asking, Is that the blue you're using?

Blue Streak

★

At *Rolling Stone*, Eve found both occupation and vocation. Plus love. With her editor, Grover Lewis, a writer, too, a poet and a New Journalist, originally from Texas. (Eve's first letter to Lewis after "The Sheik" was accepted, written care of the magazine, on a typewriter, is business formal: "Dear Mr. Lewis: . . . Enclosed is the 'brief biography' of myself to which you alluded. And upward, Eve Babitz." A few months later, Eve sent Lewis

another letter, also written care of the magazine, also on a type-writer, though with a cursive PS: "I yearn for you tragically.") Says Eve, "Grover came up with the line 'Turn on, tune in, drop out, fuck up, crawl back.' He was great. I was almost thirty, too old to fuck around, I decided." And when Lewis asked her to come live with him, she said yes. "I've always associated San Francisco with retirement, so I moved there to become a square. I thought that the move was for good, that Grover and I would get married and I'd be a grown-up. I lasted three months."

Eve called Mirandi. Mirandi agreed to jump in her car, drive the four hundred miles up the coast, retrieve Eve. But Mirandi had a live-in boyfriend, not to mention a business, so she couldn't jump straightaway. It would be a few days. Lucky for Eve, she just couldn't help herself and had formed multiple romantic attachments while at *Rolling Stone*. Well, she was looking especially foxy, slim after an all-juice diet, and she'd been given a drop-dead new haircut—hair that was "too good for her," as she'd describe it in a letter to Lewis—by her LACC friend Marva, now working at the salon of Gene Shacove, inspiration for Warren Beatty's cocksman-hairdresser in *Shampoo*, on Rodeo Drive. (From that same letter: "[Marva and I] met in [introductory] Italian in summer school and she asked me for a match. She was trying to befriend me [during] a break while we stood outside in the arcade. . . . I told her there were matches in my purse and she opened my purse, found this . . .

match box I used to keep my diaphragm in and out snapped my diaphragm and rolled down the entire length of the arcade past the other students and down the hall. 'Go get it,' I commanded darkly. Marva had the decency to burst into hysterics and she actually did go get it so we became friends.")

Among those who succumbed to Eve's charms was photographer Annie Leibovitz. Says Eve, "Joan Didion told the people at *Rolling Stone* to get me, so they tried, and they couldn't. I kept dodging out of their orbit. Annie was their one hook in me. She came to my place. I had this book of Lartigue pictures—Lartigue was how I got everyone in those days—and she looked through it, and that did it. She was in my life. We were on and off for a long time." Julian Wasser, who finally seduced Eve almost ten years after he got her naked, recalls, "As I left Eve's apartment the next morning, I ran into Annie. She was not happy to see me—the look I got!" And it was at Annie's apartment that Eve stayed as she waited for her sister.

It was a shame about Lewis, but there'd be other editors. As it so happens, there already was one: Seymour Lawrence, known as Sam. Lawrence, Boston-based, ran his own imprint at Delacorte, and published such luminaries as Katherine Anne Porter, Kurt Vonnegut, Richard Brautigan, and J. P. Donleavy. After reading "The Sheik" and a few of the similarly themed pieces Eve wrote for the *Los Angeles Flyer*, the short-lived insert section of *Rolling Stone*, he got in touch. She touched back, and

there was an affair. Says Eve, "Sam went to Turkey and bought me a pair of gold earrings because that's what I demanded. But then I didn't like them." Fortunately, lousy taste in jewelry only cooked him as a boyfriend, and she let him sign her to a book contract, which included a $1,500 advance. "I blew it all at Musso's [Musso & Frank Grill, the oldest restaurant in Hollywood]. I ordered caramel custard for everyone, the whole place."

Eve's Hollywood, released in 1974, is a series of autobiographical sketches, some already published, some not, arranged more or less chronologically, and forming a loose memoir. It's not a mature or disciplined work. Has, in fact, an everything-but-the-kitchen-sink quality to it. Certain pieces, you don't know what they're doing there, and most of them fail to reach the level of "The Sheik," the high point of the collection. And yet, the riffs are marvelous: on watching the Pachucos dance the Choke in the gymnasium of Le Conte Junior High during Phys Ed;* on vamping at the bar of the Garden of Allah hotel with her friend, Sally, catching men with their jailbait; on eating taquitos on Olvera Street, two for forty cents, forty-five cents if you wanted a second helping of sauce and a paper plate, which

* A precise definition of *Pachuco* is hard to come by. A hoodlum of Mexican extraction, is my best guess. As for the Choke, here's Eve's definition: "a completely Apache, deadly version of the jitterbug." How's that for precise?

you did. And the book, overstuffed as it is, never seems soft or flabby, but rather baby-fat voluptuous, the extra weight appealing, giving you something to grab on to, to squeeze, to pinch.

If *Eve's Hollywood* has a flaw, non-niggling, I mean—every so often you'll notice a slight strain in the prose, a bit of grammatical sloppiness, a questionable word choice—it's related to identity: L.A.'s and Eve's, one and the same in Eve's mind. In Didion's *Slouching Towards Bethlehem* is a piece called "Notes of a Native Daughter," which Didion, who grew up in Sacramento, graduated from Berkeley, lived and worked in Hollywood when Eve knew her best, was. But it was in New York that Didion established herself both professionally (her first job was at *Vogue*) and personally (there she met her husband, John Gregory Dunne, from Hartford, Connecticut, the son of a surgeon and a member of Princeton's class of '54). She was a Westerner, certainly, yet a Westerner who was at home in the East, approved of by the East, part of the East in all the ways that mattered, and it was therefore okay to take her seriously. In other words, she was as much a prodigal daughter as she was a native.

Eve, by contrast, was L.A. from the top of her (often) platinum head to the tips of her (always) painted toes. She was born and raised there, obviously. Hollywood High was the extent of her formal education, not counting the semester or so's worth of classes she daydreamed her way through at LACC. And,

apart from those three brief stints—in Europe, New York, and San Francisco—all served prior to her thirtieth birthday, she never left. Moreover, she declared her allegiance to L.A. before she declared anything else, before she declared anything period. The book's cover is a photo taken by Annie Leibovitz: Eve in a black bikini and white boa, face in profile, breasts straight on, almost 3-D. Her appeal is as immense, as flagrant, as no-brainer as that of L.A. itself. She's a true native daughter.

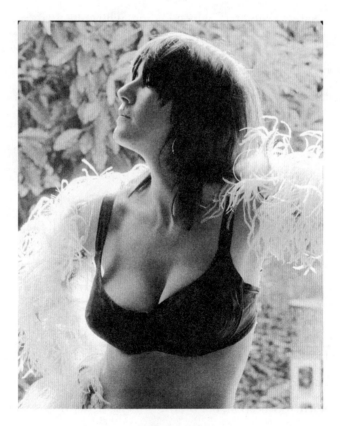

Eve Babitz, 1972

Little surprise then that she took L.A. personally. And the condescending attitude toward it adopted by the rest of the country, New York especially, galled. (Eve will defend her city as she would never defend herself, but, of course, that's what she's really doing when she squares off against those "travel[ing] to Los Angeles from more civilized spots," as she sarcastically refers to the snooty out-of-towners, the "stupid asshole creep[s]" and "provincial dopes"—she gets mad enough, and sarcasm goes out the window—who miss the "pink sunsets" and the "sk[ies] of rain-swept blue" and the "true secrets of Los Angeles [that] flourish everywhere" because they're so determined to believe that something with obvious superficial charms cannot also have subtle deep ones. She fumes, "It's perfectly all right [for them] to say, 'Los Angeles is garish' . . . as they sit beneath the arbors and pour themselves another glass of wine though it's already 3 p.m. and they should be getting back to the studio to earn their money.") As a matter of fact, she was alluding to that classic put-down of L.A.—"cultural wasteland"—as well as to Didion, with the title of her opening piece, "Daughters of the Wasteland," refuting the charge simply by listing the people who walked through the front door of her childhood home: Stravinsky, Herrmann, Schoenberg, et al.

So Eve's parents conferred cultural legitimacy upon L.A. Who, though, would confer it upon Eve? She could've conferred it upon herself, and easily, sheerly through the force

and originality of her voice and sensibility and observations. Only she didn't trust these things yet, believe they were sufficient to compel attention. Which is why the skimpy bathing suit, and the cleavage deeper than Bronson Canyon. Which is also why the name-dropping, so out-of-control compulsive it's practically a form of Tourette's.

Before even the table of contents is the dedication page, or, I should say, pages, eight of them in my first-edition copy. Eve thanks the greats in her life—"And to Joseph Cornell. A Real Artist . . . And to Steve Martin, the car"—the greats formerly in her life—"And to Marcel Duchamp who beat me at his own game . . . And to Jim Morrison running guns on Rimbaud's footsteps"—the greats she wished were in her life—"And to Orson Welles, the light of my life . . . And to Marcel Proust"—along with a few intriguing non-greats— "And to Mr. Major, I'm sorry I turned out this way . . . And to the one whose wife would get furious if I so much as put his initials in." The style is half Oscar-acceptance-speech, half yearbook-inscription-ese, all those inside jokes: Joseph Cornell was another pen pal of Eve's ("I wrote him a letter after I went to that show in New York with Carol. He wrote me back asking for a pinup picture. I knew what he meant but I couldn't give him one. I loved him too much. I just wanted to be his fan"); Steve Martin bought her a VW Bug when they were together ("Linda Ronstadt was his girlfriend and

I was his girlfriend and we were both doing him wrong!"); Mr. Major is Harry Major, Eve's English teacher at Hollywood High ("Poor Mr. Major");* and the guy with the unforgiving spouse is Tom Dowd, a renowned producer and engineer for Atlantic Records ("Tom and I used to go to a place on the Sunset Strip called Gino's. It's where people took people they were having affairs with. You could order weird things like venison").

The dedication is completely over-the-top, and it tells you that Eve, at this stage, is unsure of herself, the implicit message being that if her famous friends think she's all right, so should you. And insecurity is the reason *Eve's Hollywood* takes a while to get going. It's not until nearly the one-quarter mark, with "The Choke," the story about the sexy Pachucos, that Eve stops trying to throw stardust in the reader's eyes, dazzle or blind. She breaks out of Sol and Mae's social circle, and her own—vicious circles, they had become—to talk

* After learning who Mr. Major was to Eve, I attempted to track him down on the off chance that he was still alive, could describe for me Eve as a student. He wasn't, but I'd only just missed him. He died on February 10, 2014, at the age of eighty-two. He was murdered by an ex-con named Scott Kratlin in his apartment on North Vista Street, only a handful of blocks from Hollywood High. Kratlin and Major had struck up a correspondence while Kratlin was serving a twenty-one-year sentence at the Marcy Correctional Facility in Oneida County, New York, for manslaughter. Major promised to give Kratlin a place to stay when Kratlin was released in exchange for sex. (Major had extended a similar offer to hundreds of state and federal prisoners all over the country.) Kratlin lived with Major for ten days, then moved out, though not before strangling Major and bashing in his head. Poor Mr. Major indeed.

about what she sees, the world around her. The pace and interest pick up immediately.

But again, this flaw, non-niggling though it is, isn't damaging, not nearly as much as it should be, at least. It's almost the reverse. It gives the book—and I know how peculiar this sounds, I'm fully aware—a quality similar to the one found in Marilyn Monroe's smile. When Monroe smiled, her upper lip quivered slightly because she was trying to lower it to cover the gums she believed over-large. And this quiver, a flaw, or rather an attempt to mask a flaw, or rather an attempt to mask an imaginary flaw, is, I think, the source of the smile's special power, what saves it from being merely pretty, blandly, boringly perfect, makes it instead unsettling, as poignant as it is entrancing, and totally unforgettable.

Eve's Hollywood, good as it is, however, was still in the promising category. That promise would be fulfilled with her next book.

The publication of *Eve's Hollywood* went mostly unnoticed by critics—the all-mighty *New York Times* declined to weigh in. And it didn't exactly fly off shelves either. Says Eve, "It sold, like, two copies. I mean, nobody in L.A. read it. Well, except for Larry Dietz." Lawrence Dietz, a writer and editor, someone with whom Eve had a nodding acquaintance from Bar-

ney's, sized up the book for the *L.A. Times*. In the review, he cast himself as the stern yet loving schoolmaster; Eve as the naughty little girl in need of a spanking. Index finger wagging, he chided her for not taking greater care to cultivate her gifts ("To deny the full range of [your] talent because you don't want to work in developing it is not only to diminish yourself, but also all of us who could have been enriched by it"), and for failing to live up to the shining example set by Joan Didion ("*Play It as It Lays*—a book so cruelly accurate that it made Nathaniel West look like Shecky Greene"*). He ended with a direct address to the reader: "[*Eve's Hollywood*] is a seriously flawed book, but if you don't mind some sloppy and self-indulgent writing, you'll be rewarded with four or five chunks of good work." Eve was angered by the piece, though not surprised by it. "The main thing about Larry was that he was a twat."

Still, *Eve's Hollywood*, lackluster reviews and sales figures notwithstanding, changed things. No longer was Eve a groupie, in a tongue-in-cheek sense or any other, or a struggling artist and album-cover designer. She was a writer with a book to her name. Consorting with rock 'n' roll royalty and trash—and it's almost always one or the other—at the Troubadour bar wasn't for her anymore, even if a photograph she took of Linda Ronstadt did make it onto the inside sleeve of

* Dietz misspelled Nathanael West's first name. Some schoolmaster.

Ronstadt's *Heart Like a Wheel* album (Capitol Records, 1974). She needed a new hangout.

Sticking to West Hollywood and Santa Monica Boulevard but moving a few blocks east, Eve found a recently opened restaurant, Ports. In a January 7, 1975, letter to Grover Lewis and his wife, Rae, she wrote, "I have so entangled my life with Ports that they no longer bother to charge me for food or drink and I'm interior decorating the new room and otherwise inflicting my personality on the place. It's like a salon, just what I've always wanted."

Ports was run by Micaela Livingston and her husband, Jock, an intermittent actor (his best-known role was as Alexander Woollcott in the 1968 Julie Andrews turkey of a Gertrude Lawrence biopic, *Star!*), who lost his temper when he was drunk, which was most of the time, regularly giving customers the heave-ho for offenses both real and imagined, occasionally choking the help. Says Eve's friend, British-born L.A.-based designer Paul Fortune, "L.A. then was still a small town, the same one hundred people everywhere you went. It wasn't groovy, that hadn't happened yet. It was like this great, weird blank slate—you could write yourself into the story. And even though it was the seventies, it was also still the forties. The old cars were there, the old buildings,

the rain-slicked streets out of Raymond Chandler. Ports harkened back to forties Hollywood. It was erratic. It was personal. It was strange. It had real soul."

Ports didn't care whether you liked it or not, doubtless the reason it inspired such fanatic devotion, from famous people in particular. (The chance to wait more than an hour for a table, to be given the wrong order, to get treated like nobody in the least special, was evidently irresistible to them.) Warren Beatty would bring in Julie Christie for romantic dinners. Robert Redford conducted business lunches at a booth in the back. Sculptor Claes Oldenburg ate at Ports when he was in L.A.; so did graphic designer Milton Glaser, and Italian art-house director Michelangelo Antonioni. Other habitués included actress-singer Ronee Blakley; singer-songwriter Tom Waits; the guys from the Eagles, usually separately though sometimes together; actor Ed Begley Jr.; director Francis Ford Coppola, especially after he set up his studio, Zoetrope, across the street. Steve Martin was also a regular. And Candice Bergen. And Carrie Fisher.*

* In 1976, Eve and her old Capitol Records contact, graphic designer John Van Hamersveld, got loaded together, hatched a harebrained scheme: the *L.A. Manifesto*, an underground paper. In the first issue were, among other contributions, songs by the Eagles, poems by Ronee Blakley, and stories by Steve Martin (his first). It was supposed to be a monthly thing, but Eve and John lost steam and/or interest, and so the first issue became the only. I stumbled across a copy early in my research and used it the way I used the *Eve's Hollywood* dedication—as a combination Rosetta stone and little black book. All the people in it had, presumably, once been important to Eve and were thus potential interview subjects. Since Carrie Fisher was featured twice, a poem *and* a story, I figured I'd start with her. Fisher, though, according to her publicist, had

Says Eve, "Ports had this weird little library with Max Beer-bohm in it. And Django Reinhardt was coming out of the speakers. I felt like it was my restaurant, that it had been made for me. I stayed in the same apartment for years because it was close to Ports. It's where I met Michael Franks [singer-songwriter]. We were in bed and my feet got cold. I said I had Popsicle toes. That's where the title to that song came from ["Popsicle Toes" was on Franks's 1976 Warner Bros. album *The Art of Tea*, reached No. 29 on the Top 40, and has been covered by, among others, Diana Krall and the Manhattan Transfer]." Eve, a favorite customer, was given a brass plaque, hung above her preferred table. She even served food on occasion, when one of the waitresses quit or took the night off. Wrote Eve, "I loved it more than anything I've ever done before or since because deep down inside every woman is a waitress. The act of waitress-

no recollection of Eve. I picked up Fisher's then-still-new memoir, *Wishful Drinking*, hoping Eve would be in it. She wasn't. A transcript of the outgoing message on Fisher's voice mail, however, was. "Hello and welcome to Carrie's voice mail. Due to recent electroconvulsive therapy, please pay close attention to the following options. Leave your name, number, and a brief history as to how Carrie knows you, and she'll get back to you if this jogs what's left of her memory. Thank you for calling and have a great day." I dialed Eve, extracted from her what history I could, and it wasn't much (Eve's drug consumption increased in the mid-to-late seventies, and so her memory of this period is spotty)—"Carrie was a Ports person, and Ports was dark, so it was great if you were someone who wore hats, and I was, and so was Carrie"—relayed it to the publicist, except it failed to jog anything. A promising lead turned dead end. No big deal, I simply backed out, moved on. The only reason this anecdote even rates a mention is because it, more than any other, captures what I so often felt was my role in Eve Babitz's life: half the nameless narrator, that would-be biographer and "publishing scoundrel" in Henry James's *The Aspern Papers*, half an extra in an Abbott and Costello routine.

ing is a solace, it's got everything you could ask for—confusion, panic, humility, and food."

Though musicians and painters and actors and directors frequented Ports, most of the people for whom the restaurant was a second home were what Ed Ruscha termed "artists who do books," i.e., writers: Colman Andrews, the food writer, who'd devote a chapter to Ports in his excellent memoir, *My Usual Table: A Life in Restaurants*; Michael Elias, the comedy writer (co-wrote *The Jerk* with Steve Martin and Carl Gottlieb); Kit Carson, the screenwriter (*David Holzman's Diary*); Nick Meyer, the novelist (*The Seven-Per-Cent Solution*); Warren Hinckle of the muckraking political magazine *Ramparts*; Julia Cameron, journalist for *Rolling Stone*; and, when in town, Tom Wolfe, steering clear, no doubt, of the stuffed game hen in plum sauce for the sake of his white suit. Elias: "Ports was for people who were too hip for disco. It was like a club. I was there every night. You could do coke, fuck in the bathroom. There was a piano that this terrific jazz guy, Freddie Redd, used to sit at. Sometimes there'd be performance art, or someone would put on a play. Jock used to get drunk and decide he was going home. He'd toss us the keys and tell us to lock up when we were done. There really wasn't anything else like it in L.A. When my first wife and I got divorced, it wasn't 'Who gets the Lakers tickets?' It was 'Who gets Ports?' Eve was the queen of it all."

And every queen must have her king.

★ ★ ★

Eve, at twenty-three, en route to a wedding at which she'd been engaged to the groom and the best man ("I'd broken off with both . . . because I was impatient with ordinary sunsets"), asked Mae whether Mae believed she would ever get married. Instead of giving an answer, Mae gave advice: "If you do, marry someone you don't mind." Trickier to follow than it sounded. At least for Eve. Not minding might have been where she started out with a guy. It sure wasn't where she ended up, though. Besides, she was too restless, too imaginative, too wayward, too independent for connubial bliss to be anything but abject misery, as she was beginning to realize after calling it quits with Grover Lewis. She simply wasn't cut out to be a wife, or even a girlfriend in the conventional sense. Mistress, a role that was part-time and no-strings, fantasy-based rather than reality, was far more suitable to a woman of her tastes and temperament. Still, it was with genuine regret that she decided "those songs of love were not for [her]." And, since life is as perverse as it is perplexing, that's the precise moment she met Paul Ruscha, younger brother of Ed.

Paul: "I left Oklahoma City the summer of the Watergate hearings. I remember the exact date, June 25, 1973, because it was the half Christmas. My relationship with Larry, the man who owned the restaurant I worked at, had become unbear-

able after eight years. He'd started fucking his son's friends, and they were just high school kids, and I'd had it. Ed didn't approve of that side of me—the gay side. But he understood what I was going through in his Ed way because he'd split with his wife, Danna, the year before and was living with Samantha [Eggar, the actress]. So Ed sent for me, and I was glad of the fresh start. I worked for him as an artist's assistant and stayed with Danna. One afternoon Danna took me to Jack's Catch-All, a thrift store on Alvarado. That's where I first saw Eve. She and Danna talked. After we left, Danna said, 'I think she likes you.' I was surprised because I didn't think she'd even noticed me. Eve was heavy then, but I was so skinny that when I had sex with girls who were also skinny, our bones would just bang together and it hurt! So I didn't mind heavy. Eve invited me over for dinner. Eve was friends with Léon Bing [the fashion model], who used to go out with Ed, and she called Léon and said, 'How can I get him?' Léon told her that I love cilantro. Actually, I hate cilantro, but Léon just remembered that I had a strong reaction to it. She made a mistake.* Eve put cilantro in the soup, in everything, so I couldn't eat a bite. She called me the next day and said, 'Can I have a second chance?' I said, 'Sure you can.' She made me a wonderful dinner that

* Eve does not believe that Léon made a mistake. She believes that what Léon made was mischief, and is still, to this day, mad about it.

night. And she showed me a story she'd written, and I was blown away by it. We were together from then on."

Paul, thirty, was, same as Ed, an artist, and talented. Unlike Ed, however, who was laconic, solitary, a little aloof—a cool, cool customer—Paul was gregarious, expansive. Says Paul, "L.A. then was the Endless Party. Ed would look at me and say, 'Don't you ever stay home?' When I first arrived, we went to events together often. Then I started to notice that he'd ask me if I was going to a certain party, and if I said yes, he didn't come. I always threw myself into the action. I guess he was afraid I'd make a fool of myself and, because we were related, make a fool of him." The isolation, the rigor—the *egotism*—that's necessary to make a career out of art, where there's no objective criteria, where you can't look for an endorsement from the world or you undercut the authenticity of the work, where you must be obsessed, absolutely and utterly consumed, with getting something great out of yourself, was against Paul's nature. Art became a thing he was content to do on the side. "In the early sixties I went to the Chouinard Art Institute, where Ed had gone, and began to paint. I was having so much fun that I thought I wanted to be a painter. I asked Ed's artist friend Joe Goode about my becoming an artist, and Joe advised me to be anything but unless there was nothing else I could do better or loved to do more. Ed's success was quite daunting. He liked that I could make art. He didn't like that I couldn't keep up with his

rise to art stardom. He had the burning desire. I just didn't. It's hard being Ed's brother sometimes, but it's great working for him. He's the best boss I've ever had, and incredibly generous."

Also, same as Ed, Paul was a dreamboat, though a different make and model. Ed, small and compact, had the flinty, lean-faced handsomeness of a Gary Cooper or a Henry Fonda, actors who could easily play cowboys and other classic American male archetypes. Women took note. Says Eve, "Everybody threw themselves at Ed, and, when he had a couple of spare minutes, he'd reach." For starlets, most often. Eggar, Michelle Phillips, Lauren Hutton were all girlfriends at one time or another. Paul was taller than Ed, and rangier, with a considerably wilder dress sense: monkey-fur coats, contact lenses that turned his brown eyes silver, and a mustache that was part porn star, part Salvador Dalí. Wrote Eve, "It seemed to me that [Paul] was possessed by the Angel of Sex. . . . He was approaching my ideal in record time and even [Brian Hutton] was beginning to pale by comparison. . . . When he first took off his clothes in front of me and I saw him standing there, *there*—in my very own bedroom . . . [it] caused me to gasp."

Yet it wasn't just Paul's looks that Eve responded to, it was also his style—calm, courtly, decorous—which happened to be the exact opposite of her own. She wrote, "[Paul was] always trying to smooth things over and [I was] always trying to rumple

Paul Ruscha, 1976

them up. . . . Perhaps [he], in the beginning, looked upon me as a challenge. Maybe he felt he could show me the path to . . . gentle society." He couldn't, of course, but Eve appreciated the effort. Says Paul, "Eve was destructive, to herself more than anyone else. That only made me want to save her. I felt she did better when she was with me, that she was less agitated. I was forever apologizing for her. I remember a guy came up to her at a party and told her that she was his favorite writer, and she just looked at him and said, 'Beat it.' " If bad behavior was so loathsome to

Paul, though, why would he be with someone who refused to behave any other way? Eve knew. "[Paul] would dry lepers' feet with his hair; [I'd] often feared that he would leave me not for some prettier or richer person, but to perform some Christian act of atonement." In other words, Paul was a saint. Or in different other words, Paul was a masochist.

Which is why he and Eve, a sinner and a sadist, were matchlessly mismatched and thus a perfect match. Even the fact that her passion for him far exceeded his for her worked in their favor, like her too-muchness and his not-enoughness came to exactly the right amount. The enemy for Eve had always been boredom, and with Paul she couldn't get bored. His ambivalent sexuality—drawn as he was as powerfully to men as to women—his ambivalence in general—drifting along as he did aimlessly, pleasantly, in a free-form, episodic way—allowed her to maintain her equilibrium by keeping her off balance. And it had the same effect on him. In his memoir *Full Moon*, he wrote, "[I'd] become one of those odd birds who seem to be attractive to others, but cannot commit themselves to . . . any of them." Because without the weight of Eve's emotionalism, her intensity, her breasts and flesh and need, you feel that Paul, so pretty, so passive, so captivatingly noncommittal and gossamer light, would have floated off into the ether, dissolved like a dream in the warm Southern California air.

And between them was an instinctive understanding

and sympathy. Paul: "Eve could be wonderful in a way no one else could. I regret not saving a letter she wrote me. It was about my color blindness. In it, she described the colors, what moods went with which. It was sweet and romantic and totally Eve. Much of her chutzpah came from her blind belief in herself, and I fed into it. When we were together, she was, as I said, quite hefty. I just likened her to a masterwork odalisque by Rubens. Friends would ask me how I could stay with her when she was obviously so crazy, but I felt she was as exotic as she thought I was. She certainly had the most interesting mind I was ever privy to. And Ed very much approved of her. He loved her for her notoriety, for the Duchamp photo, for the men, for the fact that she wrote as well as she did. Eve was my main squeeze—that's what she liked me to call her—but I was hot on the market then and seeing other people. So was she. Annie was around a lot. Eve used to say that Annie was the son John [Gregory Dunne] and Joan [Didion] never had. And Eve kept old boyfriends in her life. Every few days, one would call, and she'd talk to him about his new girlfriend or wife, about books or movies or restaurants. I loved being the guy in her bed listening to her laughing with former beaux. She'd walk around the tiny apartment, tripping over the clutter or her cats, Mario and Sympathy, tangling the hell out of the phone cord. After she hung up, I'd untangle it for her."

Eve and Paul found a way of being together that largely involved being apart. "I spent the night at Eve's once or twice a week, two or three times when we were really lovey-dovey. I could never have lived with her, couldn't have stood the mess. There'd be cat fur—cat fur!—in her food. She was a great cook, though." And not only was Paul able to give Eve both the intimacy and distance she required as a woman, but also as a woman who wrote. "On Eve's door was a sign that said, 'Don't knock unless you've called first.' She always told me she liked me because I knew when to go home. What would usually happen is, we'd go out the night before, and then we'd come back to her place and fuck and fall asleep. In the morning, she'd drop two scoops of coffee in a pan of boiling water and bang the spoon against the side of the pan loudly so I'd wake up. Then she'd thrust the cup of coffee at me and say, 'Okay, I'm going to start writing now.' And I'd say, 'Okay, okay, I'm leaving.' Then she'd say, 'Would you read something first?' And she'd go over to her typewriter and grab some pages. I'd read them, and she'd ask my opinion. If she liked what I had to say, she'd let me stay a little longer. If she didn't, she'd kick me out. And the next time I came over, she'd show me the piece or the chapter again and ask my opinion. So I ended up reading everything she wrote nine or ten times."

★ ★ ★

I'd begun linking Paul and Mae in my mind long before I realized that's what I was doing. The writer Caroline Thompson, close with Eve since the late seventies, was the first to mention Paul. "Have you met Paul yet?" she asked, almost in a whisper, as if she were sharing with me a thrilling secret. "Paul's wonderful." The more people I interviewed, the more times I had to lean in, cock my ear, as their voices dropped to an enchanted hush. "Oh, Paul? Paul's wonderful." Their voices would do the same thing when Mae's name came up, and there was that word *wonderful* again. As in "It's too bad you didn't get to meet Mae [Mae died in 2003]. You'd have loved her. She was just wonderful."

I contacted Paul shortly after my conversation with Thompson and found him to be wonderful indeed. So wonderful, in fact, that I decided then and there to make him my friend. A few weeks later, I was on the phone with my brother, telling him what I'd been up to. I heard my voice go small and soft when I said Paul's name, and that's the moment I explicitly made the connection: Paul was Mae; Mae was Paul. (Incidentally, Mae made this connection herself. Says Laurie, "When Evie started going with Paul, bringing him around, Mae said, 'I thought it was supposed to be sons who married their mothers.' ") Like Mae, Paul was the quintessence of loveliness and charm, with the manners of someone from a part of the country nowhere near a coast. And, like Mae, Paul was an artist who served a more dominant artist and served

that artist superlatively. In Paul's case, Ed and Eve—double duty.

So if Paul is Mae, who does that make Eve? Why, Sol, of course. Laurie: "My mother, Tiby, didn't marry until she was twenty-five, which was late in those days. She said the reason was that she never found a man as amazing as her brother Sol. If we had any religion in my family, it was that Sol was a fucking genius, the smartest guy in the world. There was a time where I sat down and thought, Gee, maybe that wasn't true. But I couldn't face the possibility. I *still* can't. He formed us all. He had this magnificent collection of 78s, and Eve and Mirandi and I used to listen to his Bessie Smith records, the dirty ones, on the sly. But then we couldn't anymore because we got caught when Eve sat on *Empty Bed Blues* and broke it in half. And Mae started drawing, became an artist, because Sol told her she could be. His power and judgment ruled everything. I don't say I started going with Art [Pepper, famed jazz alto saxophonist and junkie] because I knew it would make a splash. But it did. I can't think of anyone Sol would have thought was cooler or hipper than Art Pepper. Getting Sol's attention wasn't easy. Evie would say something clever. That got his attention. She started writing, and the writing was good. That got his attention, too. Besides, she demanded his attention. If it meant she had to bite him on the leg, which is what she did when she was four—burst into his studio when he was practicing, which

none of us ever dared do, and bit him on the calf—then so be it. Mirandi was in a state of despair because she could never get his attention. Sol was sitting in the house talking to a friend, and Mirandi—adult Mirandi—walked through the door, and he said, 'Oh, that's my daughter, but she's not the one.' What a thing to say! Do you think Mirandi ever forgot that? Listen, I'm sure Evie, smart a kid as she was, looked at Sol and looked at Mae, saw Mae running around, doing everything to make Sol happy, and thought, Yeah, he's the one I want to be."

Another important person came into Eve's life during this period, Erica Spellman, a hotshot agent from ICM in New York who represented Fran Lebowitz and Hunter S. Thompson. Spellman, now Spellman-Silverman: "Kit Carson introduced me to Eve. When I got to town, he said, 'There's someone you've got to meet.' Eve and I had lunch—at Ports, naturally. She gave me a copy of *Eve's Hollywood*. I read it. I loved it. I called my sister, Vicky [Victoria Wilson, editor at Knopf]. I said, 'Vicky, you're not going to believe this woman I met. She's fabulous and she's going to write this amazing book for you and it'll be essays.' And Vicky said, 'Okay.' You could do that in those days, call someone up and say, 'Here's this person, let's do something,' and they would. I never considered calling anyone

other than Vicky. Knopf has always been the best publisher, and Eve needed credibility. She was seen as this sexy girl who somehow got Seymour Lawrence to publish her book. A lot of people knew she'd slept with him, which wasn't helping. I wanted her to be thought of as a serious writer, not just as this strange creature floating around L.A. Eve and Vicky really loved each other, and I think Eve felt, for the first time, like she had protection—me and Vicky, ICM and Knopf. What I did was call her up every single Monday morning for a year. 'How's the book coming?' I'd say. She sent in pages to Vicky, and Vicky helped her get those pages into shape. And that's how Vicky and I dragged *Slow Days, Fast Company* out of her."

Bluer Streak

★

Slow Days, Fast Company (1977) is, like *Eve's Hollywood*, a collection of stories and reminiscences, though considerably sleeker, ten pieces to its predecessor's forty-five. It picks up roughly where *Eve's Hollywood* left off: the beginning and end of her romance with Lewis; the beginning and middle of her romance with Paul; other romances in between and dur-ing; the publication of her first book; near-fame; stupid ques-

tions; the politesse of threesomes; the cats, tabby, sleeping on the roof of the patio of the Polo Lounge in the Beverly Hills Hotel; the spinach, creamed, at Musso's; how to properly ingest a Quaalude (circumspectly); what to wear when taking cocaine on acid (a Finnish cotton kaftan); which restaurant to go to for garlic and easy sex (Dan Tana's); which restaurant to go to for Mexican mineral water and erotic tension (Ports); jaunts to Bakersfield, to Palm Springs, to Laguna Beach.

The sensibility Eve was feeling her way toward in *Eve's Hollywood* has been refined here, the style perfected. Gone is the profusion of *Eve's Hollywood*, that teeming, overabundant quality, which aroused and thrilled but also dismayed and exhausted. *Slow Days* is the achieved work, an authentic masterpiece. It's classical yet audacious, sublime yet offhand. It's sheerest bliss to read. It's the book that made me want to write this book.

How to account for the difference between *Eve's Hollywood* and *Slow Days*? It isn't entirely a matter of sexual experience. Close, though. With *Eve's Hollywood*, Eve was throwing herself at the reader, that Leibovitz cover the most blatant of come-ons, Eve not giving the reader the chance to spot her across a crowded room, strike up a conversation, lean imperceptibly closer to get a whiff of her perfume, catch the hazel glints in her brown eyes, instead propositioning him/her as quickly and bluntly as she, at twenty-two, propositioned Jim Morrison. This

guns-blazing aggression makes her seem not like a woman of the world, the persona she's going for, but like a high school girl attempting to pass for older, pure bravura and bluff.

With *Slow Days*, on the other hand, Eve is all grown up. The book, with its stylish, low-key cover by her friend, artist Chris Blum—a sexy saluki in a sweater waiting for a glass of wine—is adroit, expert, mysterious, wicked. It's infinitely permissive. Infinitely subtle, too. It would no more say, "Read me," than its writer, thirty-four and wise, would say, "Fuck me." Nor is it merely seductive. No, it's a seduction, quite literally, of an unnamed man in Eve's life (I'll name him, it's Paul), and, by extension, us. Seduction is, in fact, the structure of the book, its unifying principle. In the opening, Eve writes:

Since it's impossible to get this one I'm in love with to read anything unless it's about or to him, I'm going to riddle this book with Easter Egg italics so that this time it won't take him two and a half years to read my book like it did the first one. . . . Virginia Woolf said that people read fiction the same way they listen to gossip, so if you're reading this at all then you might as well read my private asides written so he'll read it. I have to be extremely funny and wonderful around him just to get his attention at all and it's a shame to let it all go for one person.

Eve is playing with Paul, playing with us, knowing that he—and we—are in her thrall, confident that he—and we—are going to stay there. She's languid, serene, digressive, so totally in control she can abdicate it.

Eve has acquired patience, but, even more crucially, restraint. The dedication is five words long: "To Sol and Mae Babitz." And though *Slow Days* is as star-studded as *Eve's Hollywood*, you wouldn't know it. The stars are incognito, Eve bundling them up in trench coats, slipping Groucho Marx glasses on their faces: The character called Terry Finch, the country singer and actress who dabbles in heroin, is Ronee Blakley; the character called Nikki Reese-Kroenberg, the socialite married to a rich and powerful man from San Francisco, is Jane Wenner, wife of Jann; and the character called Gabrielle Rustler, the in-génue whose evil allure has not yet translated to the screen—"The trouble was that the men who cast her thought she was beautiful, so they put her into wistful, dreamy dresses when they should have handed her a whip and got out of the way"—and with whom Eve spends a debauched afternoon at the Chateau Marmont, is Michelle Phillips. In other words, Eve is writing about stars because she's writing about her life, in which stars just happen to be supporting players; she's not writing about stars because she's trying to validate her writing.

What's more, Eve is now letting L.A. fend for itself. She writes:

People with sound educations and good backgrounds get very pissed off in L.A. "*This* is not a city," they've always complained. "How dare you people call this place a city!"

They're right. Los Angeles isn't a city. It's a gigantic, sprawling, ongoing studio. Everything is off the record. People don't have time to apologize for its not being a city when their civilized friends suspect them of losing track of the point.

So instead of putting up her dukes, as she did in *Eve's Hollywood*, she's shrugging her shoulders. She understands that L.A. doesn't require explanation or justification any more than she does.

Something else Eve is doing: inventing a form. In the book's first piece, she declares:

You can't write a story about L.A. that doesn't turn around in the middle or get lost. . . . No one likes to be confronted with a bunch of disparate details that God only knows what they mean. *I* can't get a thread to go through to the end and make a straightforward novel. *I* can't keep everything in my lap, or stop rising flurries of sudden blind meaning. But perhaps if the details are all put together, a certain pulse or sense of place will emerge, and the integrity of empty space with occasional figures in the landscape can be understood at leisure and in full, no matter how fast the company.

And, by God, the pulse and sense *do* emerge. And the space *can* be understood. And a novel *has* been made, even if it's an unstraightforward one, one that looks nothing like a novel. Eve's pulled off the trickiest of feats. Has found a way, technically, through this narrative device she's created, to convey her romanticism, her desolation, her irony—herself.

Yet Eve's formal daring is easy to miss, her art so artful it appears artless. The absence of the clanking of plot can make it seem as if there isn't one. Not true. There's the sustained drama of her boredom, her endless orchestrations and machinations, sexual and social and chemical, to keep that boredom at bay. It's just that the style in which she tells her story is so organic as to be invisible. The handful of pieces that make up *Slow Days*—stand-alones that overlap and reflect on one another, characters surfacing, vanishing, then resurfacing—gain in power and fascination, scope and grandeur, as the book progresses. They're airy without being lightweight, blithe without being scatterbrained. And while they're full of gaiety, they're also full of something else. Tune in to *Slow Days*' music and you will catch the strains of melancholy.

In "Dodger Stadium," for example, a married lover (Tom Dowd, from the *Eve's Hollywood*'s dedication) invites Eve to a baseball game. She writes, "People take me to screenings of obscure films, they drag me along to fashionable new nightclubs, they have me meet them in a taxi, honey, and whisk

me off to dangerous Cuban samba places to *bailar* the night away. They don't take me to baseball games. . . . No wonder I'm such a sitting duck for this man." Eve is in raptures over the players, the crowds, the sharp, yellowy smell of mustard in the air. Dowd is in raptures over her raptures. Afterward, at dinner at an out-of-the-way restaurant, the tender moment of enchantment is shattered when an agent stops by the table to talk business with Dowd, ignoring Eve because she isn't Dowd's wife and is therefore someone to whom courtesy is not owed:

> I felt myself fading into the background and let their voices wash over me, well aware of my place in this traditional back-street romance. There was plenty of time to worry about who was taking advantage of whom in the war between men and women or the future of the country or any of that. I felt [his] hand reach under the table and come to rest someplace just above my knee, and I suddenly thought how fortunate it was that I hadn't had my car washed that afternoon.

There's loneliness here, maybe even a little heartbreak, but there's also wit and grace and a glancing touch, so that her pain never becomes maudlin or morose. It's just swiftly acknowledged, and then she moves on to her next emotion: gladness to be in Dowd's company, that the evening happened at all.

In the penultimate piece, "Emerald Bay," Paul, not only the book's impetus but one of its main characters, Shawn, brings Eve to the house of an older married couple, Mason and Jo Marchese, in Laguna Beach. Jo's best friend since girlhood is Beth Nanville, a brittle rich woman. ("[Beth] wore dismal colors always, powder blue and mustard, and I put her into my 'Empty Lady Hanging On' category.") Eve wounds Beth's feelings, avoidably though unintentionally, by adding dressing to a salad that Beth has already dressed. That's the climax of the story—salad dressing—until the very end, which is almost a coda, and so brief your eye nearly skips over it.

Eve, back in L.A., gets a call from Shawn informing her that he's driving down to Laguna to be with Jo because Beth has committed suicide. She writes:

> I wish, now, that I could remember [Beth's] face or the sound of her voice. But the only things that I really remember are that she left her children $2,500,000 in her will and when I tasted her lettuce I was sure there was nothing on it.

It's an extraordinary moment. There, right in the middle of that upscale little beach town, the jewel of coastal Southern

California, where "anything that [is] fascinating, a new idea, a breakthrough, [is] kept outside the gates," is Death.*

The tone of "Emerald Bay" is casual, hard (never does Eve take back or modify her original assessment of Beth, she certainly doesn't apologize for it), yet the piece is also drenched in emotion. Eve here is showing herself a master of the juxtaposition of mood and action. There's the unceasingly delightful flow of her narrative, her characters—clever, overgrown children, self-centered and self-indulgent—and their constant pursuit of pleasure, the charming triviality of it all, and then, seemingly out of nowhere, a flash of genuine anguish, reality intruding on the artifice, interrupting the fools at their revels. And, suddenly, you understand that what looks like a comedy and trifling is actually a tragedy and lyric, the laughter grow-

* Beth Nanville is, like every other character in *Slow Days*, a real person. Her name was Peg Thorsdale, and she was the best friend of Petey Mazza ("Jo Marchese"), wife of Aldo Mazza ("Mason Marchese"). And, same as Beth, Peg killed herself. Petey was, says Paul, "upset by Eve's story and what she thought was an unfair swipe at Peg." And *Slow Days* became a source of tension between Petey and Eve, which Eve being Eve scarcely noticed. A strange coincidence: New York Review Books Classics reissued *Slow Days* in 2016. The publishing house had a single copy of the original book. Petey and Aldo's. Sara Kramer, managing editor at NYRB Classics, sent me a photo of the inscription:
4/24/77
To Petey and Aldo
Without you I'd be nothing.
Love,
Eve Babitz
Under Eve's name was a lipstick kiss, the pink still bright, even after all these years.

ing out of sadness, disappointment, failure. The book is alert to the startling abruptness of life, the brutality of it, how harrowing it can be, and that one person's devastation is, for the rest of us, gossip, worth a few minutes' diversion and no more.

Slow Days is every bit as close to despair as *Play It as It Lays*. Unlike *Play It*, however, it's never a bummer. While the writing of *Play It* is sophisticated and nuanced, the attitude is not. The attitude is callow and simplistic, is that, basically, of a teenage cynic, what many of us are deep-down apparently. How else to account for the work's enduring reputation and popularity? *Play It* flatters the reader. Tells the reader what the reader already thinks he or she knows: that Hollywood is rotten and corrupt; that the beautiful people have ugly souls; that the game is rigged. *Slow Days*, with its panoramic, kaleidoscopic view not just of Hollywood but of Los Angeles, its total lack of interest in approving or disapproving of its characters' morals, and its amused, worldly skepticism, is far too tough-minded—and hip—for that crybaby stuff. Sure, there are unhappy women overdosing on Seconal, leaving behind hugely expensive beach cottages and no notes, but there are also private bays as green as emeralds until they're as blue as lapis lazulis; parties with guest lists and armed Pinkertons; girls in chiffon who resemble tulips; actors in tennis shorts, their legs tan and limber, springy with muscle. To quote Eve, "Ahhhh, me."

Now, I suppose, is the time to come clean. Eve was right. I *do*

have homicidal designs on Didion. I think *Play It* is a silly, shallow book. I think *Slow Days* should replace it, become the new essential reading for young women (and young men) seeking to understand L.A. There. I said it.

With *Slow Days*, Eve achieved that American ideal: art that stays loose, maintains its cool, and is so purely enjoyable as to be mistaken for simple entertainment. It's a tradition that includes Mark Twain, F. Scott Fitzgerald, George Gershwin, Howard Hawks, Duke Ellington, Fred Astaire, Ed Ruscha, and, of course, Marilyn Monroe.

Eve, Present Day

★

1977 was Eve's finest year, her peak both artistically and emotionally. She'd managed to gouge out of herself a book that was great in spite of, yet also very much because of, her turbulent life, her crippling vices, her idiosyncratic talent. Equally vital: the people around her. Wilson, who understood her—"Eve was an extraordinary voice, an extraordinary sensibility"—and understood how to better make that voice and sensibility come through on the page, was her ideal editor, no matter that she hated to be edited. (Recalls Paul, "Eve thought Vicky was brilliant and gave her credit for pulling *Slow Days* together.")

Spellman-Silverman, who babied her and bullied them that dared mess with her, was her ideal agent. (Eve, in a November 5, 1975, letter to Dan Wakefield, recounts with obvious glee a conversation between Jim Goode, the editor at *Playboy* who'd rejected "The Sheik," now an editor at *Playgirl*, and Spellman-Silverman: "In his bright urban way [Jim] said, 'Ahh, yes, Eve Babitz, I remember her when she was just a collagist. We really would like to use more of her things.' And Erica looked at him with this ingrown sneer she has for all business dealings and said, 'Well I'll tell ya one thing. You ain't gettin' none of her stuff for no lousy $500 like the last time so you can just forget that shit.' ") And Paul was her ideal guy, even if she was with other guys too, even if *he* was with other guys too. (When friends asked Eve why she'd chosen for a mate somebody whose heterosexuality was as touch-and-go as Paul's, she'd reply, "He's not that gay, and besides we have fun.")

The thing about peaks, though, is they're not sustainable, Eve's less sustainable than most. So let's give her a chance to enjoy hers, take in the view, maybe enhance the experience with a shot of tequila, a hallucinogen or two, and jump to 2010, when my romance with her began.

At the time I was thirty-two, living in Kips Bay with my boyfriend, Rob, in a 350-square-foot apartment subsidized

by NYU, where Rob was a medical resident. I was a writer, though I mumbled when I told people this since I wasn't a published one. It was a weekday evening, rush hour, and I was on the subway, hanging from a pole, reading *Hollywood Animal*, the memoir of screenwriter Joe Eszterhas. I turned the page and came across this terrific quote about sex and L.A., attributed to a person I'd never heard of before. Eve Babitz. (A curious thing: I can't tell you the exact quote because, evidently, it doesn't exist. At least not in *Hollywood Animal*, or any other Eszterhas opus. I've searched and searched. And yet I'd swear to you that's how I found Eve, one Hollywood animal giving me the scent of another.)

As soon as I got home, I went on Google, discovered that Eve was a writer, went on Amazon, discovered that all her books were out of print. Used copies, however, were available from third-party sellers. I picked the title I liked best, then clicked on the cheapest option. The book arrived the following week. I read it fast, in a single swallow, skipping meals, barely even taking pee breaks. It wasn't just that I thought she was good, though I did—very, very—it was that she was telling me everything I wanted to know. I had to talk to her.

Eve wasn't on Facebook or Myspace or Twitter. But she was in the phone book. The last place I looked, naturally. I could've reached for my cell, called her. I have vampire manners, though, need to be invited into a house in order to enter

it; so instead I wrote her a note on a postcard, a shot of a young Marlon Brando straddling a motorcycle (I didn't know then that he was a heartthrob of hers, lucky guess). No response. I was disappointed, but I'd bought more of her books, had them to keep me company. And I forgot about the whole matter until a few weeks later, when I found myself standing in front of her condo building in West Hollywood.

I can give you the day. October 27, 2010. I usually have zero recall for this kind of thing, except my brother, John, who was in his second year of business school at USC, and with whom I was staying for the week, had come out to me the night before. (Like Claude Rains in *Casablanca*, I was shocked, *shocked*, only I really was shocked. John and I were so close! Why had he waited so long—he was twenty-nine—to tell me he was gay?) Which is the reason that that period isn't at all hazy or grainy in my mind, but sharp, vivid, detailed. And, yes, memory is notoriously unreliable. To wit, *Hollywood Animal*. Old emails, however, time-stamped, date-stamped, back mine up.

I'd woken early. Wanting to give John privacy, myself fresh air, I'd grabbed my sneakers, tiptoed out the door. I headed south on Crescent Heights, took a left on Santa Monica, and just kept going, lost in my thoughts, until I saw a sign for G— Street, Eve's street, and stopped cold. I was so reeling

from the kismet of it all that I was halfway down the block before I realized I was walking again. I'd forgotten which number Eve's building was, but it was easy enough to look at the names on the mailboxes.

And then, at the corner of R—Street, voilà: E. BABITZ. The mailbox was attached to a quiet, house-looking building, two stories high and pleasantly slummish, the paint a faded pastel, originally pink or brown-pink, overgrown shrubbery in front, garage below, a lawn chair on the second-floor balcony. I stood there for several minutes, smelling the wet smell of hosed-down pavement, feeling the air, cool and shadowy as it always is in L.A. in the morning before the sun's burned through the haze, on my skin, and stared at the closed blinds of the bottom right unit. Eve's.

I considered what to do. I couldn't very well press her buzzer. It wasn't quite 7 a.m. yet. And even if it were a more civilized hour, I still couldn't press her buzzer, ambush her. But I couldn't just turn around either, retrace my steps to John's apartment, pretend I'd wound up on her front lawn by dumb coincidence rather than fateful design. Finally I grabbed a flyer off the windshield of a parked car, scrawled on its blank back a few words along with my cell number, folded it in half, then slipped it under the locked foyer door.

I didn't hear from Eve that day. Or the next day. Or the next next day, which was the day I was returning to New

York. That really is that, I thought, if I thought about it at all. (I had a lot on my mind at that particular moment.) And I didn't think about it again for a year and a half.

It was February 2012. Rob and I were now married. He was in private practice and we were renting an eight-hundred-square-foot one-bedroom in Chelsea. My professional situation was slightly less dire. I'd done some intellectual-property work for Penguin, written a young-adult series under a fake name. Under my real name, I'd published a few pieces in semi-prestigious, semi-obscure literary magazines. If I wasn't quite living the dream, at least I could look people in the eye, speak in a clear voice, when I said what I did.

And then I got a chance to pitch *Vanity Fair*. I pitched Eve. I never considered anything or anybody else. She'd been at the center of the most stylish kinds of action in and around Hollywood for decades, a member of both the beau monde—very fast, very rich, very famous—and the demimonde—artists and geniuses and other assorted riffraff—plus, was an artist-genius herself and under-recognized. And of course there were the notches on her bedpost. (Or the notches that would've been on her bedpost had she bothered owning a bed.) She was, in short, an ideal *Vanity Fair* subject. Over drinks, the editor, Bruce Handy,

expressed cautious enthusiasm, and I, incautiously encouraged, was off to the races.

I wrote Eve yet again, this time a proper letter on white paper. After reintroducing myself, I told her I was doing a feature on her for *Vanity Fair* (I was speaking with false authority, though I didn't realize it, had no clue how long and arduous the process of getting a pitch officially approved at *Vanity Fair* can be, never mind for a non–*Vanity Fair* writer, never mind for a non–*Vanity Fair* writer with a résumé as skimpy as mine), and asked if she'd let me take her to lunch. The response was the same: none. I overcame my aversion to cold-calling, but she didn't answer her phone, ever.

And it wasn't just me who couldn't get anywhere with her. Dave Hickey had attempted to mount an Eve Babitz revival the year before. Then a professor at the University of Nevada, Las Vegas, Hickey assigned Eve's pieces to his students. They'd flipped. He got in touch to see if she'd speak to the class. Her reaction to his request was not what he'd hoped. "She told me to fuck myself," he informed me cheerfully. "That's okay. She blows everybody off these days." She did? Really? The woman who went to every party worth going to in L.A. in the second half of the twentieth century no longer wanted to come out and play? Say it ain't so. What happened?

A fire.

In the spring of 1997, Eve, fifty-three, was driving home

from a family gathering. She struck a match to light a cigar and dropped the match on her skirt. Seconds later, she was engulfed in flames. She suffered third-degree burns over half her body. The doctors gave her a fifty-fifty chance of survival. The odds broke in her favor, and she pulled through. Her life, though, was forever altered. Whether from shame or pain or plain lack of interest, she stopped going out, turned increasingly inward, increasingly reclusive.

Hickey could take a hint. I couldn't. Or, I suppose, wouldn't. And, at long last, I established contact. Not with Eve, with those close to Eve: Mirandi and Laurie, Caroline Thompson, Julian Wasser, Paul. Either Eve got curious or hungry or both, because three months after I mailed that letter asking her to lunch, she sent word through Paul that she accepted the invitation. I booked my ticket, flew to L.A. the next morning.

I arrived at Short Order straight from the airport. I was the first customer of the day, the hostess unlocking the door as I reached for it. The restaurant was Eve's choice, a fifteen-minute walk (she hadn't driven in years) from her condo, in the Farmers' Market at Third and Fairfax. It looked like the kind of place that would have sold hamburgers and hot dogs to beach bums and bunnies had it been located on the water, only fancy. I sat at a table by the window, sipping a

seltzer, my stomach a mess from nerves and travel and being six weeks pregnant, and waited for the woman who once said she believed "anyone who lived past thirty just wasn't trying hard enough to have fun," now sixty-nine.

And then the second customer of the day entered. I stood up from my chair, half sat back down, stood up again as I thought, It's Eve, wait, it can't be Eve, wait, it has to be Eve. She no longer looked like a bombshell, her hair gray, the cut short and blunt, her clothes a way of covering up her nakedness and nothing more, her glasses, black-rimmed, the lenses thick. She didn't, however, look like a burn victim either. (Her face had been spared, as had her feet, thanks to UGGs.) She looked, remarkably, unremarkable, an older woman who didn't give much thought to her appearance out for lunch. She picked up a paper takeout menu from the hostess's stand, began studying it.

I walked over to her, touched her shoulder. She smiled, toward me rather than at me. And I saw immediately that I'd been wrong about her looking unremarkable. That was the impression she gave from a distance. Up close it was another story. Her glasses were smudged, greasy. She'd applied lipstick to her mouth, only she'd done it haphazardly, a streak of pink on her front tooth, on her chin. She had, too, a smell about her. Not body odor—it wasn't tart or tangy. Something else, something I could almost identify but couldn't quite, something heavy, sweetish. She said she was starving.

No exaggeration as it turned out. Our grass-fed burgers and russet potatoes fried in truffle oil arrived and she barely came up for air. I flashed to Paul's description of her M.O. at fetes during her party-girl heyday: "She'd bypass the host or hostess and first head to the buffet table and dive into it like Esther Williams on Dexamyl. She'd bolt if something made her uneasy, then barge back in and demand that I take her home. I'd ask her why. After all, we'd just gotten there, and she'd say, 'So we can fuck!' " The second she cleaned her plate, she pushed it away.

"I'm ready to go," she said.

I blinked at her. The whole meal had taken twenty minutes.

I threw cash down on the table, afraid she'd get impatient, walk out if I used a credit card. Trying to buy myself a little extra time, I offered to give her a ride home, even though I didn't have a car. I called a cab and we talked a bit as we waited for it, a bit more when we were in it. But the conversation never really got off the ground. We couldn't get any rhythm going, any flow. I was uptight and overeager. And she, no doubt, was bewildered: Who was I exactly and what did I want from her? Or maybe she was just checked out. The few remarks she made were addressed to an invisible point above my head or to herself. The cab turned onto G— Street and she was opening the door almost before the driver braked, disappeared into her building without so much as a wave.

★ ★ ★

I didn't sleep that night. Was too upset. Because I'd blown it with Eve, of course, and felt hot with shame at my failure. But also because sitting across from Eve at that restaurant table had been such a deeply alienating experience. Technically she'd looked at me, though she'd refused to acknowledge my presence in any of the usual ways. Technically she'd spoken to me, though she'd refused to engage in dialogue other than of the Mad Hatter variety, each sentence unconnected from the sentence that came before. She never once said my name.

Yet as strong as my urge to back away was, my urge to come closer was stronger still. You could even say that my repulsion was a form of attraction. That Eve, famous for her beauty and seductiveness, was now a ruin and a gorgon excited me. It heightened the beauty and seductiveness of her books, reinforced my conviction that she was an artist and an original. That her life had descended into either tragedy or folly or both also excited me. It meant that there was a grandeur about her, a magnificence. Logically this made no sense, but intuitively it rang cherries, one, two, three in a row. Besides, I believed that Eve was *trying* to repel me. (Reduce everything she said to me in those twenty minutes to a single word, and it wouldn't be a word, it would be a growl.) And if she was putting obstacles in my path, the jewel she

was guarding must be precious indeed. Then there was this: she was my ticket out of publishing purgatory—anonymous writer-for-hire assignments, dry-as-dust magazines that barely paid—I was sure of it. It was starting to dawn on me how ambitious I was, how far I was willing to go. It was starting to dawn on me that I might be a gorgon too.

In the morning, I forced myself to call her, thank her for coming to lunch. I was certain she wouldn't pick up. But she did, even sounded pleased that it was me on the other end of the line. It was a brief exchange, three minutes at most. She brought it to a close by saying, "And next time, I want you to take me for barbecue." *Next time*. The sheer relief at hearing those two words made my vision blur. As I said good-bye, which she didn't catch (already hung up), my heart lifted, lifted, lifted.

I was in.

With Eve maybe, but not with *Vanity Fair*. From interest in my pitch to approval of my pitch to publication of my piece was a long haul, close to two years. I was six weeks pregnant with my second baby when the issue finally hit stands. The wait was frustrating, exasperating, maddening, yet ultimately a blessing. During that time, I traveled to L.A. every twelve weeks or so and took Eve to lunch. I got to know her bet-

ter. Understand her better, as well. No small thing because she often spoke in a private code, which I learned—started to learn—to crack. "Is that the blue you're using?" was, of course, one example of Eve-speak. Another was "so-and-so likes baseball." That meant the so-and-so in question, male, was heterosexual and serious about it, macho in terms of outlook and attitude. As in "Oh, Fred Roos [the famed casting director, an ex of Eve's] liked baseball too much to be friends with Earl." (This in answer to my query as to whether Roos, who cast Harrison Ford in Ford's breakthrough movie, *American Graffiti*, met Ford through Earl McGrath.)

Though perhaps the phrase most crucial to grasping Eve's speech is "whatever." She pronounces it in a very particular way, putting a space between the *what* and the *ever*, the emphasis on the *what*. She uses it, as many do, to signify indifference or annoyance, but also as a kind of verbal ellipsis. It's what she says when she'd rather not say anything at all, wants to glide right over a subject. (For instance, I once questioned Eve about Ahmet Ertegun's caddish side—I knew he had one since Etienne Vasilly in *Sex and Rage* had one—and she replied: "Ahmet would be charming a girl and then he'd make her jump out of the limo or run out of the party, leave Earl to chase after her, because he'd insulted her, said something awful or done something awful or whatever.") In nearly every circumstance, her "whatever" defies response and ends the conversation.

While Eve was always up for meeting, she never seemed totally sure of who I was. Anytime I saw her after a few months had passed, I'd begin by giving my name, first and last, then mention *Vanity Fair*. Though her lack of interest in me was distressing, I consoled myself with the thought that it wasn't that I was so easy to forget, it was that she had such difficulty remembering. And I never lasted with her long. As soon as the food was finished, so was she, no lingering over coffee or tea. Forty-five minutes tops.

Except for once. My brother arranged to be in L.A. for work at the same time I was in L.A. for lunch with Eve. After she and I ate, he picked us up outside the restaurant. She got a load of him, and her face lost its vague expression. "I know you," she said, a serious gleam coming into her eye. "You're the one who played the jukebox at Astro." And, unbelievably, he was. When he was renting that apartment on Crescent Heights, he used to stop by Astro, a few blocks from Eve's, at least twice a week for the avocado burger and to hear Blondie's "Call Me." John, though, hadn't lived in L.A. for more than two years. Apparently her obliviousness was selective and did not extend to cute young hunk types.

Instead of having John drive her home, Eve had him drive us around Hollywood so she could point out her old haunts. Afterward, she even let me walk her up the steps of her build-

ing, though she didn't invite me inside her condo. I got an idea of why the moment she opened the door—a sliver, just wide enough for her to slip her body through and for me to realize that Paul hadn't been going for cheap laughs when he called her "the world's biggest slob." I saw filth and I saw stuff, so much filth and so much stuff that moving a foot in any direction other than toward the kitchen or the bedroom (two very narrow pathways had been forged) would be impossible. There was also that cloyingly sweet stink, a more potent version of the smell she carried on her person, so potent, in fact, it made me dizzy. I still couldn't quite identify it. And then, all at once, I could: decay. I held my breath as I leaned in to kiss her good-bye, which she normally didn't permit me to do, only this time she did. It ended up being our best afternoon together.

The wait was a blessing in another sense, as well. It allowed me to get a feeling for her rhythms and moods, her quirks. So that when it came time, finally, finally, for her *Vanity Fair* shoot, I knew what to do. She requested that a former boyfriend of hers (also of Paul's), the photographer Lloyd Ziff, take the pictures. Ziff: "I was gay but Eve was still my type—funny, sexy, a smile like Marilyn Monroe's. It's not as if she and I were some big romance. We didn't make the columns or anything like that. But we were an item for a while

back in, I think, '73. Or maybe it was '74. Could it have been '75?* I don't remember the year we were together, but I do remember when we broke up. Eve came to dinner with me and my mother. Afterward she said to me, 'Anyone who has to deal with a mother like *that* cannot be my boyfriend.' And we were done! We stayed friends, though."

Ziff scouted out a number of locations in advance: Hollywood High, a prop lot on Melrose, Bronson Canyon, the Sunset Tower Hotel. He suggested that we start at Musso's for an early celebratory lunch, spend the afternoon hitting the spots. It was a good plan. The only problem with it was that it would never work. Food is, obviously, a big thing for Eve. If we gave it to her first, no way would she cooperate. She'd wolf it down and, having got what she wanted, demand to be driven home. We had to make her earn it. Use the spinach (and sandabs) as a carrot. I explained all this to Ziff with much self-conscious shuffling of the feet, many an embarrassed clearing of the throat, before proposing we reverse the order. Ziff gave me an is-this-really-necessary? look. I nod-

* A question I frequently asked myself when I was researching Eve: Do West Coasters have, in general, worse memories than their East Coast counterparts? Most of the people I spoke to about Eve are Angelenos, and I noticed that they have difficulty fixing dates, even the vaguest of ones, to events. The reason for this is, I suspect, climatological. Southern California lacks definitive seasons. Days, weeks, months, years become indistinguishable in the drift and the haze of sunshine and smog, of dope and frolic, of an existence so absolutely temperate and free of friction that time passes and nobody realizes. Anyway, it's a theory.

ded. He sighed, laughed—made an attempt at a laugh, at least—then nodded back.

Eve was cranky by Bronson, there were dark mutterings at the Sunset Tower, but she stuck it out, made it to Musso's, which is where, as it so happened, Ziff got his best shot, the one that would appear in *Vanity Fair*'s 2014 March/Hollywood issue. It showed Eve sitting at one of Musso's famous red booths, a half smile—exactly half, neither more nor less—on her face; Mirandi on her right, Laurie on her left, both smiling hugely.

Mirandi Babitz, Eve Babitz, Laurie Pepper at Musso's, 2013

★ ★ ★

Though Eve and I were eventually able to achieve a certain level of comfort with each other in person, perfect ease was beyond us. Is beyond us still, frankly. It's difficult for me to relax with her since I always feel like I'm playing beat-the-clock. I know how quickly she's going to want to leave wherever it is we are, so I tend to overdirect the conversation, get impatient if she wanders off on one of her tangents: a sugar substitute found only in Japan, the Queen of England's bra-maker, the health benefits of unpasteurized milk. And I'm sure my wound-up intensity is unnerving for her, that habit I can't seem to break of looking at her too hard, of lunging at her every remark as soon as it drops from her lips. Nor have I managed to completely shed my awe of her, my neediness around her, and it's a strain on us both. Another issue: physical pain, hers, which she never mentions but which I guess at. I learned from Laurie and Mirandi that a number of her burns didn't fully heal, are still open. And her body can no longer efficiently rid itself of heat because the fire destroyed so many of her sweat glands. Sitting in a chair at a table for an extended period, especially in warm weather, must be excruciating.

On the phone, however, where my gaze isn't merely averted, is eliminated, the story is entirely different. Our rapport is not just reliable but surefire, not just easy but instinctive. She takes

my calls now, has ever since that lunch at Short Order. *"Oui, oui?"* she says, her favorite greeting. I tell her who it is though I know she already knows. Caller ID. And she says, "Lili!" the exclamation point audible in her voice, which—and I think this every time I hear it, the same thought, without fail—is so charming, unusually charming. It's girlish and lilting, the enunciation softly crisp, laughter always bubbling up in it; yet it's drowsy, too, as if the phone's ringing has pulled her out of a heavy slumber. And this is what I start to picture, despite my knowing exactly what Eve looks like now: Eve *then*, *Eve's Hollywood*–era Eve, sitting up in bed, tousle-haired and mascara-smeared like a good bad-girl movie babe, a sheet wrapped around her torso, the receiver cradled between her chin and shoulder as she lights her first cigarette of the day and lets fly some deeply unfair, deeply funny observation, a man beside her, only his back visible, trying to stay asleep.

I should add: my fantasy is, I suspect, really our fantasy, mine and Eve's, not just shared with her, but co-created by her, and necessary to us both. I'd bet money that Eve is picturing the same Eve I'm picturing when we're on the phone. It's obvious she'd rather talk on it than face-to-face. And who can blame her? To have changed forms so abruptly, gone from, if no longer, in her early fifties, a sexual paragon, then still vital and enticing, fully capable of attracting, in her words, "fun and men and trouble," to mundane in the span of a few seconds, must've

been beyond disorienting, must've been dislocating, as if her life had suddenly become a case of mistaken identity. Small wonder that she prefers her communication to be disembodied.

Mostly Eve and I talk about the past. What she says is invariably sharp and amusing, and her recall is exceptional. On the disagreeableness of Edie Sedgwick: "I never met Edie. I didn't want to. I knew she was obnoxious, so I stayed out of her way. I did see her, though, a few times at Max's Kansas City, sitting at the bar with Bobby Neuwirth. She used to buy her clothes in the boys' section." On the strange case of Walter Hopps: "Chico [Hopps's nickname] had a room in his house filled with Joseph Cornells. He stole them from everybody. He even stole them from Tony Curtis. Don't ask me why Tony Curtis had a huge collection of Joseph Cornells. All I know is that he did, and that Chico took them." On fame: "There was a period there where it looked like a book I wrote might become a bestseller. It didn't. But for about a week people thought that it might, and that I might become famous. It was one of the most horrible weeks of my life. Why? Because I thought being famous would cramp my style." By the way, "cramp my style" is more Eve-speak, a phrase invoked by her here in response to fame, earlier in response to the Thunderbird Girls. But I've also heard her invoke it in response to higher education, to deadlines, to black-widow corsets—to anything, basically, that threatens her ability to do exactly as she pleases.

She's great on the present as well, if you're willing to wait out the political rants. (Her views took a sharp right turn post-fire.) She tells me about the book she's reading, *Life*, Keith Richards's autobiography: "The reason Keith doesn't die is because he doesn't mix his drugs." Why she isn't writing: "I'd rather do nothing for as long as I can stand it." What her skin looks like: "I'm a mermaid now, half my body." It's the last remark that knocks me out the most. I love it not simply because it shows how tough she is, how unbowed, what a sport and a champ and a trouper, but because of its sneaky eroticism. She's comparing her burned epidermis, a painful and grisly condition—a disfigurement—to the scales on the tail of a mermaid, the seductress of the sea. As an image, it's grotesque and romantic at once. Not just sexy, perversely sexy. Not just perversely sexy, triumphantly perversely sexy. On the phone, she talks like she writes.

Novel *Est Morte!*

★

Back to the past.

Slow Days made more of an impression than *Eve's Hollywood*. Knopf put money, muscle, and hoopla behind it, taking out half-page ads in major American newspapers. Clearly the publishing house believed in it. As did Eve. "I thought what Knopf

thought—that it would sell a million copies." (This is the book of hers around which hopes of bestsellerdom hovered.) That didn't happen. "Nobody read *Slow Days* either. Well, Jackie Kennedy read it. She loved it. She gave people copies of it before they went to L.A. That's what she did with X, my AA friend."*

Still, *Slow Days* was widely reviewed, including twice in the *New York Times*. The second review, by critic Mel Watkins, was near glowing and twigged to Eve perfectly: "Eve Babitz is philosopher, quidnunc and wit here, and the amalgam makes for a collection that is light enough not only to entertain and flaunt the West Coast glitter but also insightful enough to reveal its somber underside." The damage, however, was done by the first. Novelist Julia Whedon surveyed and dismissed Eve in three short paragraphs. In her closing, Whedon wrote, "I discern in [Babitz] the soul of a columnist, the flair of a caption writer, the sketchy intelligence of a woman stoned on trivia."

In any case, by the time *Slow Days* was released, Eve was already at work on her third book.

Sex and Rage (Knopf, 1979) was about the same thing *Eve's Hollywood* and *Slow Days* were about: Eve and Los Ange-

* X, a lawyer-turned-actor-turned-back-to-lawyer, takes the Anonymous part of Alcoholics Anonymous seriously and prefers not to be named.

les. *Eve's Hollywood* and *Slow Days* are both autobiography, and yet I'm drawn to them as literature. *Sex and Rage* is also autobiography, and I'm drawn to it only as that. By which I mean, I'm interested in it because it gives me insight into the context and mind-set that led to the creation of the works that actually interest me—*Eve's Hollywood* and, more particularly, *Slow Days*. In plain English, I don't like *Sex and Rage* and regard it, in spite of its killer title, as a failure.

On the one hand, so what? If a writer takes risks, doesn't just concoct a formula, follow it again and again, he or she is sure to produce an uneven book or two. You can't knock it out of the park every time is what it comes down to. And it isn't that Eve whiffed with *Sex and Rage* that's noteworthy or compelling, it's why she whiffed. Because what's changed isn't her style. No, her prose has its usual dash and luster. (Of the Harrison Ford character: "His mouth looked as though he'd just been hit with the news that he had a week to live and he didn't care.") Nor is it her content, similar, as I said, to that of *Eve's Hollywood* and *Slow Days*. It's her form.

I've already quoted that wonderfully self-aware line of hers from *Slow Days*: "*I can't get a thread to go through to the end and make a straightforward novel.*" Yet that's precisely the task she's forced herself to perform here. She's abandoned indirection and disorder, arguably the making of *Slow Days*, that willingness to forgo the tidy linear narrative, instead pre-

senting life in all its unruly complexity; to be oblique, elusive, elliptical; to tell a story that "turn[s] around in the middle or get[s] lost." *Sex and Rage* is, contrastingly, structured as a classic three-act setup-conflict-resolution bildungsroman—L.A. girl artist falls in with a fast crowd, suffers heartache and disillusionment, reinvents herself as a writer—and it's the structure that does the book in. The wild, heedless energy, which ran amuck every so often in *Eve's Hollywood*, was perfectly channeled and commanded in *Slow Days*, is constrained in *Sex and Rage*, bound and gagged.

The expressive potential, too. Eve is no longer Eve. Eve is Eve posing as Eve. Eve is a character named Eve. Well, technically Jacaranda. "[Jacaranda] was a rare enough thing—a native-born Angeleno grown up at the edge of America with her feet in the ocean and her head in the breaking waves, with a bookcase full of the kind of reading matter that put her in touch with the rest of the world." (It's like she's describing a talking dog!) Eve has, in short, novelized herself—her background, her experiences, her thoughts, the way she looks and talks and moves—and, consequently, both vulgarized and trivialized herself.

What's more, she now does consciously what she once did unwittingly. Spontaneity has become premeditated, and, poof, the magic is gone. The most striking example of this occurs when Eve-Jacaranda enters the living space of Max, the Earl McGrath character, and is looking around:

There was art all over the walls. Jasper Johns, Rauschenberg, a David Hockney swimming pool, and a huge pornographic watercolor by John Altoon. In the front to the right, where people came in, was a carefully framed photograph by Julian Wasser of Marcel Duchamp playing chess with a naked girl. The contrast between Duchamp's dried-out ancient little person and the large young girl's Rubenesque flesh was not (unlike chess) at all subtle. This photograph was the only thing on Max's wall that people actually looked at; even Altoon's pornography was a little too tasteful to arouse real interest.

"You've got a print of this," she said, her voice filled with hurt surprise. She'd never imagined that anyone might *own* a print and not have to tear it out of an art magazine as she had had to do.

"You *know* this photograph?" Max asked.

"Well, I mean . . ." (She'd have to be an idiot to spend all her time around artists and not know *this* photograph.)

So Eve the character is examining and then commenting on a work featuring Eve the person. The scene is coy, contrived, mannered, too cute by half—is, in other words, everything that the photograph could have been but wasn't. (It's as if the Eve in the photograph turned to the camera, peeked out from behind her hair, and winked obscenely at

the viewer.) Art has been replaced by artifice, mystery by mystique, and all is lost.

The obvious conclusion to be drawn is that Eve isn't a natural novelist, and I'm not going to suggest otherwise. And neither, by the way, is Eve. "Writing a novel was my idea, but I didn't really want to do it. I preferred short stories, short essays—whatever you want to call them. Nobody told me I had to write a novel. Vicky didn't tell me, nobody at Knopf told me. They didn't have to tell me. I just knew. If you were a serious writer, then a novel is what you wrote." And it *was*. The novel, in America, at the time Eve started to write, in 1961, the year of "Travel Broadens," was considered not just a vocational calling but a spiritual. Tom Wolfe: "It's hard to explain what an American dream writing a novel was in the 1940s, the 1950s, and right into the early 1960s. The Novel was no mere literary form. It was a psychological phenomenon."

The problem is with Eve's novel in particular. *Sex and Rage* flat-out doesn't come off. The problem, however, is also with the novel in general. Only the worst kind of blowhard engages in that the-death-knell-ringeth-for-the-novel talk, yet here I go. The novel as the dominant—nay, supreme—medium of literary expression is doomed, sunk, toast, and has been for decades. It goes without saying but I'll say it anyway: good novels, some better than good, continue to get written year after year. I'll say this, too: Jane Austen's description of the novel as a

"work in which the greatest powers of the mind are displayed, in which the most thorough knowledge of human nature, the happiest delineation of its varieties, the liveliest effusions of wit and humor, are conveyed to the world in the best-chosen language" is as true now as it was in 1817. And, to top it off, this: I spent the second half of my twenties, the first half of my thirties, trying to write a novel. The idea of writing a novel *still*, to this day, makes me go moody and tender and wistful. Doesn't matter. And the reason it doesn't matter is because it fails to change the fact that the novel's historical moment has passed, that cultural centrality has given way to cultural marginality. We want to believe that the art forms of our time are the art forms of all times, and it simply isn't so. Just think, five hundred years ago lyric poetry was the hot thing, what all the pale-faced, dreamy-eyed young men were doing.

The wind went out of the novel's sails with the advent of women's equality and the Pill and the no-fault divorce, the point at which the marriage plot, the novel's greatest plot, lost its tension and urgency. Wait, I want to withdraw that statement—it's extreme, off its rocker—or at least modify it so it's less extreme, less off its rocker: *a* wind went out of the novel's sails with the advent of women's equality and the Pill and the no-fault divorce, the point at which the marriage plot, *among* the novel's greatest plots, certainly in novels by women—Austen, Eliot—or featuring women characters—

Madame Bovary, *Portrait of a Lady*—lost its tension and urgency. (If Charles Bovary had, on his and Emma's wedding night, whipped out his doctor's pad, written her a prescription for Enovid, told her he was cool with an open relationship, wouldn't sexual tragedy have been averted? Why scarf arsenic when what happens in Rouen stays in Rouen? And if prenups had existed in 1881, would Gilbert Osmond have come sniffing around Isabel Archer in the first place? Probably not.)

And the possibilities of any form are finite; they get exhausted. What was there left to do with the novel after James Joyce and Virginia Woolf were through with it? For a while, writers such as Fitzgerald, Hemingway, Dos Passos found something. They wrote books that were less interior, more exterior, that were, in effect, more like their new rival, the one that had sprung up out of nowhere and whose dust they were already eating: the movies. By midcentury, though, those limits, too, were being reached. Plus, there was the fractured nature of modern life, the manic pace, the near-constant interruptions. The novel—meditative, leisurely, requiring long stretches of concentration—couldn't answer the needs of the reader as it once did.

So where to go from there? Where to go if fiction, if *story*, seemed not like a link between our inner selves and the outer world, but like a falsehood or trick? Why, to fact, of course,

otherwise known as nonfiction, where story wasn't story at all, it was a thing that actually happened. Which is the place it's been since Norman Mailer, in 1960, in the pages of *Esquire* magazine, wrote the following line: "I had some dim intuitive feeling that what was wrong with all journalism is that the reporter tended to be objective and that was one of the great lies of all time." New Journalism and the personal essay (not quite interchangeable, but close) had arrived. On the heels of Mailer were Gay Talese, Tom Wolfe, Hunter S. Thompson, Joan Didion, Michael Herr. And Eve Babitz. Moreover, New Journalism/the personal essay was a supple and wily beast, could assume many guises. Truman Capote wrote New Journalism/personal essay in the form of true-crime reportage; Pauline Kael in the form of movie reviews; Janet Malcolm, slightly later, in the form of exposés on journalism itself.

Fiction has always treated real people and true events as raw material and fair game. Engaged in what the impish and perverse Malcolm called "Promethean theft, of transgression in the service of creativity, of stealing as the foundation of making." Used nonfiction for its own ends, in essence. With New Journalism, the using would be the other way around. Now nonfiction would avail itself of fiction's techniques: the reporter would become a character in the story he was reporting on; the reporting of the story would become part of the story itself; the old unobtrusive no-style style was out, a styl-

ish style, whistles and bells, in; subjectivity would, as Mailer decreed, reign supreme; dialogue would play a crucial role, livening up the narrative, goosing it along; and details and timelines would be elided and condensed to avoid redundancies or losses of momentum. The short writings, often appearing initially in magazines, would read like short stories, and the collections like short-story collections (*Slouching Towards Bethlehem*, for example), the extended writings like novels (*Dispatches*, for example). And even if the extended writing read like a novel and was categorized as a novel, as was the case with *Fear and Loathing in Las Vegas*, it was still New Journalism. Nobody believed Raoul Duke was a figment of Hunter S. Thompson's imagination. Raoul Duke was Hunter S. Thompson hiding in plain sight.

And now for a final twist: the New Journalism short writing *was* the new short story, and the New Journalism extended writing *was* the new novel. Fiction has, as I said, traditionally ripped off fact. Yet facts are inanimate. Imagination, in both fiction and nonfiction, is what sparks them, brings them to life. Nonfiction, therefore, is doing the same job as the form considered its antithesis. The novel didn't die, it just found a different host to inhabit.

The novel is dead, long live the novel.

★ ★ ★

If New Journalism was actually the same ol' same ol', though, it was repackaged cleverly enough to *seem* new. And the writers beginning their careers in the sixties and seventies, the ones for whom it was the Great American Novel or bust, must've needed desperately to believe it was new. With the novel, the pressure for them to measure up, not just to the giants from their own country but from Europe, too, and not just to present-day giants but to giants going back centuries, would have been more than daunting, would've been crushing. They were defeated before they'd uncapped their pens. With New Journalism, in contrast, the pressure was off—why, journalism wasn't an art, was barely even a profession—and there wasn't any tradition to follow. It was the Wild West. No laws or rules, all danger and opportunity. They could make it up as they went along. Which is doubtless the reason that so much of the writing was fresh and inventive and outrageous. Yippee-ki-yay.

Or Was It the Coke?

★

If *Sex and Rage* was Eve's attempt to shape up, get with the program, write something with broad appeal, it was a flop. Says Eve, "*Sex and Rage* didn't sell any better than *Slow Days*

did." The book got thumped by reviewers, too. (The title of the *L.A. Times*' assessment: "Surf's Up on a Sea of Mediocrity.") So it was a failure both commercially and critically. What I wonder is, did this failure secretly gratify her?

I think back to the comment she made about fame cramping her style. To be un-famous, in Hollywood terms—the only terms Eve would ever consent to live by—is to be a failure. Yet fame, if you're talented enough, beautiful enough, smart enough, willful enough, lucky enough to even get it, isn't something you're allowed to keep. Which means that failure is inevitable. (Marilyn Monroe found the loophole. By killing herself at thirty-six, perhaps not her final year of sex-symbol viability but close to, she let go of the fame that was about to be torn from her grasp anyway in order to reach for immortality.) Did Eve, sly and instinctive as she was, understand this? That fame wasn't a gold ring, it was a fool's-gold ring? That an aura of romantic ruin and mystery, properly cultivated, won't dissipate, will linger? That losing has a power over the imagination that winning can never hope to match?

Eve's creativity had always been, at heart, morbid, operating as it did on the edge of self-destruction. After *Sex and Rage*, it went over.

By the late seventies, Eve had a drug problem. Of course, Eve

had had a drug problem since the late fifties—her Hollywood High days—and her drug problem was never a problem. Until it was. What changed? The drug. Cocaine, always around but suddenly around a lot more. And perennially unfaithful Eve had eyes only for it. It was all the stimulant she wanted or needed, and depressants could take a hike, too. Says Laurie, "Evie was living in Santa Monica then, in Femmy DeLyser's house, renting the apartment on the top floor. Have you heard about Femmy yet? Femmy was this crazy Dutch woman, ate vegan, macrobiotic, all that. And she was the birth coach to all these movie stars, including Jane Fonda, and in the eighties she wrote Jane Fonda's pregnancy workout book, which was a big, big bestseller. Anyway, I remember Evie calling me from Femmy's and telling me she'd stopped drinking—you know, bragging. And I was so impressed because she was like Mae. She really loved to drink. Except later I found out she wasn't drinking because she was hooked on coke instead. Yeah, that part she forgot to mention."

Cocaine did bad things to Eve's personality. Chris Blum: "Eve was a hard-core consumer. I couldn't have lasted a week with her. She never ever stopped. And she became moody, difficult. And when Eve was difficult, she was *really* difficult. Eve could be, like, 'Eat shit and die.' " Paul: "Eve started getting crazy with the coke. I would wake up in the morning to her pacing around in circles. She'd say that Erica

169

wasn't doing enough for her, and that she wasn't happy with not having complete access to Vicky. Neither were taking her obsessive calls. I felt sorry for anyone who had to work with her at that point. I mean, the tirades! I remember her calling me and saying, 'I just fired Joan Didion.' Well, obviously Joan didn't work for Eve. What I'm sure happened was that Joan got tired of dealing with Eve's enfant-terrible actions and cut her off. So to save face—although Eve wasn't ever aware of anyone being fed up with her—she said she fired Joan. I started to stay away from her. I couldn't take it."

Cocaine did worse things to Eve's prose. Novelist and screenwriter Henry Bromell: "I met Eve in the summer of '79. Caroline [Thompson, Bromell's girlfriend, soon-to-be wife] and I drove across the country with our dog, Ariel. Vicky Wilson was my editor, too, and she'd given me a couple of Eve's books. I thought Eve was this beautiful, original voice. Completely from L.A. She told great stories. She'd say to me, 'Look at these breasts.' I'd say, 'Nice.' And she'd say, 'Nice? *Nice?* These breasts have conquered the world!' She was so much fun. But she was in a battle with drugs, which was ultimately a losing battle. And the work suffered. Her language was really disintegrating."

The social life that fed Eve's artistic life was now eating it. Inspiration had turned into devastation.

★ ★ ★

Eve submitted her new book, *L.A. Woman* (this is the one with the Morrison-penned song for a title), to Spellman-Silverman and Wilson. Neither was pleased. Says Spellman-Silverman, "Vicky and I read it and we were both, like, 'Hey, wait a minute.' It needed a lot of work. Eve basically said, 'Fuck you, I'll get somebody else to publish it.' And that was the end of our relationship for a while."

L.A. Woman was acquired by Joni Evans, editor in chief of Linden Press, an imprint of Simon & Schuster. Evans: "John Gregory Dunne was one of my writers then. I'd spend a lot of time with him and Joan at their house in Brentwood. John and Joan were crazy about Eve, John particularly. He said, 'Eve is great. You must publish Eve.' So I did. And I'd loved her earlier work, books like *Slow Days, Fast Company*. She handed in *L.A. Woman*, though, and I thought, This is not one of her better efforts. But I couldn't think how to fix it, and she seemed in a hurry."

With *Sex and Rage*, Eve took a step in the wrong direction. With *L.A. Woman* (1982), also a novel, also a roman à clef, also a bildungsroman—L.A. girl artist falls in with a fast crowd, suffers heartache and disillusionment, reinvents herself as a (screen)writer—she took a leap. I hadn't cared much for her first novel/roman à clef/bildungsroman; I cared even less for the second. Do I sound bitter? Disappointed? Spiteful? That's because I am. Really, I'm putting down *L.A. Woman*

more than I mean to here. It isn't Eve at her most inspired, yet there are still wonderful passages. (I can't sit across from Laurie without Eve's description of Ophelia, the Laurie character, running through my head: "big brown eyes and the look of a Russian wolfhound about her when she laughed.") The truth of the matter is, *L.A. Woman* is my bête noir.

During the years I spent toiling away on the *Vanity Fair* piece, I'd occasionally run into someone who'd actually read an Eve Babitz book. And, invariably, this was the Eve Babitz book that had been read. (A case of bad timing. People were starting to hear about Eve in the early eighties because of what she'd done in the mid-to-late seventies. *L.A. Woman* happened to be the book of hers in stores at the moment her reputation caught up with her talent.) Consequently, the person didn't understand why I was carrying on so. I'd argue that you judge a writer by his or her best work, not his or her worst, but it didn't get me anywhere. I could see that the person, behind the mask of polite attentiveness, was unmoved. The cause was lost. I was wasting my breath.

Dave Hickey was one of the first people I interviewed about Eve, and I often think back to a remark he made: "Eve only has one story to tell, but she tells it better than anybody." At the time, I believed this a sage observation and incontestably true. I'd nearly snapped my head off my neck I'd nodded yes yes yes so hard in response. Now I believe the opposite. It's when Eve

is telling *other* stories, not hers, that Eve isn't just at her best but at her most Eve. It's when Eve is using her brains and feelers to interpret the world around her—what it's like to dance at a honky-tonk in Bakersfield with a gentleman grape farmer, for example, or on a lawn in Hollywood with her sister while the Santa Anas blow—that her persona emerges with vividness and specificity and force. Here's when her persona does not emerge with vividness and specificity and force: when her persona *is* her subject, as it is in *Sex and Rage* and again in *L.A. Woman*, at which point her persona becomes simultaneously blurry and cartoonish. In short, if *Sex and Rage* was the beginning of downhill for her, *L.A. Woman* proved that the slide wasn't stopping soon.

And yet, there's something Eve wrote during this period that I absolutely love, *Fiorucci: The Book*,* though it isn't a book really, is really an extended magazine piece—mostly pictures, huge text—and, like a magazine piece, assigned—a publishing house's idea—on the fashion label and chain of shops started by the Italian designer Elio Fiorucci.

* As I mentioned in an earlier section, *Fiorucci* was the very last work of Eve's that I read. I did not have to pay $2,000 for the privilege as I feared I might. In the summer of 2016, Jewish Family Services cleaned Eve's condo. A copy was found. She let me borrow it for an afternoon.

Fiorucci has none of *Slow Days*' depth. But then, it isn't trying to, surface what it's all about, and why risk spoiling so alluring a one by scratching? The opening:

> Fiorucci is the name of a man, the name of a look, the name of a business. A phenomenon. Walking into a Fiorucci store is an event. Milan. New York. London. Boston. Beverly Hills. Tokyo. Rio. Zurich. Hong Kong. Sydney. Fiorucci is Fashion. Fiorucci is flash. Fiorucci stores are the best free show in town. The music pulses; the espresso is free; the neon glows. Even the salespeople are one step beyond—they often wear fiery red crew cuts. But it is, after all is said and done, a store—a store designed to sell clothes. But the difference is all that sex and irony. Anyone who knows anything can see that finally the entire operation is motivated by the very same energy that lights the fire under rock 'n' roll.

Fiorucci is totally off the wall and so minor it almost isn't there, and yet it is, in its way, perfection. A daft delight.

Eve recalls writing it. Sort of. "There was this weird girl and she was always trying to get me to write this book on Fiorucci, and I would say to myself, 'Who is this weird girl and why is she bothering me?' I'd never been interested in Fiorucci. But then I met another girl, Carolyn, and she was the ultimate

sharpie from San Francisco, and she wore Fiorucci. Carolyn wasn't beautiful, but because of the clothes she was beautiful. So I said yes to the weird girl. And the weird publishing house she worked for, Harlin Quist, which published children's books, only they wanted to start publishing adult books, sent me to Milan. I had shoes when I got on the plane but not when I got off. I guess I lost them. The woman I was staying with gave me her boots. They were suede. I wore them every day I was in Italy. Those suede boots with the same baby-blue skirt and black sweater because I guess I forgot to pack a suitcase."

Eve found herself once again in need of an agent. Enter Nan Blitman. "I already knew Eve through Annie [Leibovitz]. I was a writer when Annie and I first met in 1975. Annie had taken the pictures for a story I'd done for *Ms.* magazine. In those days, Annie was driving—not flying—back and forth from San Francisco to L.A. She amassed a tremendous number of speeding tickets. I'd gone to law school, so I helped her out with the tickets, and then with her contracts with *Rolling Stone*. Before I knew it, I was an entertainment lawyer. And, when Eve left Erica, she asked me to represent her."

The advance Blitman secured Eve for *L.A. Woman* was substantial. It was also insufficient. (For a cheap thrill,

cocaine is expensive.) Eve toyed with the notion of writing a screenplay. Says Bromell, "Screenplays were a kind of distraction for Eve, a get-rich-quick scheme. The idea was that she'd strike it big and then go back to doing what she wanted to do. Her screenplays would finance her books."

And her habit, getting more habitual by the day. Blitman: "Eve was hired by Don Henley and Irving Azoff, the Eagles' manager, to write a screenplay about the rise of the Eagles. She never really wanted to do it. And she didn't. I mean, she sort of did. She turned something in, but it wasn't what the Eagles wanted. They wanted the screenplay to be about them, and she made it about a groupie, about herself, basically. So she had a hard time getting her money. And she really needed it, probably because she owed a drug dealer or something. Finally she called up Azoff and said to his secretary, 'If I don't get paid today, I'm going to kill myself. I've already bought a body bag and I'm going to kill myself.' Well, Azoff paid."

A brief note on Eve's attitude of cheerful indifference toward the movies, and during a period, the late sixties through the end of the seventies, in which movies were driving everybody else mad with desire. (Wrote Pauline Kael in her introduction to *Reeling*, her book of collected *New Yorker* reviews cov-

ering 1972–75, "A few decades hence, these years may . . . be the closest our movies have come to the tangled, bitter flowering of American letters in the early 1850s.") The attitude was genuine. Not a put-on or a defense mechanism, a way of inoculating herself against rejection. My proof, definitive: it wasn't until the sixth year of our friendship that I learned she'd appeared in one of the greatest films ever made in this country.

The day before, Mirandi had emailed me a bunch of photos from an old scrapbook of Eve's. In one was a man I didn't recognize. I called Eve, described him.

"That sounds like Mario," she said.

"Mario who?"

"Puzo."

After a confused pause, I said, "The guy who wrote the gangster book? *The Godfather?*"

"Mm-hmm. Mario was a friend of Joseph Heller's. And when the studio bought *The Godfather*, Joe came to Hollywood with Mario as Mario's bodyguard. He wanted to make sure Mario got a good deal."

"*The Godfather* is my dad's favorite movie," I said, more to myself than her. "He quotes it a lot. It's actually kind of irritating."

"I was in it, you know."

After another confused pause, I said, "In *The Godfather?*

The Godfather The Godfather? Best Picture of nineteen-seventy-whatever? Directed by Francis Ford Coppola, starring Marlon Brando? That *The Godfather?*"

"Yes. Well, no. Not the first one, the second one. As an extra. Just one scene."

"Because of Mario Puzo?"

"No, because of Fred Roos. Fred was Francis's casting director and producer, and sometimes my boyfriend. He must've been my boyfriend when Francis was filming." All at once her voice changed, got sly. "You know those chocolate-covered strawberries you sent me?"

I'd ordered her a box from Amazon the week before for Christmas. "Yeah?"

"They were good."

She was quiet for a while, letting the subject float. I didn't bite, though. Instead I said, "Which scene?"

She sighed. I was being difficult. "The Senate committee. It looked like it was filmed in Washington, but it was filmed in Hollywood, right on the studio lot. They had me in this horrible jacket and it was hot, so I took it off. They had to reshoot the whole scene because the shirt I was wearing was polka-dot and polka dots ruin everything."

It's always a cinch to get off the phone with Eve. I say the words, "Evie, I've got to go," I *think* the words, "Evie, I've got to go," and she's already hung up. Not angry, just

on to the next thing. This time was no different. I turned my cell to vibrate, clicked the iTunes icon on my computer, and downloaded *The Godfather, Part II*, started watching. I didn't believe I'd see her. I figured she'd either gotten *The Godfather* mixed up with a lesser-known gangster picture on which she'd worked as an extra; or that she had worked as an extra on *The Godfather*, but hadn't made it into the finished film; or that she had made it into the finished film, but it was in some enormous crowd scene where she was impossible to pick out—one among hundreds.

And then, there she was, in front of the Senate committee. Or, rather, just off to the side of the Senate committee. I leaned forward in my chair, my face practically touching the screen. She wore a dark jacket, a polka-dot blouse visible underneath, and was sitting at the table to the right of Al Pacino and Robert Duvall's, one of the few women, other than Diane Keaton, in the scene. She appeared bored throughout, though she did manage an expression of mild interest during Pacino's heated back-and-forth with a bald senator whose name I didn't catch.

I picked up the landline—better reception—and called her, punching in the numbers so fast I got them wrong and had to punch them in again.

"I told you," she said, after I'd reported back on what I'd found.

Doing my best not to sound defensive, "I believed you."

"No, you didn't."

"But I—"

"It's okay, my feelings aren't hurt."

I waited a beat before trying to jolt the conversation onto a different track. "Your second Senate committee, though. Quite a coincidence."

"What do you mean?"

"Remember? In the sixties? You told Teddy Kennedy your grandmother was a pothead?"

"I didn't tell Teddy Kennedy that."

"You did. I'm sure you did."

"No. It was the *New York Times* reporter." She cleared her throat to indicate that I'd do well to mull over this distinction for a bit. "That's who I told."

"Sorry, right."

"You know"—her tone grew thoughtful—"both my grandmothers were still alive when that *Times* piece ran."

"Did you get disinherited?"

"No, they weren't mad. Each said it was the other grandmother who was high."

"Ahh."

In the silence that followed I could hear her shift the receiver from one ear to the other. "So, about those chocolate-covered strawberries. I really liked them. Hint, hint."

I laughed. "All right, Evie, I'll send another box."

"Good. The same as before. Only instead of strawberries, cherries. And more of them."

"How about I send two boxes?"

"Yes, that would be fine," she said, suddenly businesslike. "One cherry, one strawberry."

"You got it," I said. As usual, I bid my farewell to her dial tone.

By 1981, that body bag was looking more and more like it was going to come in handy. Paul: "Eve had blown her *L.A. Woman* advance on coke, fucked up her nose. She called me, begged me to come over. I drove all the way to Femmy's place in Santa Monica. When I walked into Eve's room, I couldn't believe what I saw. There wasn't an inch of floor not covered in bloody Kleenex. The cats were running around high. I boxed Eve up and took her back to my Western Avenue apartment, and she was quite happy easing herself into a long, languid bubble bath. My mind was still trying to get over what it had seen when Eve got out of the tub and insisted that I fuck her. I was dumbfounded. She looked like a Dalmatian she had so many bruises covering her body. I told her to go to bed, alone, and she got really pissed off and started to scream and pummel me. I took her by the shoulders, shook her, and forced her to turn around and face a full-length mir-

ror. I cried and told her that she was breaking the hearts of those of us that loved her by letting herself get so goddamned low with her life, and did she want to die?"

Paul's words seemed to reach Eve, but he wasn't convinced he'd truly broken through, so he called Mae. Mirandi was grateful he did: "Paul had the good sense to rat out Evie to Mother. Mother said to her, 'This is not working. You've got to come home.' Eve moved into Wilton Place with Mother and Dad. There was a little garage apartment in back of the house, and that's where she lived. She didn't stop with the coke, though. And then, when Dad went into the hospital with a bacterial infection, she started drinking again. So she was doing coke and drinking, taking Valium, too. I think she was using so hard because she was upset about Dad and not dealing with it."

Sol died on February 18, 1982, of a combination of congestive heart failure and endocarditis. Paul: "Art [Pepper] and I were standing in Sol's bedroom before he died. Downstairs Mae was cooking up a storm, and Eve came in and led us over to his bed and said, 'Talk to Daddy.' I looked at Art, and we both nodded and sat down awkwardly. Sol was staring straight ahead and clacking his teeth. Art leaned over and said into Sol's ear, 'Don't worry, Sol. Everything will be all right and you'll be back.' I thought it was wonderful of Art to encourage Sol to accept the Great Whatever, and I noted that Art had so much more time to live than Sol. It shocked me when he didn't [Art

died four months later, on June 15, at fifty-six, of a stroke]."
Mirandi: " 'Eighty-two was a big year for the family. First Dad
went, and then Art, and then Evie got into AA."

If the seventies were the party, the eighties were the hangover.
Says Eve, "We were all addicted to everything. If you took
cocaine, you could drink longer and insult people more bril-
liantly. But I knew I was doomed if I didn't get a new idea
of glamour. And, on top of that, there was a review of *L.A.
Woman* in the *Times*, a horrible hideous pan by that P.J. per-
son [P. J. O'Rourke, "Not a Bad Girl but a Dull One," *New
York Times*, May 2, 1982]. See, I was sure I'd written a book so
wonderful I'd never have to do another thing in my life, only
apparently I hadn't. Which meant I needed to clean up my act.
And, anyway, AA was the social scene of all time. All of L.A.
was there. And the last straw was different for everybody. My
friend Connie said she had to fuck two midgets before she
knew it was time to join. It was great."

So great, in fact, that Eve encouraged non-substance-
abusers to attend meetings, just for kicks. Eve's friend, writer
Sarah Kernochan: "The way Eve got me to go to AA—and I
wasn't an alcoholic—was by telling me, 'The best stories are
in AA. You'll hear the best stories.' And the stories *were* the
best. A lot of people in Los Angeles are performers, and the

zeal with which they talked about their high highs and low lows was enthralling."*

This isn't to say Eve took her sobriety lightly. Recalls Michael Elias, "Eve had the best of the AA ethic. If anyone had a problem, you could send them to Eve and she'd jump on it. She could be the most generous, kind person."

The eighties were a mostly fallow decade for Eve. Staying on the straight and narrow took up a good deal of her emotional energy. There was, too, the worry that she didn't just want alcohol and drugs, she needed alcohol and drugs, to have fun, sure, but also to create. And she spent much of this period treading water—not writing, not not writing. She and Elias collaborated on a couple of screenplays. Elias: "One became a French movie. I can't think of the title. Whatever *Send in the Violins* translates to in French [*Envoyez les violons*]. It was about an American in Paris. His wife leaves him and he gets

* A stray detail I can't resist including: At a meeting, Eve introduced Kerno-chan to Steve Reuther, an ex–William Morris agent who'd hit bottom and was in the process of bouncing back. (Says Kernochan, "Steve was really handsome, so of course Eve noticed him.") Reuther hired Kernochan to do a rewrite on a picture he was associate producing. It led to Kernochan's first screen credit and the most famous soft-core porn of my youth, *9½ Weeks* (1986). I remember being eight years old and in my suburban video store and trying to shake my mom, leave her in the Family section with my brother, so I could look at the poster—Kim Basinger in a white slip, standing next to a window, razor slits of light bleeding through the closed venetian blinds—contemplate its tagline— "They broke every rule"—in private.

back to life by playing the flute. They ruined it by making it a Frenchman in Paris."

Eve wasn't attempting books, though she did blurb one, the debut of a Valley Boy, a mere sixteen when he completed the first draft. "This is the novel your mother warned you about," said Eve of *Less Than Zero* (1985), and went on to compare its writer, Bret Easton Ellis, to an old flame. ("Jim Morrison would be proud.") That Eve was an early booster of *Less Than Zero*, about a disaffected and dissolute L.A. teenager named Clay and his disaffected and dissolute L.A.-teenager friends, is ironic since *Less Than Zero* was, as Ellis freely admits, "such an homage" to *Play It as It Lays*. Ellis: "Did I want a blurb from Joan Didion? Are you kidding? I hoped she'd never even see the book."

Though Ellis grew up close by, just over the Hollywood Hills in Sherman Oaks, he and Eve didn't meet until after *Less Than Zero* was published. Recalls Ellis:

It was a dinner with my editor, Bob Asahina, who was a big fan of hers. My memory of Eve in the semidarkness of Ports in 1985 is that she was very buxom, very flirtatious, great smile. She wasn't a ditzy Southern California girl. She was almost a parody of that idea. And then, through the parody, this no-nonsense intelligence would come out. She laughed a lot and just

seemed really friendly and was all over me in this nice way. I knew Joan through her daughter, Quintana, who went to Bennington with me. And, let me tell you, sitting around with Joan Didion is no picnic. It's the most awkward thing in life. Eve, though, was delightful, so warm and accessible. It's funny to be talking about this now because I just reread *Slow Days, Fast Company*. The first time I read it I was in high school. I liked it when I was fifteen, sixteen, but it certainly wasn't speaking to me in the way that *Play It as It Lays* was speaking to me, in the way that punk was speaking to me. But reading *Slow Days, Fast Company* again in my fifties was a revelation, and kind of breathtaking. It's got this friendly, wandering, expansive, open-to-anything vibe that's the polar opposite of *Play It as It Lays*, which is very locked and rigid. Eve is doing something so difficult—comedy is hard, harder than drama. And she sustains that comic mood and tone. But because her mood and tone is comic, she runs the risk of having her work seem lighter, airier, fruitier than it actually is. What she achieves in *Slow Days, Fast Company* I appreciate more now that I'm older. And I consider it one of my favorite books ever about L.A.

★　　★　　★

At AA, alcohol and drugs were, obviously, off the table. Not men, though. And it was at a meeting that Eve encountered "the Last Rock Star," Warren Zevon. Says Eve, "Warren wasn't actually in AA, but he should have been. I guess he came that night because somebody was trying to get him to go. He was addicted to heroin. Heroin, Scotch, and the pork at Musso's." To something else, too, but it would take a while before she clued in to that one.

Eve moved out of Mae's, into Zevon's. Says Caroline Thompson, "I ran into Eve outside a thrift shop. She'd just bought a nurse's uniform. It had a nametag on it—Trish, Trudy, something like that. She held it up to me and said, 'For fun and games with Warren.' "

Alas, it wasn't always Eve with whom Zevon was having his fun, playing his games. (Now we get to addiction #4.) Eve: "Warren was so wonderful and funny, but he almost did me in. If he went downstairs in an elevator, he'd come back up with a woman. He couldn't help himself. The only way I could stand to be with him was by going to Ashtanga yoga class every day. Ashtanga yoga is so horrible to do that when you stop doing it, you feel like you're floating on air. But after a while even that didn't work."

Eve moved out of Zevon's, back into Mae's.

★ ★ ★

In the early nineties Eve stirred again creatively, striking up a relationship with *Esquire* magazine. Recalls editor Bill Tonelli, "Terry McDonell [*Esquire*'s editor in chief] put me in touch with Eve. She did that Jim Morrison profile for us, and it was great and people loved it, and I wanted her to do more. It never occurred to me to assign her anything. I didn't feel like you could do that with Eve. I thought, What else has she lived through that she could write up?" The Duchamp photo for one. The Manson killings for another. She would also cover surfer-businessmen, the Chateau Marmont, the James Dean–looking actors on the popular teen soap *Beverly Hills, 90210*, and other L.A.-ish topics.

The *Esquire* stint gave her confidence, plus the urge to stretch her legs, attempt something longer. In 1993, she returned not only to Spellman-Silverman and Wilson, but also to form, when she published the collection *Black Swans*. Says Mirandi, "That was big for Eve. She really didn't know if she'd be able to write a book sober." With *Black Swans*, she proved she could. In it are pieces about Rodeo Drive, Hollywood's centenary, a friend's death from AIDS, her romance with Dan Wakefield, jealousy. *Black Swans* isn't up to *Slow Days*, doesn't have that breadth or magic. It's a good, serious work, though, and a marked improvement over *Sex and Rage*, certainly over *L.A. Woman*.

A year later, Eve noticed that something funny was going on with Mae. "It was right around the time that O. J. Simp-

son killed his wife. My mother came into the room when the freeway chase was on TV. 'What's this, darling?' she asked. I explained what was going on and she went blank halfway through." Alzheimer's, early stages.

Another change: mother and daughter now had a roommate. Eve's old Hollywood High pal Sally. Says Mirandi, "Sally had a rough time of it after high school. The acting thing never worked out. She was a hooker on Hollywood Boulevard, with pimps and all that. And she was a junkie. Once Evie got straight, she went and found Sally, who was also trying to get herself straight and was in this fleabag dive of a sobriety house. Eve took her out of there and stuck her upstairs at Wilton Place. Eventually Sally went back to school and paid for it by doing phone sex. She was good at it—those old acting skills. She wanted to become a teacher, which she did." The arrangement lasted for the rest of the decade.

An obsession that began for Eve in the eighties when she first saw *Dirty Dancing*—"I was in love with Patrick Swayze for years, but I tried to stay out of his way and never to meet him because I knew if I did, he'd want to talk about yogurt or some weird dietary restriction"—grew in the nineties. Says artist Mick Haggerty, "I was with Eve when she got into tango, and that whole L.A. tango-dancing scene. To me it was ghastly, about as crude and sad and frightening as possible. But not to Eve. She was having the time of her life. She

projected enormous amounts of romance and fantasy onto things. She was an artist doing what she did. Her personal viewpoint was just so heightened. We'd be at some gruesome studio in Glendale or someplace, and I'd look at her face, and she was just entranced."

In fact, Eve was working on a book about tango when she dropped that match.

It happened on April 13, 1997, a Sunday, late morning, warm even for L.A. Eve, Mirandi, Laurie, Laurie's mother, Tiby, and Mae, now deep into both Alzheimer's and alcoholism, were having brunch at a restaurant in Pasadena called the Raymond. They were celebrating the birthdays of Mirandi and Tiby, only a week apart. When the meal was over, Eve got behind the wheel of the '68 VW Bug that Steve Martin had given her all those years ago. She took out a cigar. She attempted to light it. She failed.

Mirandi: "She was wearing an Indian skirt, very, very thin, and it burned up like tissue paper. Her panty hose melted into the skin of her legs. She stopped the car and rolled on the grass and actually set the grass on fire. But she did manage to put herself out. Then she got back into the car and drove to Wilton Place. I was there because I'd taken Mother home. When she pulled into the driveway, I was talking to Mother's neighbor,

Nancy Beyda. I saw Eve, and I was aghast. She was naked from the waist down, and the lower half of her was just this awful charred orange. She was clutching a wool sweater to her crotch, which, if you can believe it, is what saved her crotch. Good wool is hard to burn. 'It's okay,' she said to me. 'I'll put some aloe on it. I can still go dancing.' I guess she was supposed to have some kind of date that night with Paul. I followed her into the house and called an ambulance."

Eve spent six weeks in the ICU, several months after that in a rehab hospital. She survived two twelve-hour operations in which the skin from her scalp, shoulders, back, and arms was grafted onto her midsection, groin, and legs; the removal of the hundreds of staples and stitches that were keeping those grafts in place; hallucinations from ICU-induced psychosis; bedsores that had to be cut off with a knife; relearning to walk. And all while kicking smoking. The doctors tried to help her cope with the withdrawal symptoms by giving her a nicotine patch, but they couldn't because there was nowhere to put it, not a single inch of undamaged skin. Eve: "If you have third-degree burns, your nerve endings are gone, but I still screamed in pain. I was always screaming in pain, morning and night, drugs or no drugs. If I sat up in my bed, it felt like I was sitting on crushed glass."

It wasn't the first time that Eve had set herself on fire. Paul: "I went to spend the night with Eve when she first moved into

that garage apartment behind her folks' house at Wilton Place. I got there and her bed was a bed of charcoal. She'd thrown a fur coat I'd given her over a space heater at the base of the bed and it caught fire. She would have died because she was dead drunk, but Mae saw it or smelled it and threw water on it, and Eve was okay. I was horrified by the bed. Eve was pissed I'd noticed. That's the fire that should have gotten her. She was loaded on coke and drinking to come down from the coke. But the fire that actually *did* get her, the fire she started with that ridiculous cigar—that was just Eve being her inattentive, absentminded, accident-prone self. She didn't even smoke cigars. That was Mae."

I've got to break in here, say something. If Eve were my character instead of my subject, she wouldn't have set herself on fire once, never mind twice. She plays with fire metaphorically and then goes up in flames literally? Too on-the-nose, such plot contrivance strictly for hacks. I mean, how cornball can you get? And, yet, that's exactly what happened. God, that old sentimentalist, just couldn't resist.

Eve was, of course, without insurance. Her medical bills ran to half a million dollars. Six months after the accident, to raise money, Mirandi, Laurie, and Paul, along with Michael Elias, Caroline Thompson, Nancy Beyda, and artist Lad-

die John Dill—Friends of Eve, the group called itself—arranged a benefit at the Chateau Marmont. An auction was staged with works donated by, among others, Ed Ruscha, Kenny Price, Larry Bell, Billy Al Bengston, John Baldessari, and Dennis Hopper. Even Jack Nicholson, who knew Eve from Barney's—"Jack and I didn't have sex, oh, but I loved him!"—helped, sending a white cowboy hat, bought by artist Ed Moses. Steve Martin showed up. So did Jackson Browne and Don Henley, Henley's girlfriend, actress Lois Chiles. And Eve, just out of the hospital, was able to make an appearance, accepting a kiss on the hand from Ahmet Ertegun. Says Eve, "Ahmet was carrying a cane that had belonged to Victor Hugo. One of his French girlfriends gave it to him."

Prior to the benefit, Friends of Eve had sent out a letter soliciting donations through the Allisa Ann Ruch Burn Foundation. That's what brought in the big money. (The Foundation was tax-exempt.) Laurie reported back to Eve, still at County General, told her how Steve Martin and Harrison Ford had kicked in $50,000 apiece. A prostrate Eve raised her head. Through dry, cracked lips she croaked out, "Blow jobs," before collapsing on the pillow.

A year and a half after the cigar, in 1999, Eve's tango book, the slight *Two by Two* (Simon & Schuster again), came out. But

other than the final chapter, *Two by Two* was written before that fateful day in April. Says Mirandi, "Every time Eve tried to write, she kept going back to the fire. I suggested she write about it, just get it all out, and then see if she could write anything else. It didn't seem like she could, though. Getting burned tore apart her breezy attitude."

Mirandi, on this last point, is, I think, both on the money and off the mark. In life, Eve's breezy attitude remained intact, in spite of the trauma she endured. As evidence, I'll cite the mermaid comment. I'll cite the set of business cards she had printed up after she got out of the hospital:

Eve Babitz

Better red than dead

And I'll cite this anecdote of Laurie's: "When we finally took Eve home, she looked at us and said, 'People think this will make me a better person. It won't.'" Eve was telling her family, in so many words, that she would not allow the catastrophe that had befallen her and changed her so utterly externally to change her a whit internally, because even to change for the better would be to change for the worse. It was a promise, and a defiant one, and so far she's kept it.

In Eve's work, however, her breezy attitude met a harsher fate. I read the forty or so unpublished pages she wrote about

the fire in the months immediately following her release from the hospital. It's a collection of false starts. She begins to tell the story. Stops. Begins to tell it again. Stops. Begins to tell it yet again. Stops. And so on and so forth. She was unable, try as she might, to turn what happened to her into a cohesive narrative, or to even get to the narrative's end, never mind find a tone or determine a theme. Was unable, in short, to master it, stayed its victim. My guess as to why: Eve has always maintained her aesthetic distance, regardless of how crazy things got, how drug-addled or upsetting or chaotic. She looked at life, its complications and unhappinesses, through an artistic prism. The fire melted that artistic prism. Therefore she could no longer function as an artist. It's that simple. It's that sad.

In good news, Eve could afford not to write. There was the money from Friends of Eve and the Chateau benefit. And when Mae died in 2003, and the Wilton Place house was sold, Eve was persuaded (read: begged, hectored, cajoled) to use the $225,000 she received to buy the condo on G— Street. And, thanks to a fast-thinking Mirandi, she had coming, as well, a small annuity. Says Mirandi, "I'd saved the burnt-up waistband of her skirt, pulled it right out of the trash. And Michael Elias showed it to a friend of his who just happened to be Larry Feldman, the lawyer who'd gotten Michael Jackson

off for molesting that boy [in fact, Feldman represented the boy, winning a twenty-five-million-dollar out-of-court settlement against Jackson in 1993]. Eve's case was ridiculous—she didn't have one. There's no warning on clothes for adults that says, 'This garment may be flammable.' Eve hadn't even bought the skirt at a store. She'd bought it at a Goodwill. But the clothing company was scared to death of Feldman, so they settled for $700,000. $450,000 of that went to medical bills and legal bills. Eve was given a choice as to what to do with the remaining $250,000. She could either take it as a lump sum, or get paid two thousand a month for the rest of her life. She wanted the lump sum, but I was able to convince her that the two-thousand-a-month was a better deal for her." And then there were people like Michael Elias, Caroline Thompson, Steve Martin, Ed and Paul Ruscha, who could be relied on to pitch in from time to time.

Not that there's much need. Eve lives cheaply, quietly, no computer and, as of a few years ago, no TV either. (She was yielding to the temptation of the Home Shopping Network too frequently.) Just a radio, portable, with a huge antenna, always tuned in to KEIB or KRLA, Los Angeles's conservative talk stations. Says Mirandi, "Eve started getting into conservatism sometime after 9/11 with Dennis Prager and his show. Dennis is Jewish, from Brooklyn, with a voice exactly like Dad's. Then it was funny guys like Dennis Miller and Larry Elder. I think part

of it was that she liked the male company." Her only excursions are her morning strolls to the Farmers' Market, her Sunday AA meetings, her Saturday lunches with Mirandi and Mirandi's husband, Alan, Laurie or Dickie Davis occasionally joining.

The phone still rings, though not as often as it used to. Eve's friends are mainly artists and writers, and artists and writers tend toward liberalism, as she herself once did if never quite wholeheartedly (she'd quote this maxim of her mother's, "I don't know anything about politics—or rather I know too much to care"), and are therefore uneager to discuss whether or not Israeli ambassador Danny Danon has the sexiest sneer since Jim Morrison, or listen to her express the desire to possess a blouse "the same shade of blue as Melania Trump's eyes." But I'll discuss, and I'll listen. Or at least I'll stay on the line until she exhausts herself on these topics, after which she'll let me guide her to ones I find more congenial. Her growl scares off other people. Not me, though. Not anymore.

My *Vanity Fair* piece helped, too, by renewing interest in her. Interest would have renewed no matter what—her story is so good, her books are even better—but the piece got it going. *Eve's Hollywood* was reissued in October 2015; *Slow Days, Fast Company* ten months later. (Eve has used some of the extra cash to hire a cleaning woman. Her condo isn't spick-and-span by any stretch. It is inhabitable now, though, the wall-to-wall junk cleared out.) Also in 2015, *Eve's*

Hollywood, *Slow Days*, *Sex and Rage*, and *L.A. Woman* were optioned through Sony Pictures TV's TriStar Television. Eve, the rare local girl who never dreamed silver-screen dreams, might wind up there anyway, irony of ironies.

The Little Sister

★

I first met Mirandi the day after I first met Eve. I took a cab from my hotel in West Hollywood to her condo in San Pedro, a working-class port town on the southern end of the Palos Verdes Peninsula. The condo was in a gated community, the entrance difficult to find, and she was standing on the sidewalk outside, hand raised in a wave, a pretty, open-faced woman, younger looking than her sixty-odd years. She wore eyeglasses, the frames of which, I noticed, were the same as Eve's but not the color, and a thin gold chain around her neck with an AA pendant on it. She helped me with my bag as I got out of the cab, her manner an appealing mixture of shyness and friendliness. We'd spoken on the phone several times at length, so hugged rather than shook hands. When I told her how quickly Eve had blown me off after lunch, she laughed, mock-sighed. While we waited for the driver to print a receipt, she pointed out Terminal Island prison, where Art Pepper served a stretch

for narcotics possession in the mid-fifties, a few other San Pedro sights. Then she led me through a maze of little walkways, cool and surrounded by greenery, to her front door. On the opposite side of it was her husband, Alan, Japanese-American, a pharmacist, and very warm.

Alan retreated discreetly to the bedroom to watch a baseball game as Mirandi and I settled in the living room, bright and airy, the shelves filled with books, Eve's, of course, and *Straight Life*, Art Pepper's memoir, co-written with Laurie, along with various psychology texts. (Mirandi has been a cognitive-behavioral therapist specializing in addiction and anxiety disorders for the past twenty-plus years.) The walls were covered in family photographs and Mae's drawings. Advertisements, too, for rock concerts Mirandi had produced in the seventies and eighties.

Mirandi and Alan have two cats, a boy and a girl, but only the boy made an appearance that afternoon, Blackie, big when you look at him, small when you pick him up—all fur. He drowsed on the floor in a patch of sunlight while Mirandi and I drank tea and talked, occasionally reached down to stroke his silky ears. My morning sickness had gotten worse during the cab ride. I confessed to Mirandi what was happening, even though you're not supposed to say anything until the end of the first trimester, because I wasn't eating the cookies she'd laid out and didn't want to seem unappreciative, and because her demeanor was so sympathetic. The impression she gave

that day and every day since was of extreme sweetness: sweet face, sweet voice, sweet nature.

Now Eve, Eve's great, but sweet she isn't. It's not that she's abrasive or rude—she's too thoroughly a blithesome California girl to be either. It's that in her cheerful, un-mean way, she doesn't give a fuck. She really and truly doesn't, and never did. How many people can you say that about? Virtually none. And women? Closer to actually none. She's a genuine bohemian, and thus a genuine renegade. A genuine aristocrat, as well. A queen, no matter that she's spent much of her life living in squalor, or a hair's breadth from. Even the squalor is part of the queenliness. Queens don't Ty-D-Bol the toilet, don't wipe down the stove after each use or vacuum under the bed ever, don't recycle. There's something unfathomable about Eve. She's too wild, too radical, too singular. And then there's this: for all her apparent sociability, the profusion of friends and boyfriends, of dinner parties and house parties and party parties, shows and aftershows, Eve is, essentially, solitary and perfectly self-sufficient. (Self-sufficient in an emotional sense. In a practical sense, God, no. She's as helpless as a newborn, the helplessness also part of the queenliness, since a queen wouldn't stoop to take care of herself. What, after all, are servants for? And Eve has a talent for turning everybody into one of those.) Stated plainly, Eve is impenetrable. There's simply no way in.

Or is there?

Mirandi, born Miriam, on April 18, 1946, shares with Eve family, genetics, and a past. An extended one. (The sisters' lives ran on parallel tracks all the way up until early middle age.) So Mirandi can be viewed as another version of Eve, Eve's alter ego—sane and commonsensical, present and tangible, a solid citizen who believes there are such things as too much and too far—as Eve is Mirandi's alter id. Mirandi is simultaneously a point of comparison to Eve and a point of contrast, as well as a, as *the*, point of entry. Which is why Mirandi's story can be viewed as another version of Eve's story, Eve's story told from a different angle and perspective.

Now, listen to Eve and you'll think her and Mirandi's childhood was out of a fairy tale. Their family life was conducted not just lovingly and intelligently, but gloriously. Their parents, the brilliant Sol and the magnetic Mae, were what an imaginative, sensitive kid born to parents who were neither might conjure. And their house, which looked like any other from the outside—a typical Southern California two-story Craftsman—was, on the inside, something rare and wondrous: the lemons Mae laid out instead of flowers scenting the air; the latest compositions by Schoenberg or Stravinsky, Sol writing the violin fingering, scenting the air, too; plus, for

fairy godparents, Igor and Vera Stravinsky, better even than actual fairy godparents because the Stravinskys' magic wasn't the hocus-pocus kind. It was a place where nothing bad could happen. Was, in a word, charmed.

Listen to Mirandi and you'll also think their childhood was out of a fairy tale. Only bad things happen all the time in fairy tales, which, as every little boy and girl knows, are really horror stories in disguise. To be clear, Mirandi felt about Sol and Mae as Eve did, speaks of them even now with an admiration that borders on adoration. And the privilege of growing up among such accomplished artists still leaves her breathless. Yet, for her, 1970 Cheremoya Avenue wasn't all light and fragrance and frolic. Darkness and stench and fear dwelt there as well. Sol and Mae, while doting parents, weren't always mindful ones. They could get distracted—by each other, by their art, by the art of their lives. This was less of a problem for Eve, spunky by nature, and fiercely self-preoccupied. But Mirandi's personality was softer, gentler, more dependent. She needed protection in a way that Eve didn't.

Needed protection, in fact, from Eve. Dan Wakefield: "Did Eve tell you what she said when Sol and Mae brought Mirandi home from the hospital? 'Take her back!' " Sol and Mae laughed at Eve's joke, except it wasn't one. A few months later, Eve would throw an electric heater into Mirandi's crib. (As you can see, fire is, for Eve, an abiding theme.) At the

last second, she called for Mae, and Mirandi was saved, but Mirandi's left hand was badly burned, requiring extensive plastic surgery. Wrote Eve, "To this day I can remember how surprised I was when I realized that she was actually on fire and that it hurt and that I hadn't meant to hurt her, I'd only meant to dispose of her permanently." Which Eve never quite succeeded in doing, though she did take several more cracks at it. As a girl, Mirandi would be forced to endure fly spray in the eyes, a knitting needle in the ear, a boulder dropped from on high and missing her skull by mere inches, not to mention cruelties of the psychological sort. Recalls Laurie, "When I'd come over, Evie would pull me into her room. She'd slam the door in Mirandi's face. And Mirandi was darling. She looked just like a baby animal in a Disney cartoon—big-eyed and fawnlike."

Eve's murderous impulses toward Mirandi would operate less urgently over the years. She'd even express misgivings about them: "I try not to imagine what would have happened if I hadn't changed my mind and gotten my parents in time. Setting your own sister's crib on fire is a hard one to forgive yourself for." And, in her way, she'd atone. When the girls were teenagers, living with Sol and Mae in Paris, Eve talked Mirandi into coming with her to see trumpeter Chet Baker, a favorite of Brian Hutton's. ("All of Brian's friends were jazz musicians or junkies or actors or cat burglars. He absolutely worshipped Chet.") The club was in a dicey section of town. Mirandi: "The show

ended late—at eleven or midnight. We were on the rue de la Huchette, and these drunk French sailors were walking toward us. They linked hands and charged. Eve skirted around them, but they pushed me against the wall. Eve hit and punched them and screamed, 'You leave my sister alone!,' until they backed off. Then she grabbed my hand and we got out of there."

In fairy tales, princesses and monsters abound. Mirandi, her aura so like that of the former—delicate, tender, pure of heart—had to contend with more than her share of the latter, Eve not the only she faced, Eve not even the only she faced in the house. Says Mirandi, "We had a gardener. Mr. Sorenson. He lived in a shed out back. Oh, Mr. Sorenson." Laurie: "I never knew what Sorenson was doing there. Well, I did. Sol was a musician. He couldn't risk his hands. Art was the same way. Mae needed a man around the house. So she went to skid row."

Sorenson, dirty, derelict, alcoholic, without family or friends, embodies so many clichés about men who prey on children that he's a near-allegorical figure. When Mirandi was five, he started coming to her room on Saturday nights, invading first her ears—"He wore clogs, I could hear the sound they made on the floor"—then her nose—"He always smelled like apricot brandy"—then her doorway, where he would stand and masturbate—"I was too young to know what he was doing, but that's what he was doing." When she was seven, and taking zither lessons from him in his shed, he forced her to perform oral

sex on him, this after failing to rape a neighbor boy in her presence. "Mr. Sorenson said he'd put one of my kittens into a sack and beat it to death with his shovel if I told anybody, so I didn't. Not even Mother." (That Mirandi still refers to her abuser by his honorific, as if he were the adult and worthy of respect, and she a little girl, minding her manners and eager to please, is, for me, the most heartbreaking detail in a heartbreaking account.)

Fortunately, Mirandi, in addition to being a waif and imperiled, was also a plucky American kid. She kept her mouth shut around Mae about what Sorenson was doing to her, but she did tell Mae she hated him, and Mae, baffled, let her quit the lessons, which got her out of his shed and clutches. And she would, eventually, confess her secret to her best friend, Janie Corey, who lived across the street. The Coreys' house offered precious escape. Says Mirandi, "All that fabulous stuff was going on at my house, but I was happiest not there. Evie called me the white sheep of the family, and she was right! I was like some sort of changeling. I arranged my room, kept track of my allowance. The Coreys were a more conventional family than ours. I tried to move in with them at one point. Evie was treating me miserably, and I thought, If you hate me so much, I'll leave. I thought I could live in Janie's closet."

A source of consolation to Mirandi: though she may have been on the outside at home, she was in the thick of things everyplace else. "I loved to be assimilated, in the middle of the

pack. I really loved school. I felt safe there and in control. I excelled. And I had a million friends." It's from Mirandi that I learn Eve did not, had difficulty, in fact, fitting in. Which wasn't the impression of Eve's younger years that I'd received from her books. From *Sex and Rage*: "It was an easy life, growing up by the beautiful sea with her tan sister, her beautiful mother and black-curly-hair genius father."

Eve's popularity as an adult would be vast, terrific, legendary. As a kid, however, she was, according to Mirandi, a loner and a four-eyes and something of a misfit, prone to mood swings and bursts of temper, head in the clouds or a book, a little klutzy. Says Mirandi, "Evie hung around more with our parents' friends than with people her own age. I had these gigantic birthday parties—my entire class would be at our house. Evie never did. She was constantly reading. I mean, she'd walk reading. She loved, loved, loved the *Arabian Nights*, which is, I think, why she was so crazy about Hollywood High and Valentino and the Sheik, and, later on, Ahmet Ertegun—'the Turk' was her nickname for Ahmet. Then, in junior high, it was Colette she was obsessed by. Scheherazade and Colette, those were her models. And she was extraordinarily nearsighted. Plus, whatever we used to call ADHD [attention deficit/hyperactivity disorder], she had that, too. So she had a tough time connecting. The situation changed a bit when she went through

puberty, and socially things picked up for her then because she had friends and they were good ones. She was thirteen or fourteen when her breasts came in. By fifteen she was built to the walls. That gave her power. I remember her saying to one of my little friends, 'You'—of course she didn't bother to learn the girl's name—'you, light my cigarette.' But I don't think she knew how gorgeous she was."

Hearing these words, I'm shocked. Completely flabbergasted. I immediately call Eve to ask her if this was so, expecting her to demur, and violently. (Eve, unlike so many good-looking women, isn't sheepish about her physical assets, doesn't feel the need to downplay them or apologize for them. "Falsely modest" is about the last charge you could level against an Eve Babitz self-description. From *Slow Days*: "Any fool can want to sleep with *me*. . . . Men take one look and start calculating how they can get rid of obstacles and where the closest bed would be.") But she does not demur. Instead she says, "I go through old pictures of myself, and I see I was perfectly fine. Only back then I thought I was a total washout. My forehead was huge, and I tried to hide it by bleaching my hair and growing out my bangs. Do you know what my hat size is? It's seven and seven-eighths. That's big for a man."

Still, Mirandi maintains that the improvement in Eve's appearance helped. So did alcohol. (Mirandi: "Drinking loosened her up.") So did Ritalin. (Mirandi: "The pills

calmed her down.") So did Dexamyl, marketed as an appetite suppressant/antidepressant but really just speed. (Mirandi: "Sally got it from her doctor and shared it with Evie.") And pot, which Eve's friend from Le Conte Junior High, Sue Shaffer, was smoking before anybody else. (Mirandi: "Sue was a wild one. Has Laurie told you about the time Sue pierced her ears? All right, so Laurie was at our house. Sue drove up onto the front lawn in a new Volkswagen as tiny and cute as she was. She pierced Laurie's ears with an ice cube, a peeled potato, and a sewing needle. Then she got back in her car and drove away. It must have been a few weeks later that she ran off with that sculptor, Vito, a friend of Laurie's father's. Sue was sixteen. Vito was almost fifty.")*

And because Eve's writing about Hollywood High was rap-

* If ever there was an anecdote that's a short story waiting to happen, this is it. After I heard it, I fell down the Sue Shaffer rabbit hole, lost three days. What became of this marvelous creature? I had to know. Well, the former high school cheerleader married Vito—full name Vito Paulekas—and changed Sue to Szou. Paulekas was a pioneer of the "freak" scene. He and Szou operated L.A.'s first official crash pad on 303 North Laurel Avenue, around the corner from Szou's old stomping grounds, Fairfax High. It became home to countless female runaways. In 1964, Paulekas, along with Karl "Captain Fuck" Franzoni, started a dance troupe called Vito and the Freaks. Vito and the Freaks were associated initially with the Byrds, later with Frank Zappa's band, Mothers of Invention, at whose performances they'd dance and "freak out," get the crowd going. (It's through Szou that Eve knew Zappa, why she was able to set him up with Dalí that year she was living in New York.) Paulekas and Szou would have a son, Godot. At two, Godot was brought by his parents to one of their all-night party-orgies. A witness: "They passed that little boy around, naked, in a circle with their mouths. That was their thing about 'introducing him to sensuality.'" Godot died soon after, falling from the scaffolding in his father's studio.

turous, I assumed that her experience there was, too. (From *Eve's Hollywood*: "In my high school, I was pretty and smart and impatient. . . . I was usually triumphant and had fun being wide-eyed and sarcastic in class.") Not so in Mirandi's view: "Evie wanted out. That's why she graduated a semester early. I don't think she ever really felt part of things. She and Sally certainly had a social life, but it was mostly outside of school."

Once again I go to Eve. Once again I'm confident that when I hold up Mirandi's memory to hers, I won't get a match. Once again I do: "I was so scared of Hollywood High and the sororities that I lied and gave a fake address so I could go to Marshall. That's where I did the tenth grade. I came to Hollywood High in the eleventh grade, after rushing was over. Sally came in the eleventh grade, too. Neither of us rushed the Deltas or any other sorority, even though sometimes the sororities made an exception for newcomers. We decided to duck instead. That was our solution. Evade the issue. Then Sally met Sandra Kirchner in acting class and knew the rest of the Thunderbird Girls through Sandra. Sandra was twenty-four and the living end. Her waist was tiny and she wore sexy-starlet clothes from Jax [a boutique in Beverly Hills]. Every time she left the house, her grandmother, this little old Jewish woman in black, would follow her out the door and try to get her to put on a sweater. 'Fuck you, Grandma,' she'd yell over her shoulder. Lenny Bruce loved that line even more than I did. He put it in

his act. Sandra was just great. She rescued me and Sally from oblivion. Actually, you want to know who really rescued me from oblivion? At LACC was a girl everyone hated, Myrna Reisman. Myrna walked up to me one day and asked me if my godfather was Stravinsky, and I said, 'Yeah,' and she said, 'Great, I'm going to pick you up at eight.' Myrna came by in a little silver Porsche. She took me to Barney's. I was nineteen and suddenly life was fun. Up until then, I couldn't stand being a teenager. Being a teenager was awful!"

And then there was Mirandi, for whom being a teenager was a snap and a breeze and nothing to it. Mirandi had the kind of looks that were just what boys and men liked: a few inches over five feet, and slender, barely ninety pounds, with large breasts, lips, and eyes; small nose, waist, and hips. And the kind of temperament that kept girls from holding those looks against her: thoughtful, caring, loyal. She was a lock for the Deltas, though sisterhood would have to wait. Her actual sister was heading to Europe along with her parents for Sol's Bach grants, and she'd drop out of the tenth grade to join them.

After a year of correspondence courses, Mirandi insisted on returning to L.A. to finish high school. "Can you believe what Mother and Dad did to me? Those rats! No, no, Daddy had to be in Europe for his work, and Mother stayed with him, naturally. It was hard for me to leave them, though. I was very attached to Mother and always by her side. And I

was afraid to travel all that way by myself, but I was falling further and further behind. Evie was home by then. I couldn't live with her, of course, so I decided to live with Aunt Tiby."

And Step-Uncle Milt. Milt did as step-uncles have done since time immemorial and tried to put the make on his step-niece. Mirandi might have looked like a sex kitten, but she wasn't one. Was fifteen and never been kissed. Says Laurie, "The truth was, Mae abandoned Mirandi at the most important age. Mae loved Evie and Mirandi, but she loved Sol more, and when he got those grants, she went with him."

To get Milt to cool off, Mirandi found herself an age-appropriate boyfriend, a cute, wholesome football player, Rick Mosher. "Rick was in the Kingsmen. That was the brother fraternity to the Deltas. He couldn't have been sweeter and we made out so much we gave each other pimples. I lost my virginity to him right before I went back to Europe with Evie."

And two years after first sex, first love—for Mirandi a much more traumatic experience. That 1963 celebration at the Hotel Green, Duchamp's retrospective party that Eve turned into her coming-out party, was also, in a considerably quieter way, Mirandi's.

Mirandi had gone as Julian Wasser's date but, because Wasser was on assignment, had spent most of the evening unattended. The artist Joe Goode swooped in. Says Mirandi,

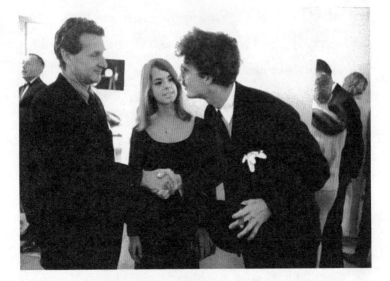

Mirandi with artist Larry Bell and photographer Irv Glaser, 1963

"I still had a year of high school to go. Joe was twenty-six. He was from Oklahoma, like Ed [Ruscha], and the two were best friends. Ed told Joe he was cradle robbing, but Joe didn't care. And when he met my dad a few days later, he asked if he could ask me out and my dad thought it was fine. Joe and I were a couple for about six months. It didn't end well. I was at the house in Pasadena he lived in with Walter and Shirley [Hopps]. We were in the bathtub together when he told me that he was also sleeping with a woman who worked at his gallery. I'd been faithful to him and assumed he'd been faithful to me. I became hysterical. I jumped out of the tub and threw on my clothes and ran out the front door barefoot, wet

hair, no purse. My parents came and got me. I never dated Joe again. I was devastated, really devastated."

She'd recover.

It was half a year later, August 24, 1964. Mirandi, eighteen, had, at last, graduated from high school. Not from Hollywood High—her second trip to Europe had ruined her forever for saddle shoes and letterman jackets—from Hollywood Professional School, intended for students with show business careers, but open, too, to regular students eager to get on with it, start working. (Another milestone passed: her first abortion. A few months prior to receiving her diploma, Mirandi got pregnant by a flamenco-guitar player at Chez Paulette, the coffeehouse on the Sunset Strip where she waitressed. "The whole family drove down to Tijuana. Dad and Evie went shopping to make it look like any other vacation, while Mother and I headed to the clinic. Abortions were illegal in Mexico in that Mexican way—like, Who do I have to bribe to make this happen?") Mirandi was no more compelled by the prospect of college than Eve had been, and her long-term goals were hazy. Not her short-term, though. She wanted to do what the band's most recent album cover said to do and Meet the Beatles!, John, Paul, George, and Ringo on their first US tour and still in town after playing the Holly-

wood Bowl the night before. Says Nan Blitman, "Did you hear the story about how Mirandi got Ringo? Oh my God, it's like hearing about how some other kid got into Harvard. The planning, the maneuvering, what it took to land him!"

The story: Mirandi was tooling around the city that afternoon in her aunt's car, radio blasting the Beatles, a group she'd been onto before everybody else in America thanks to an English boyfriend who'd mailed her their first record (she'd loaned it to Beach Boy Carl Wilson, her Hollywood Professional School classmate, and he'd given it back with a shrug— "Carl thought that the music was good and the harmonies were interesting, but he didn't see what the big deal was"), and feeling blue because she'd failed to score a ticket to the previous night's show. A motorcade forced her to the side of the road. On a hunch, she followed it to a mansion in Bel Air. She spotted an agitated-looking girl in a limo parked across the street. Mirandi began chatting up the girl, a journalist covering the Beatles for a fan magazine. The journalist had lost her driver and was frantic to return to her hotel since she had a daily report to file. Mirandi offered the journalist a lift on the condition that the journalist get her into that evening's party. The journalist agreed. Mirandi dropped off the journalist, sped home to rat her hair and change into a Frederick's of Hollywood bra, picked up the journalist, drove back to Bel Air. When Mirandi and the journalist reached the road manager with the guest

list, the journalist finked, pretended she didn't know Mirandi. Mirandi made it past the road manager anyway. Once inside, she drank soda pop and did the Mashed Potato with Peggy Lipton [future star of counterculture cop show *The Mod Squad*, David Lynch's *Twin Peaks*], another Hollywood Professional School classmate, and, after beating out actresses, models, and cage dancers, enjoyed a passionate interlude with the Beatle of her choice, Ringo, twenty-four, in a walk-in closet.

From a letter Mirandi wrote Laurie in the fall of '64:

As far as Ringo, what was really going on was I was balling ·
him. . . . I met him at a party on Monday and I finally went
home to change Tuesday night. He is the saddest little tiny
guy that I've ever met but the greatest. . . . Reporters are
after me but I'll be damned if I'm going to open my mouth
and ruin everything.

Spending a hot-and-heavy twenty-four hours with Ringo was a dream Mirandi didn't want to wake from. So she didn't. She decided to treat his casual parting words—"Why don't you come to England?"—as a serious invitation, moved to London and Liverpool for six months.

She got pregnant again, this time by Robert Whitaker, the Beatles photographer, whom she met in London, but continued to see after she returned to L.A. There was a second

Mexican abortion. Not in the Tijuana clinic, which had been shut down, in a motel room in Ensenada. Mirandi: "I remember white sheets draped over wire strands around an operating table. I remember the table had stirrups. It was stark and terrifying. But my first trimester was almost over. I felt like I had to go through with it." The procedure was, unsurprisingly, botched. "As soon as I got back across the Mexican border, I started hemorrhaging. My gynecologist admitted me to Cedars of Lebanon, the hospital I was born in. He finished the abortion because it was a matter of life or death. Why didn't I ask Robert or any of the other guys to wear a condom? I didn't want to be seen as a drag—that was my highest aspiration at that point. Asking a guy to please put on a condom seemed unromantic and like too much of a hassle. I was unable to take care of myself in that basic way."

Mirandi was still recuperating, physically and emotionally, when, in the summer of 1965, she walked into a club on the Sunset Strip called the Fred C. Dobbs. There she first encountered musician Clem Floyd. Clem was twenty-nine, Cockney, runty, ugly, sexy, dynamic, and sitting at a table with David Crosby, his bandmate, and Taj Mahal of the Rising Sons— a studly trio. The men began fighting over Mirandi, half in jest, half not. Clem won. He seemed destined for fame, yet

it turned out he was destined only for almost fame. (Crosby's other band at the time was the Byrds; and Clem's other band was the Sound Machine, its drummer, John Densmore, whose other band was the Doors.) Says Mirandi, "I put my money down on Clem for rock 'n' roll stardom. He was my horse in the race, the one I bet on. I was a lot dumber than I thought."

On that hot August night, though, Clem was a sure thing, a when-not-if as far as making it was concerned. He and Mirandi moved in together. They'd wait for darkness to fall, then hit one of the canyons, Laurel usually, but sometimes Topanga or Coldwater, get high, jam, or just hang out, with David Crosby, obviously; fellow Byrd Roger McGuinn; also Joni Mitchell, Mama Cass, Graham Nash; Jerry Garcia, Phil Lesh, and Bob Weir when the Grateful Dead were in town; Paul Kantner and Jorma Kaukonen of Jefferson Airplane; the Lovin' Spoonful's John Sebastian. Says Mirandi, "It wasn't just that these musicians treated Clem as an equal, they looked up to him. For a moment there, the Sound Machine was it, the best band around."

Clem was also heavily involved in politics, as was Mirandi, the daughter of a Trotskyist ("Dad was a member of the Socialist Workers Party, though a hidden member because he worked at the studios and didn't want to get blacklisted"), and a self-proclaimed hippie. But so was almost everyone under thirty. The mid-to-late sixties was, after all, a tumultu-

ous time. Draft cards were being burned on college campuses; the National Organization of Women was being founded in a D.C. hotel room; the civil rights movement was more than gaining momentum, was becoming unstoppable. Clem and Mirandi went from protests to marches to rallies to—

I'm cutting myself off here, interrupting, because I need to make a point, or maybe just an observation. When I listened to Mirandi talk about fleeing the cops cracking flower-child heads with batons at the 1966 Sunset Strip riots, or driving a limo full of guitars for Crosby, Stills, Nash & Young in 1969 at Altamont, Hells Angels, flat-eyed and greaseball-looking, flanking her, I suddenly realized how outside history Eve was. Eve seldom referenced anything beyond her own feelings or experiences. (One of the few political events I can recall her writing about is the 1965 Watts riots, which she watched on TV in a penthouse suite at the Marmont that she was sharing with a Stanford-educated oil heir with a sideline in racehorses she'd picked up the night before.) She certainly wasn't a hippie, a category of humanity she disdained. "It wasn't just that [hippies] were poor, though that was about half of it. . . . I was also enormously horrified by Eastern religions . . . Buddhism with that fat guy in lotus position. . . . I always wondered what his cock could ever be like in all that flab." Wild when you consider how closely identified she is with sixties and seventies Los Angeles.

But I suppose the same is true of F. Scott Fitzgerald, chron-

icler of the Jazz Age. Catching mood and magic is one of the great gifts of these two writers, the reason why their prose, period-associated as it is, seems so paradoxically undated, so fresh, and why their books stand among our enduring monuments. Fitzgerald's already do, of course. The best of Eve's— *Slow Days*—I believe will. Getting older was problematic for both Eve and Fitzgerald in life. Yet their work has aged beautifully, that is, hardly at all. Looks, in fact, better as the years pass, their frivolity, in retrospect, profundity. This in contrast to so many of their contemporaries who were far more engaged by the issues of the day, and whose subjects and themes felt far more urgent and important. How much do you want to bet that counterculture vulture Hunter S. Thompson will go the way of John Dos Passos and James T. Farrell, once essential thinkers turned curiosities and relics? Nothing becomes passé faster than au courant.

Back to Mirandi and Clem: Clem had a domineering personality, a serious turnoff, except for Mirandi it wasn't. "My relationship with Eve was one of being controlled, so it was a familiar place for me. It sounds ridiculous, but it felt comfortable."

Clem was a kind and considerate mate for the first year he and Mirandi were together, unkind and inconsiderate thereafter. Out of the blue, he announced that he could only be with one woman if he could sleep with other women. He generously

allowed that she could sleep with other men, which she had no interest in doing, though she sometimes did to please him. Mostly she ended up sleeping with him and the other woman, which she also had no interest in doing. Out of the blue, he started hitting her. He generously allowed that she could hit him, which she really had no interest in doing. "I was a hit-ee. My sister had always hit me, but I didn't hit back."

Since paying the bills was a middle-class fetish and Clem was an anti-bourgeois, nonconformist rebel-stud-genius, it was up to Mirandi to earn the money. She waited tables and answered phones. (Clem, to be fair, did have a part-time job. He dealt drugs so he could buy his own.) She also made clothes and began selling them to local stores. "I guess it was an art, but I thought of it as a craft. I couldn't think of it as an art because I didn't want to be an artist. I saw what being an artist did to Mother—not getting recognized, never selling a painting, and she was good! She was good and she still couldn't get anywhere. It's what made her drink. I thought, No thanks. And, besides, of us girls, Evie was the artist."

Mirandi and Clem married and started a fashion label called Mirandi, the moment Miriam became Mirandi. "I thought it would be a great name for a line of clothes. And everybody was changing their names at that point, though it hurt my parents' feelings, and I didn't know what I was going to tell the Stravinskys [Igor had named Mirandi as well as

Eve]. Actually, it was Eve who was the most bothered. She refused to call me Mirandi for the longest time because she thought it was a Clem thing—a name he came up with."

In March of 1968, Mirandi and Clem opened a custom-leather boutique at 8804 Sunset Boulevard. They stuck two signs in the window: CLOSED and BY APPOINTMENT ONLY. The brush-off/come-on worked. Steve McQueen's wife, Neile, became a customer. As did British actor Terence Stamp. And Celeste Yarnall, the pretty girl in the latest Elvis movie. And John Kay of Steppenwolf. Christian Marquand, who'd just directed the porno-spoof *Candy*, co-starring, of all people, Ringo, stopped by with his producer, Peter Zoref. In no time, Mirandi and Clem were doing private fittings for Marquand at the house of Marquand's close friend Marlon Brando.

They'd do private fittings, too, for Sharon Tate, in acting class with Yarnall, at the house Tate lived in with Roman Polanski. Says Mirandi, "Sharon was so beautiful. The house we went to was the one before the Cielo Drive house. Roman was there, and some kind of weird flirtation was going on between them and us. Clem was necking with Sharon. He would have loved the opportunity to get in her pants, but I was so repulsed by Roman that I couldn't imagine any of it. I said to Clem, 'We're leaving.' I never wanted to go back."

By far the boutique's most important customer, however, was Jim Morrison. Mirandi went way back with Morrison,

whom she'd met through his girlfriend, Pamela Courson, her classmate at LACC. (Mirandi would, as Eve had done before her, enroll in and drop out of the school practically simultaneously.) Further back even than Eve. In fact, it was Mirandi who introduced Eve to Morrison, if indirectly. Mirandi watched Morrison perform at the London Fog, then called Eve. "You have to see this guy," she said. "He's Edith Piaf with a dick." Eve stopped by the club the next night, seduced Morrison the night after that, which, for Mirandi, rankled because it made things awkward for her with Courson, though she must've realized she had only herself to blame. Her description of Morrison was pretty irresistible, and Eve, as a rule, didn't resist.*

Mirandi and Clem would live with Morrison and Courson, sharing for a period the couple's house in Laurel Canyon on Rothdell Trail, nicknamed Love Street by Morrison and immortalized by him in song. While Mirandi was closer to Courson, she felt a deeper kinship with Morrison. Says Mirandi, "Pam was tiny but tough. Once, when she and Jim were fighting, she wrote FAG in huge letters on the back of his favorite vest in India

* A fun bit of trivia: Eve's Morrison was a collaboration between her and Mirandi. Says Mirandi, "A lot of Eve's time with Jim was a blur—all the alcohol. So when she was writing that *Esquire* piece, she'd call me and ask, 'Now, what happened then?' And 'What was Pam like with Jim?' And I'd tell her what I remembered, and she'd sort of put it together with what she remembered. And that's how it worked."

ink. I guess at some point in the past there was the possibility that he'd been with a guy—you know, sexually, in college or something. And she'd get physical too. Would tear into him with her nails. I related to Jim because I felt he and I were the more vulnerable ones in our relationships. We were both being pushed around and bullied by our partners."

In June of '68, Morrison would walk into the store.

An aside that's also to the point: During the year that Eve spent in New York, March 1966 to March 1967, she ran into Morrison in the Village. Recalls Eve, "Jim and I just fell into each other's arms. Strangers in a strange land, you know. I brought him to my hopeless little apartment on Avenue A. He was in town to play Ondine [a club on East Fifty-Ninth Street, a favorite haunt of Warhol's]. After his set, I took him over to meet Andy." Present, too, that night was Warhol's right-hand man, Gerard Malanga. Malanga was possessed of a striking and distinctive personal style—part Lord Byron, part juvenile delinquent, part sexual sadist. Says Malanga, "I was always into clothes, even as a teenager. The next step for me was leather pants. No one else was wearing them at the time. There was a shop on Christopher Street, the Leatherman, and that's where I bought my first pair. This meeting between Andy and Jim must've taken place in October or November of 1966 [the Doors played Ondine for

a month that year, starting on November 1]. I don't remember seeing Jim, but I would've been there. I can almost pinpoint the night. I was with my girlfriend, the Italian model Benedetta Barzini, and we broke up in early November."

Morrison commissioned his first pair of leather pants in the summer of '67 from designer January Jansen. He loved how Jansen's pants, made of brown snakeskin, looked, though not how they felt. Mirandi: "When he came into our store, I could see his guilt. January was his friend. He believed he was betraying January getting his pants from someone else, but snakeskin is difficult to move in, and it's also incredibly noisy." Mirandi and Clem fashioned Morrison a new pair using a soft brown cowhide imported from France. They fast became Morrison's favorite stage pants (and are now behind glass at the Hard Rock Cafe in Hollywood). "It was glove leather, basically. Very dainty, very sexy, very tight."

Morrison returned in August. Mirandi: "This time he was fully on board with the idea of us dressing him. We worked through a lot of ideas before we came up with the primarily black-leather look. We'd been making colorful clothes for all the other rock people, but Jim wasn't into colors. And by this time, he was looking older than his twenty-four years. His skin had become puffy from drinking. Up close he wasn't a pretty sight and he knew it."

Morrison wasn't the first rock 'n' roller to strut his stuff in

black leather, but he was the first famous rock 'n' roller. Black leather is what Elvis would wear later that year when he staged his celebrated "'68 Comeback Special." And it's been rock-star de rigueur ever since, the signature look of Freddie Mercury, Billy Idol, Tina Turner, the Clash, the Ramones, Def Leppard, the list goes on and on.

A cultural phenomenon traced all the way back to its origins: Eve and Mirandi Babitz.

Soon after visiting the store, Peter Zoref invited Mirandi and Clem to a dinner party at his house in Malibu. French director Roger Vadim and American actress Jane Fonda, Vadim's third wife and the lead in his comic-strip, sci-fi, sex-romp extravaganza, *Barbarella*, one of the biggest movies of 1968, were guests. So was Nouvelle Vague screenwriter Paul Gégauff, older, handsome, depleted, and Danièle, his lovely young wife. Says Mirandi, "Jane was either filming or about to film *They Shoot Horses, Don't They?* She was a hotshot. A major, major movie star. I remember how beautiful she was—those long limbs and cornflower-blue eyes. I also remember she sat next to me and ate off my plate, even though she kept saying she wasn't hungry. I got the feeling that Clem and I had been brought in as fresh meat. But I actually found Vadim creepy. Paul was the one I wanted. He'd worked with all those great

auteurs like Claude Chabrol and René Clément. And everybody thought French movies were so important then. I used to go and see them with Eve."

Vadim and Fonda moved the party to their house, a mile or so up the road. As the night wore on, Clem and Danièle paired off, as did Mirandi and Gégauff. Gégauff was, as his looks promised, too jaded-sophisticated and spiritually bereft to achieve an erection. In spite of Mirandi's repeated objections, a substitute was brought in: Vadim, on his own after Fonda disappeared to take care of their new baby. Says Mirandi, "I guess my 'Stops' and 'No, nos' were taken for 'Well, okay, sure, I guess.'" (Chabrol: "When I want cruelty, I go and look for Gégauff.") Still, a more or less good time was had by all. And the next day, Gégauff invited Mirandi and Clem to live with him and Danièle and their two small children in the French countryside.

In March of 1969, Mirandi and Clem closed their extremely successful store, only one year old, and hopped on a plane.

Vauréal was a magical time for Mirandi. The entire Nouvelle Vague seemed to wash up on the shores of the Gégauffs' house during her stay. Chabrol, Godard, actress-singer Françoise Hardy all came for meals, or to spend the weekend. So did Barbet Schroeder, whose first movie, *More*, was written

by Gégauff and featured Eve's Hollywood High classmate Mimsy Farmer. And Mirandi was happy with Gégauff, no matter that the only thing they did in their shared bed was sleep.

Clem, however, got restless. And after six months, the *ménage à quatre* broke up. (In 1975, Chabrol would make *Une partie de plaisir*—translation: "a piece of pleasure"—scripted by Gégauff, and starring Gégauff and Danièle as Gégauff and Danièle, though their characters would have different names. There'd even be characters based on Mirandi and Clem. The movie ended with the husband killing the wife, which would, spookily enough, happen in real life, except it was the wife killing the husband, and it wasn't Danièle who killed Gégauff but Gégauff's second wife, Coco, stabbing him to death with a kitchen knife on Christmas Eve 1983. At the trial, Coco claimed that the "psychological terrorism" Gégauff subjected her to had driven her to murder.)

Mirandi and Clem returned to L.A. in late 1969. She would finally work up the courage to ask him for a divorce, but not until 1971. After giving her a beating to remember him by, he consented.

For the next few years, Mirandi cut loose, bouncing back and forth between Barney's and the Troubadour. Though

she had a boyfriend—"Oh Ted, Ted was this sweet hippie carpenter guy who, believe it or not, was the former roommate of Tex Watson [Charles 'Tex' Watson, member of the Manson Family, stabbed Sharon Tate and her unborn baby and reported afterward to Manson, 'Boy, it sure was helterskelter']"—there'd be affairs with famous artists, like Chuck Arnoldi and Boyd Elder, even more famous musicians, like Jackson Browne and Don Henley. Eve: "There were A-list groupies and B-list. You had to be under a size three to be A-list. My sister was A-list." Laurie: "I don't think you can tell from pictures just how great-looking Mirandi was in her heyday. When Mirandi was young, she was Brigitte Bardot's twin. She could attract anyone—Ringo, Jackson, the Eagles, all those guys. But she didn't get to keep them."

In 1976, Mirandi, thirty, left the third custom-leather store she'd started. "The second was on West Washington Boulevard, the cool part of Venice. But Venice was dangerous then. I was regularly getting violently mugged. So I closed that store, opened a new store on Santa Monica in West Hollywood, and that wasn't much better. I filed five police reports in one year. And then I got hit by lightning outside Mother and Dad's house. I thought, What is happening to me? I felt almost like I was being contacted by a higher power. I decided I'd better fucking behave myself and think about what I was doing in the world. I called Evie and told her I'd had a kind

of spiritual awakening. There was a pause and then she said, 'Well, do you want a Valium?' "

Mirandi began working for Ronee Blakley, just nominated for an Academy Award for playing Barbara Jean in Robert Altman's *Nashville*, and warming up crowds for California governor Jerry Brown, then running for president. Mirandi: "Ronee took Evie on the road with her, as sort of an assistant-compadre. But Evie was getting drunk and high and being generally not-helpful. When Evie came home, she said to me, 'This is too crazy. You do it.' So I did. I became Ronee's tour manager, and I was good at it."

In 1978, Mirandi reconnected with Jane Fonda, now married to political activist Tom Hayden. Mirandi would stage benefit concerts for various Hayden-related causes with such artists as Bonnie Raitt, Little Feat, the Grateful Dead, Willie Nelson. In 1981, she struck out on her own with Ocean Front Productions. Professionally, she was smoking. The rock 'n' roll lifestyle, though, was taking its toll. "I had Evie as an example. Whatever she was doing—coke, alcohol, guys—I was doing a third of it, so I thought I was okay. I wasn't."

Mirandi joined Eve in recovery, entering a program in 1983. In 1986, at age forty, she'd enroll in Antioch University to become a therapist. (That point of divergence I mentioned earlier.) Says Mirandi, "When I started at LACC, they gave me a test to determine my aptitude. Social worker was at the

top of the list. I was horrified! I was Stravinsky's godchild, surely not a social worker. Well, I could've saved myself a lot of time if I'd just listened." It was while she was in training that she met Alan. They'd marry in 1988.

For me, Eve is Dorian Gray, Mirandi the Portrait of. The sisters would so often have the same or a similar experience, and it would mark only Mirandi. Mark emotionally, I mean, not physically, though physically, too, sometimes. There's the scar from the electric heater, obviously, and the cuts and bruises from Clem. And her second Mexican abortion, the one that at nineteen nearly killed her, doomed her chances of ever again conceiving a child, and she'd have been a wonderful mother. If Eve is the artist, and invulnerable, Mirandi is the woman, real and broken.

And here, I suppose, is where I confess that I needed the woman as badly as the artist, that if it hadn't been for Mirandi I'd never have made it to the end of a piece on Eve, forget a book. I'd have lost heart. Forming an emotional bond is beyond Eve at this point. Mirandi, though, would be my friend, and, perhaps more importantly, she'd let me be hers. I could give to her the affection that Eve was unwilling or unable to accept. Eve understood this, and probably better than I did, certainly faster. I remember her saying

thank you to me just once, and it was for a small thing I'd done for Mirandi. (I'd edited a bit of Mirandi's writing, easy and a pleasure.) I was taken aback. Eve didn't say those two words on her own behalf, yet here she was saying them on her sister's—why? It was only as I was responding with a grace-less, mumbled "You're welcome" that it dawned on me that Eve *was* saying thank you on her own behalf, that of course the favor was as much for her as it was for Mirandi. She was acknowledging what lay between us, the peculiar psychologi-cal arrangement we'd made. It's the one time she would.

When I called Mirandi broken before, I didn't mean bro-ken beyond repair. She is, in her way, as tough and resilient as Eve. She survived Clem. And cancer, two bouts. Her second marriage has been a success, as have all three of her careers. But damage is sustained.

Much of it, I suspect, comes down to sex, or, rather, to Eve and Mirandi's respective attitudes toward sex. To use the example of the Duchamp party: both sisters were or would soon become involved with older men, and these older men would betray them. Mirandi was heartbroken. Eve was heart-broken with quotation marks around it. And the revenge Eve exacted on Hopps had quotation marks around it, as well. She posed naked with Hopps's idol in a fit of pique, not rage. It wasn't thwarted passion she was expressing, but something altogether lighter, looser, brisker, drier. *Ironic* thwarted pas-

sion, a contradiction in terms if ever there was one. Sex, as she saw it, wasn't tragic (her view of life is too amused to easily accommodate pathos), it was comic, a farce. Or, more precisely, a game: a lover would do her wrong, she'd do a lover wrong; a girl would steal her guy, she'd steal him right back; she'd get the clap, she'd give the clap. If she won, a smile. If she lost, a shrug. It didn't matter. Either way, she'd play again. It was musical chairs, only never-ending and, instead of chairs, beds.

For Mirandi, in contrast, sex was this fraught and freighted thing, tangled up and weighted down with love and longing and men and women and birth and death and self and other. How it is for most of us, I think. To the casual observer it might have seemed that Mirandi was, like Eve, bold, and into getting around. Yet even at her most unbridled—when it was rock stars, and threesomes, and couple-swapping—Mirandi yearned for convention and tradition, to do what her mother had done: find that special someone and stay with him forever and ever. Says Mirandi of her time with Clem, "At heart, I was a woman of the fifties. I wanted to feel safe in my relationship, and for me that meant being monogamous. My desire was crushed by the great hippie ideal of free love, an ideal that went against every instinct I had."

Another revealing detail: Mirandi always knew how many people she'd slept with. She kept count, no matter the number

of fingers and toes she needed to use and reuse. Which means she was playing at abandon rather than experiencing it; was not a libertine but a bourgeois posing as one.

If the times goaded Mirandi into acting wilder and more sexually subversive than she actually was, then they hid how wild and sexually subversive Eve actually was. Eve hit her prime at the height of the sexual revolution—even squares were swingers—so it looked as though she was doing what everyone else was doing, just more of it. Only she would've been doing what she was doing regardless of the decade her prime occurred in, regardless of the century. She was a true hedonist and incorrigible, and, on top of which, polymorphously perverse. No path to pleasure was barred. (I remember my surprise when, casually, over lunch one day early in our acquaintance, she mentioned Annie Leibovitz, referred to Leibovitz as an ex-girlfriend. "But, Evie," I said, "you're straight." And she, reaching for a roll, buttering it, replied in that voice of hers, sexy, lazy, insatiable, "Me? I love everybody.") And pleasure is fundamentally what beauty is all about, the giving and receiving of. Art, too.

Hang on a second, though, because I'm afraid I'm giving the wrong impression here. I don't mean to suggest that sex was never ugly or brutal or scary for Eve, that its dark side was known only to Mirandi. Sorenson also raped Eve. Not when she was a child, when she was eighteen. She'd snuck out to see Brian Hutton one night, then climbed back through her

window, drunk, diaphragm still in, and fell into bed. Sorenson climbed in after her and on top of her. Nor was Mirandi alone in getting knocked around. Eve had her share of rough boyfriends. Grover Lewis got violent on occasion. Warren Zevon, too. Says Laurie, "Evie told me a story about how she did Warren's laundry and then he hit her. And she took that and went back for more. I can understand it because she would repeat things he said, and it sounds like he was one of the only guys smart and funny enough for her."

What's more, the sex Eve was having wasn't always sexy: billowing curtains, discarded garments on the floor leading like a breadcrumb trail to a four-poster bed, orgasmic firecrackers popping outside the window, etc. Says Mirandi, "Ahmet [Ertegun] was charming, very, very. It's the first thing you noticed about him. But he could be cruel. To women. To Eve. There was some S & M club or bar in Manhattan that he just loved to go to and talk about—the whips and chains and dominatrixes. And I have no idea what Eve and Jim [Morrison] were doing together in bed. Neither does Eve, they were both so drunk." Says Laurie, "I don't know how willing Evie has been in her life to debase herself for these guys and just not think about it." Pretty willing, I would guess. Though I would also guess that she wasn't debased by it, that the sex was good for her even when it was bad. Ertegun was an artist-tycoon, a princely figure; Morrison an Adonis in skin-tight leather; and Zevon, one

of rock 'n' roll's slyest and wittiest lyricists—"Gets a little lonely, folks, you know what I mean / I'm looking for a woman with low self-esteem"—made her laugh. Therefore all three gave her pleasure. See what I mean? Polymorphously perverse.

Something else to chew on: I've never heard Eve speak less than fondly about one of her exes. She recollects them—all of them—it seems, with a kind of unregretful, slightly vague, yet very real affection. Even Dan Wakefield, whom she says cheated on her (Wakefield, by the way, pooh-poohs this claim). "Dan didn't just dump me, he fucked my friend! Dan was darling, though. And he had the bluest eyes. It took me years, but I got over it and we became friends again." When I sent her Jean Stein's book on L.A., *West of Eden*, I told her how stiff and portentous I found the Walter Hopps bits, and she said, "Walter was a genius but he was a stuffy writer."* *A stuffy writer.* That's as close to disloyal as she ever got.

Sex was essential to Eve, and procreative, if not in the traditional child-bearing sense. It, along with alcohol and drugs—any and all ingredients for a high good time—was a stimulus to her, allowing her to give vent to herself, tap the source. I compared her earlier to F. Scott Fitzgerald. But she's Zelda Fitzgerald, too: the party girl who became the mad-

* *West of Eden* is an oral history, so Hopps didn't write his lines, he talked them. Still, I knew what she meant.

woman, and without whose inspiration and example Fitzgerald would never have written his best books, as Fitzgerald himself was well aware. (After the critic Edmund Wilson drew up a list of Fitzgerald's influences—the Midwest, Irishness, liquor—Fitzgerald declared that the most vital had been left off, "the complete fine and full-hearted selfishness and chill-mindedness of Zelda.") In fact, Eve was both Scott *and* Zelda. She's the artist and the artist's muse. Or, rather, the artist's muse and the artist, the one necessarily preceding the other. She was out of control and debauched once the sun set, disciplined and focused once it arose, ready to cast a cold eye on the previous night's antics, reap the fruits of her beauty and daring. Says Eve, "Even at my worst, I usually never stayed out that late since I got up in the mornings. That's when I wrote." Michael Elias confirms, "After a while I refused to take Eve to parties because she always wanted to get there before it got started and leave before it got good."

It's a perilous way to work, a kind of desperate gambling. Yet, against heavy odds, Eve won, at least for a period. Dissipation, blight, madness, ruin (and that's if she was lucky, death if she wasn't) were inevitable. That she managed to produce one brilliant book and several very good is astonishing—a miracle, really—since her method wasn't just self-destructive, but self-immolating. She'd burned herself up long before she'd burned herself up.

To Eve—with Love and Squalor (Also, Squalid Overboogie), Part I

★

Eve, as I said, is an artist, was one when she hadn't quite found her art, and is one now though she hasn't made or written anything in twenty years. And she operates the way an artist operates, thinks the way an artist thinks: is both exquisitely sensitive and totally unfeeling; is simultaneously immersed in life and detached from it; is having the experience yet is already, even in the midst of it, transmuting it into something else; is there but not.

Paul Ruscha and I were in his car in the summer of 2015. We'd just had dinner—social, for fun, not an interview—at the restaurant we always go to, Il Forno Caldo, a little Italian place near his house in Beverly Hills. He was driving me to my hotel, and we were both stuffed and relaxed, a bit sleepy. As we turned onto Sunset, I mentioned that I'd taken *Slow Days* with me on the plane. It was the first book of Eve's I bought, all the way back in 2010, and I was ravished by it, completely seduced. Eve's voice was so alive and so happy and so forlorn and so bewildered and so delirious, and it was like nothing I'd ever heard before. The experience was transcendent, there's no other word for it. And that's why I'd avoided having it again. Or, rather, not having it. Was I so in need of a transcendent

experience five years ago, when I couldn't get anything going with my own writing career, was in a rut, spinning my wheels, that I'd invented one? Did I over-like—over-love—*Slow Days*? If that was indeed what had happened, I'd just as soon not find out. (Disillusionment is usually inevitable, a matter of time. Why court it?) Only I had to because I was under contract to Scribner for this book, so I dropped *Slow Days* in my bag as I left for the airport, giving myself no choice but to read it since the flight was six hours and since those tiny JetBlue TVs make me motion sick.

I needn't have been afraid. After the second go-round, I was as under *Slow Days*' spell as ever, deeper even. And knowing the principals as I did now added nuance to my appreciation. Paul was a stranger to me in 2010. He'd become a close friend. I told him how struck I was by Shawn, the character based on him, as richly conceived and finely wrought as any Eve ever wrote, how good he must've looked to her, how good she made him look to the reader. She'd captured his physical presence, but also his metaphysical—his deftness, his tact, his almost otherworldly radiance. ("[Shawn] always looked wonderful at a party, like a Henry James fortune-hunting prince—weak and kind—marrying the heiress from Poughkeepsie and being worth every penny she spent on him if it was only for how well he listened. How he looked in those white pants and blue blazers was extra. Slender and

smiling with white teeth and sympathy.") Paul was quiet for a moment, then spoke in that halting way people speak when they're saying something that's hard for them—hard emotionally, or hard because they're expressing an idea they've never before put into language, or both. "I recognized myself in Eve's books. I mean, I recognized that it was supposed to be me. But I never felt that it was me, or that I was really like that. I felt she made me up." A disbelieving laugh. "But I liked what she made me and I tried to become it."

In other words, Paul is Eve's creation. Her imagination, roiling, surging, bursting, its potency enormous, staggering, is fundamentally generous. She makes things better than they are, which is lovely and sweet but, finally, incidental because the impulse is neither. Paul was already a creation, his own or God's. For Eve, though, he was material, to do with what she chose. And looked at from a certain angle, her art—all art— is a form of exploitation, and totally and utterly barbarous, as amoral as it gets.

The Keyhole, an Interlude

★

Eve is not my character. I'm stating the obvious—restating— and less for your benefit than my own because it's a truth I'm

sometimes able to trick myself into forgetting. When a writer is writing fiction, he or she can be, should be, inquisitive to the point of intrusive, and guiltlessly, needn't suffer a single pang of conscience, as the people whose privacy he or she is violating so egregiously aren't real. Eve, however, is. Which makes it harder for me to sustain the illusion that my interest is only of the most elevated order, that I'm a scholar and an aesthete engaged in a sublime literary experience, that I'm not also a snoop and a peeper, creeping down the hallway on stockinged feet, crouching in front of a closed bedroom door and pressing my eye to the keyhole, the sound of my ragged breaths filling my ear. Particularly since the bedroom door I'm crouched in front of belongs to Eve, about whom my curiosity is savage, unappeasable, and on no subject more than her love life. Is the fascination she exerts over me simply that of the Other—she's an adventuress and sexual outlaw, and I'm married to my college sweetheart, have never taken a drug, am as compulsively abstemious as she is compulsively excessive, and I therefore can't get enough? Or am I fulfilling a desire still more illicit, profound, and secret, so secret, in fact, it's unknown even to me? Either way, my show of reluctance is just that. What I'm wondering is: will Eve fling open the door, wave me across the threshold, tell me to pull up a chair, to take notes or pictures, whatever I'd like, that between beholder and beheld nothing is concealed, all is transparent?

Chances, at first, seem pretty good. There was, of course, Eve's and my initial awkwardness. Once we got past that, though, the thing I was struck by most forcefully was her frankness, a frankness so frank it made candor blush. In an early conversation, she told me a story in which she and a famous lover shot coke at the Chateau Marmont:*

"Actually, it was BLEEP who was shooting the coke. I was just watching. I mean, I snorted coke to death, but I never liked needles. BLEEP didn't like needles either, but BLEEP liked to see blood geyser. BLEEP liked the patterns the blood made on the Chateau's ceiling and the white Martha Washington bedspread. BLEEP thought it was art. And it was sort of. The blood looked like a Rorschach test, but beautiful."

I heard this and I knew I was in the presence of someone splendidly, magnificently, thrillingly indiscreet, about herself, about others.

Except I was wrong, at least about the about-others part, though I didn't realize it for a long time—years. It wasn't until I was rereading all my interview transcripts in order to highlight

* I'm not going to identify this famous lover or any of the other famous lovers mentioned in this section. Why not? To paraphrase Eve, so I don't get sued!

certain quotes, assist the *Vanity Fair* fact-checker, that it hit me: the choicest bits of Eve sex gossip hadn't come from Eve. It was from family and friends that I'd learned of the famous lover (a different famous lover) who insisted on showering immediately postcoitus, didn't even wait long enough for the sweat to dry before he was soaping up, and the famous lover (a different different famous lover) for whom it was fist-fucking or nothing, the only depravity that would do. Eve will tell tales on other people about drugs. She will tell tales on herself about drugs and sex. She will not, however, tell tales on other people about sex. She's a born courtesan, naturally circumspect.

Come to think of it, I was even wrong about the about-self part so far as sex goes. Or, that is, I was right but only selectively. Says Paul, "When Eve and I were together, especially in those early days, we had this mystique. The way we'd look at each other in public, or kiss—it got attention. Eve loved this. Once we were at a party. There were a lot of people there, getting stoned or drunk. We started making out, which we would often do. Then we moved to the bathroom to really nail each other. The door either fell open or somebody opened it. I didn't care, I never minded having an audience. But Eve was fucking because she wanted to fuck, not because she wanted other people to watch her fuck, and that's why she shut the door." (So much for her waving me across the threshold.) There are, for me, two big takeaways from this story: (1) the purity and

intensity of Eve's desire, how elemental it was, how once it took her over, it took her over completely, her focus solely on it, everything else a distraction to be ignored; (2) the Duchamp photo and the manner in which Wasser captured a fundamental psychological truth about Eve—her need to reveal herself and conceal herself simultaneously.

In *Slow Days, Fast Company*, Eve wrote, "I'd always believed that sex masterpieces were the best kind . . . better than Bach, the Empire State Building, or Marcel Proust . . . that sex is art." Aha, so it's not sex *and* art for Eve, it's sex *is* art. And sex, as much as writing, is her métier. (Interestingly, writing, the craft of, is the other topic on which open-book Eve is closed. I ask her a question related to it, and I get the same answer she gave the jerk guys in *Slow Days* who wanted to know, "How do you write?": "On the typewriter in the mornings when there's nothing else to do." In short, buzz off. It's only because of Paul that I know how compulsive she was, what a perfectionist, the high number of drafts—nine or ten—each piece was subjected to.) Sex is undeniably the source of her energy. It's what's propelled her through her ambiguous and complicated life.

Which is why I refuse to let my better self prevail, refuse to do the decent thing and brush off my knees, straighten my spine, step back from the door. (Not that you could pry me from it with a crowbar.) I need to find out what goes on behind it. To know Eve carnally might be the only way to know her at all.

Let's start with Eve's virginity, when she lost it and to whom. Her testimony on this point is conflicting, in writing as well as in conversation. In *Eve's Hollywood* and *L.A. Woman*, she refers to herself as a virgin while at Hollywood High. But in "Sins of the Green Death" in *Eve's Hollywood*, she recounts a run-in with the girls' vice principal before graduation: "Mrs. Standfast . . . gave me the 'You are now about to embark upon the road of life speech,' which, I hoped, would keep her mind off the fact that come was dripping down my leg." Eve's bitched to me about the lack of action she saw in high school. ("I didn't get asked on a single date!") She also, however, has laughed with me at the memory of picking up Tony Santoro at the beach with Sally on that day she and Sally played hooky. ("He was fucking us both when he wasn't fucking Mamie Van Doren!") I once asked her directly who her first boyfriend was, and she replied airily, "Which first boyfriend? I had a lot of first boyfriends." This answer is so purely her that it's the truest she could have given even if it isn't one. And, anyway, it doesn't matter who was technically first. The first who counted was Brian Hutton.

Eve met Brian the day she turned eighteen at a party in Laurel Canyon. She'd re-create the moment in *Eve's Hollywood*, calling Hutton "Graham":

It was a fast crowd. . . . This guy who knew everyone was having about 2 years of winning at the race track, so he threw parties all the time and lechery for young girls was de rigueur. . . . [Graham] came in with a friend from an overcast night, so how is it that I remember him *still* as coming in alone from the stars? . . . I half rose up against the impact and he saw me across the room. . . . He was swamped by girls, deluged in a tangle of beautiful arms and feminine exclamations of flower-petal softness. Three of the prettiest had twisted free of their conversations and it was like Santa Claus in an orphanage.

I, it turned out, wasn't the only one.

Hutton had trained at the Actors Studio in New York before moving to L.A. He'd booked jobs, and steadily, mainly Westerns, mainly TV. By the time he moseyed into that party, though, he was saddle sore. He told Eve, "I'm a director. I used to act but they make you ride horses all day and I got sick of breaking my ass." While he became known as a director of men's pictures (*Where Eagles Dare* and *Kelly's Heroes* were his biggest hits, both starring Clint Eastwood), it was women who aroused his imagination. He was a lady-killer of the most lethal type—the type that loved his prey even as he showed it no mercy. Wrote Eve, "All really enormous charm, the kind that Graham exuded, does

much more than it needs to. It gushes out so much that you can live inside it. . . . I have girl friends who have met him and are actually frightened of him like people used to be afraid of witches."

When I ask Eve about Hutton, she says, "Brian had the greatest voice in the world, like a Dead End kid's. He called everybody 'darling.' He knew Marlon Brando, and that'll get you a million miles in my direction. We used to get in these terrible fights, only they were just my fights, he wasn't in them. He'd just wait until I was done being mad." This description has Eve's usual free-associative lucidity and nutty verve, but it isn't enough. Hutton is someone she mentions all the time, repeating a remark he made, a joke he liked, a preference he expressed. And a Hutton character is featured in four of her books. Obviously he meant a great deal to her.

So I press, ask again, and she recalls the time Hutton was supposed to get together with the actor Al Lettieri (Virgil Sollozzo in *The Godfather*). "They were meeting at Ben Frank's, an all-night coffee shop on the Strip. Brian had ulcers, which is why he never really drank. He had tea instead. I hated Al. I thought he was a violent monster, but Brian liked him. Al was late, and when he finally showed up, he was trailing cop cars, a whole string of them. What had happened was he'd left his wife in pieces. Not dead but almost. Brian had to bail him out." It's a honey of a story, no question, and I listen to it,

rapt, though it's more revealing of the relationship between Lettieri and Hutton than her and Hutton. And, besides, something about the way she tells it—carefully blasé—makes me know to drop the subject. So I do.

It's December 2017. I'm in Los Angeles for the week. Mirandi's driven up from San Pedro to show me Babitz Hollywood: the various dwellings—all within blocks of one another—occupied by the clan; her and Eve's elementary school; the street she, Sol, Mae, and Eve would walk to after Christmas dinner for an annual family photo because Mae liked the looks of the palm trees that lined it, vertiginously tall and evenly spaced. A literal trip down memory lane. We've taken one already, a few years back when I was dipping a toe into this book, just starting out, and I want to take another now that I'm neck-deep to make sure I haven't missed anything.

It's a beautiful morning, the sky a hard, clear blue and cloudless. And though Southern California has endured among the driest autumns on record as well as wildfires of near-biblical proportions, everything I see is blooming, the colors of the flowers and plants and trees glowingly, psychedelically vivid, and Mirandi and I always have fun together, and we're not due to collect Eve for lunch for a full two hours

and so aren't in any rush. Plus, there's no place I like to talk and be talked to more than in a moving car.

We've just left 1970 Cheremoya Avenue, the Babitzes' house before they went to Europe, and are now on our way to 1941 Bronson Avenue, the Babitzes' house after they came back from Europe. We're at a stop sign, and Mirandi is about to turn onto Franklin, when I bring up Hutton.

"Oh, Brian, Brian," says Mirandi, craning her neck to see if the break in oncoming traffic is big enough to accommodate her little Acura, settling back into her seat with a frustrated sigh after concluding it's not. "Brian was really important to Evie. He was very cute and very hilarious and very married. He was absolutely her sexual teacher. He showed her how to give head brilliantly, and she showed me, and then we passed it on to Laurie."*

I fiddle with the sun visor. "So—what? Head was starting to become a thing even nice girls did?"

"Right, in the early sixties. We used to be able to get away with hand jobs, but those days were over. What guys wanted was for a girl to give head and do it well."

* There's some dispute as to who in the family was sentimentally educating whom. Laurie: "Mirandi is the youngest and she thinks she remembers, but she doesn't. Evie asked *me* to tell *her* how to give head. I was already married at that point. I went home and started drawing her a diagram. Yes, a diagram. But when I told her I was ready to explain it, she said, 'That's okay, I found out.' From Brian, I assume."

"Did girls get head?"

"Funny you should ask. No, we didn't. Eventually we'd clear that one up, but it took us a while. Not Evie, though. Evie got head from the beginning. She was nobody's fool. Unlike the rest of us."

In my mind, I hear Paul's voice telling me, *There was one thing that Eve loved and taught me very well, and that was how to go down on her. Before Eve, it was like I was eating watermelon in Rush Springs, Oklahoma. After Eve, I didn't slobber.* I laugh.

Mirandi gives me a look of soft puzzlement, followed by a sweet, slightly unfocused smile, then returns her attention to Franklin. All cars having safely passed, she makes a left onto it. She says, "Brian also taught Eve that guys would cough up. Taught her the value of her product, I guess you could say. He was the first to give her money—for that plane ticket after Marilyn died so she could come back to L.A. And financially he got her out of a lot of jams over the years. Really what Brian was, was a mensch. Only Evie wanted him to leave his wife, and he wouldn't do that. Not that she wanted to marry him. Well, she did, but I don't think she actually did." A long exhale. "Evie never really got marriage."

Mirandi continues to talk, but I'm no longer able to listen. *Evie never really got marriage.* This sentence strikes me as so profound, so essential—as maybe the key to unlocking everything—that I can't move beyond it. I want to take it back

to my hotel room and turn off the lights, think about it alone in the dark. Is it true? Do I agree with it? Was marriage a concept Eve fundamentally failed to grasp? And then I recall another sentence, a sentence of Eve's, and one I've already quoted: "My secret ambition has always been to be a spinster." It's from her first book, *Eve's Hollywood*, written, of course, when she was in her late twenties. And a form of it would appear in every book, save *Fiorucci*, thereafter. A form of it, however, also appeared much earlier, as I'll soon discover.

I roll down the window, let the breeze slap me in the face a few times, snap me out of my trance, and force myself to tune back in to Mirandi's voice, which is saying cheerfully, "Here we are." I look. See we've arrived at 1955 North Wilton Place, the Babitzes' house after Bronson. Mirandi squeezes my hand. "Should we step out of the car, get a closer view?"

I squeeze her hand back, unfasten my seat belt.

It's after Mirandi and I have finished our tour, after we've brought Eve to the Village Idiot for a lunch of ale-steamed mussels and deep-fried brussels sprouts and cinnamon-sugar-dusted churros, after Eve has dragged me to a nearby 7-Eleven so I can buy her $100 worth of British tabloids and disposable e-cigarettes, after Mirandi has dropped Eve at her condo and me at Palihouse, after I've typed up my notes and

made phone calls and taken a shower, and right before I walk out the door for a drinks appointment, that I receive an email from Mirandi, now home in San Pedro. Its subject heading is "Found this thought you might be interested . . ." When I click to open it, I see three photos: the front of a letter, the back of a letter, and the envelope the letter came in.

The letter is from Eve to Mirandi, still Miriam, dated October 21, 1966, and postmarked New York City. The information contained therein is mostly unremarkable: Eve thinks working for a living is the pits; she's taking too much acid but so is everybody else; she's spending entire weekends holed up in her apartment making collages. Yet it's fun for me to see. Young Eve just sounds so touchingly young. (She recommends that Mirandi read Hermann Hesse while stoned!) And though Eve is recognizably herself, she's a rawer, blunter, less complicated, more manic version of that self. Rough-draft Eve.

Thoughts such as these are floating around cloudlike in my head as I skim pleasantly along. Then I come to the last paragraph before the sign-off and almost fall out of my chair. Eve writes:

These days I'm trying very hard to figure out what it is I'm doing. I've thought of a lot of things and one day the thought that I might never live with a man or get married dawned on me. I thought in my mind that there are only three men

I got smashed on anyway and two of them were inaccessible (Brian and Chico) and the third was John Barry [an artist], for some reason. And then I got a letter from John Barry. So he wants me to come to Oklahoma, drop everything and marry him and live in Oklahoma. Only, shit! Heaven forbid—Oklahoma! My God! So it turns out I can't do it.

It isn't the words that so floor me. I've heard them from her before, obviously. It's the tone in which she says them. When she declares her spinster aspirations at twenty-eight and beyond, it's with a jollity, a bravado, a swagger. She knows who and what she is, and more than accepts her identity, glories in it, seeing the artistic intelligence that isolates her not as a thorn in her side but as a star in her crown. Only it wasn't always thus, as this letter, written when she was just twenty-three and still unformed, shows. She's getting an inkling here of where her personality is driving her, of what her destiny might be— how stark, how lonely, how extreme—and it scares her. On the one hand, of course it does, she's human and how could it not? To be Eve Babitz is a daunting prospect even if you happen to be Eve Babitz. On the other hand, though, her humanness is a quality I've taken largely on faith. Meaning intellectually I know she's human, while emotionally I know no such thing. It's why Mirandi is, for me, so vital. She's Eve in a human guise.

This letter is the first proof I've had that Eve has her own human guise, no matter that she shed it early and for good.

All artists, male and female, have to battle against convention as well as their own demons to forge a style and sensibility. For women, however, especially pre-boomer women (it wasn't until the sixties that the nineteenth century truly ended in America), the battle against convention is even bloodier, even more brutal and protracted. An artist must be willful, selfish, ruthless, calculating, egoistic. In short, not nice. And niceness is considered by many to be the sine qua non of womanhood, the most essential characteristic. And what happens so often with women artists is that, at some point, they need to sacrifice—or believe they need to sacrifice—the artist for the woman, relinquish their ambition to helpmate a husband or raise children or tend a home, to perform the duties required of the traditional feminine roles of wife and mother, basically. But that didn't happen to Eve. While she encountered difficulties of her own, principally in finding her art, she seemed immune to the biological and social imperatives that were doing a number on the rest of her gender. Yet, as it turns out, she, too, felt the fear and the pain, that her obliviousness to such things was feigned, a kind of gallant posturing, a species of whistling in the dark.

★　★　★

When I first quoted that spinster line back in the early part of this book, I followed it up by remarking that it was an ambition Eve was always true to, which she was. But she was untrue to it, as well, and near constantly. With just about every important romance in her life, and a few trifling, her thoughts took a conjugal turn. They did with Brian Hutton. And with Walter Hopps. She's told me more than once the story of Hopps presenting her with a small box and how she felt upon opening it and discovering a silver bullet where a gold ring should have been: "I was cheerless and fucked-up for days, and how could he?" I've also listened to her refer to both Grover Lewis and Dan Wakefield as "the One," her eyes growing misty as she expressed the conviction that these relationships were bound to end in matrimony until they didn't.

Léon Bing, during our interview, mentioned a guy, an artist, Eve was hell-bent on marrying in the mid-nineties. (His name was unfamiliar to me, so I questioned Eve about him, only I couldn't because she barely remembered who he was.) It was déjà vu all over again in my interview with Sarah Kernochan, except the guy Eve was hell-bent on marrying in Kernochan's account was different from the guy in Bing's, an actor instead of an artist, and the madness struck in the early eighties instead of the mid-nineties. (Eve remembered even less about this amour.) And, according to Paul, she was forever trying to browbeat him into a proposal: "It was something we fought over and fought

over. But I knew marriage would have been a disaster for us. The last thing I wanted to deal with was Eve's motherhood. She'd probably have eaten our children."

Yet, in spite of all this, I believe I had it right the first time, that, in a fundamental sense, Eve stayed true to her spinster ambition. If she'd really wanted a husband, she'd have got one is my strong feeling, so therefore she didn't. Nor should she have. The notion of her deriving satisfaction from the continuity and regularity of *la vie quotidienne*, or that the bourgeois solution could ever have been hers, is ludicrous, demented. She and the institution of marriage were incompatible, both theoretically and practically. And she knew it even when she forgot she knew it. Or at least when she forgot she knew it, she forgot she knew it with guys who could be counted on to know it for her. My suspicion is that she occasionally indulged in fantasies of being taken care of by a man, of having a house and security and stability, the way a young suburban matron might occasionally indulge in fantasies of being a wicked single chick, hustling for her keep in the big bad city—a harmless bit of self-deception.

Marriage was the topic Eve couldn't leave alone. She returned to it obsessively, helplessly, resolving her feelings about it only to experience the need to examine those feelings one more

time. And I believe that this tension wasn't just her great theme, it was the very mechanism of her art. The pressure of her internal interrogation—to say *I do*, to say *I do not*—is what caused her to move from lover to lover, in eternal pursuit, but it's also what produced the work itself. Marital apprehension was the coal, *Slow Days*, for example, the diamond. The marriage plot, even if she never got married, even if her best plots were plotless, was her plot, too.

Well, well. So for Eve it was Madame Bovary (and, for that matter, Isabel Archer, Emma Woodhouse, Jane Eyre, Anna Karenina, and Dorothea Brooke) *c'est moi*, after all.

To Eve—with Love and Squalor (Also, Squalid Overboogie), Part II

★

I said at the start that this book was, more than anything else, a love story, and love, as those of us much past the tender age of sixteen are only too aware, isn't all rainbows and buttercups, German-imported cocaine binges, and fly-by-night affairs with groovy young actors on the cusp of super-stardom. It also has a dark side, and occasionally I'd go over to it.

In the fall of 2015, eighteen months after my piece appeared, New York Review Books Classics reissued *Eve's Hollywood*,

and then *Slow Days, Fast Company*; Simon & Schuster reissued *L.A. Woman*; and Counterpoint Press reissued *Sex and Rage* and *Black Swans*. That much of Eve's oeuvre, all of it previously out of print, was suddenly available, though, doesn't give the full picture, convey just how ubiquitous she'd become in certain bookish circles, and how fast. When I began writing about her in early 2012, there was an interview she'd done with Paul Karlstrom for the Archives of American Art, a brief article by Holly Brubach in *T* magazine, and a blog post by cultural critic James Wolcott. That was it, the whole shebang, the entirety of her internet presence.

By 2018, she'd be featured in—and keep in mind, this is an incomplete list—the *Washington Post*, the *Sunday Times*, the *L.A. Times*, the *Chicago Tribune*, the *Boston Globe*, the *Village Voice*, the *Guardian*, the *Jewish Journal*, the *Seattle Review*, the *New Republic*, *GQ*, *Aperture*, *Bookforum*, *Newsweek*, *W*, *O*, *Vice*, *Vogue*, and, obviously, *Vanity Fair*. Plus, the *New Yorker* blog, the *Paris Review* blog, and the *Tin House* blog, along with *HuffPo*, *Buzzfeed*, *PopSugar*, *The Millions*, and *Vulture*. Every newspaper, magazine, and website you can think of, in short. *Esquire* was reprinting her 1991 piece "I Was a Naked Pawn for Art" for its eighty-fifth anniversary April issue. *Elle* was offering to teach anyone who wanted to know "How to Live Like Literary Icon Eve Babitz." Actress Emma Roberts was posting glamour shots of herself reading *Sex and Rage*—named, by the way, an

NPR Best Book of 2017—on Instagram, getting 310K "likes" a pop. Most gratifying of all, on May 4, 2017, there appeared in the *New York Times*, a periodical hostile to Eve when it wasn't being dismissive of, an affectionate tribute that was also a belated apology. Stated the critic: "I'm here to talk about *Eve's Hollywood*, and thus to right a historical wrong: This potent cocktail of a book was never reviewed for this publication."

Eve wasn't being rediscovered because to be rediscovered you must first be discovered, and she never was, not properly. No, she was being discovered. In 2012, Victoria Wilson said to me of the writer she'd started publishing in 1977, stopped publishing in 1993, "It seemed like Eve was on the verge of breaking through, always on the verge, but it didn't happen." Who could have predicted that Wilson was speaking too soon? That in a few short years, Eve would be It, the latest craze and the hottest topic, the new now and next of the literary world? After spending her life ahead of her time, her time had come.

Eve Babitz: in her eighth decade and an overnight success.

To witness all this was beyond exciting, was thrilling. And more for me, I think, than Eve, who commented on the subject just once, the very droll, "It used to be only men who liked me, now it's only girls." At last Eve was receiving the recognition she so richly deserved, and I'd got to play some small part in it. (Isn't that the writer's ultimate fantasy, that a thing he or she writes has an actual effect, changes the world in a visible,

tangible way?) Yet, there was bitter—just a touch, the faintest hint—to go along with the sweet. For a period of three or four years, I'd looked upon Eve not merely as L.A.'s secret genius and sharer, but as my own personal secret. Except I'd blabbed and the secret was out. No longer was she mine mine mine. Others were laying claim to her now, too.

When "All About Eve—and Then Some"* came out, readers got in touch. These readers were mostly young women who saw in Eve a model for how to live life, or Hollywood executives who saw in Eve a chance to fill the void left by *Sex and the City*. Both sets seemed to regard Eve as the original Carrie Bradshaw: an adorable kook who went to evil, sexy parties and tumbled into bed with evil, sexy men, then journaled about it. On the one hand, how great, new fans for Eve, and who cares if they were fans for the wrong reasons, and is there such a thing as a wrong reason, and bless their ingenuous little hearts in any case. On the other hand, though, Jesus fucking Christ. And as they talked, I'd nod and make appropriate remarks, all the while internally sighing and muttering sarcastic comments to myself. Because unh-uh, because give me a break, because absolutely not. Eve is nothing like Darren Star's heroine, a tough cookie with

* This was not my title, it was *Vanity Fair*'s. I tried to have it changed, the "and Then Some" striking me as particularly egregious. Eve, on the other hand, loved it, the "and Then Some" especially.

a gooey marshmallow center. Eve's sleep-around, trouble-maker front is real. There's no doe-eyed snookums looking for the right fella behind it, no twinkling heart of gold. She isn't an Every Girl, or relatable—the opposite. She's about as far out as you can get: an existential outlaw plus a demon plus an artist. Straight down the line.

Of course, I'm partially to blame for the young women and Hollywood people regarding Eve as the original Carrie Bradshaw, though it took me a long time to realize this, even longer to admit it. In my piece, I showed Eve in the present, but I smeared the lens with Vaseline. Her fear and loathing, and my horror at her fear and loathing, I didn't include, or only subtextually. Instead I turned Eve into a lovable eccentric. In other words, I sentimentalized her, diminished her. Eve is not eccentric, she's seriously, radically strange. And Eve is not lovable, one of the reasons I love her.

Surrounding Eve is the unmistakable whiff of danger. She's ill-fated, certainly—the match falling in her lap was the worst kind of bad luck. But that only partly accounts for what I'm talking about. If the fault is in her stars, it's also in her nature. There's an avidity to Eve coupled with a purely reckless streak. It's the source of much of what is visceral and exciting about her. It's the source, too, of much of what is macabre and frightening. In the early sixties, Laurie took a trip to Rome and visited the Babitzes, staying in the city at

the same time: "Evie was eighteen, witty, and sexy. She had these horrible hip friends, the *8½* crowd. God, those people were awful. Later I had this dream. In it, Evie was living at the top of this very beautiful building. And I was jealous that she got to live in it because it was so beautiful. I went in and started to climb the stairs to get to her. Inside, the building was falling apart. The staircase was rickety and crumbling. It was a really terrifying place to be. And I thought to myself, 'You couldn't pay me to live here!' And I left Evie where she was and backed down the stairs."

Laurie's dream wasn't just revealing but prophetic, less a dream than a vision. The beautiful building would come crashing down, leaving Eve underneath the rubble, buried alive, my, and probably everyone else's, idea of hell on earth. Which is the only way to describe her present circumstances: body ravaged by fire; not quite broke but close enough; the desire and perhaps the ability to write gone; alone and in an apartment that's somewhere between slovenly and foul. And yet, they're hers. Meaning if ever anyone's been true to herself, it's Eve, unremittingly and unrelentingly. She's fulfilled her destiny rather than fallen short of it. Has lived a life without compromise, and so it's a triumph even if it's also a tragedy. Yes, I'm appalled by her. Yes, I recoil. But I still see her as the epitome of artistic audacity and impudence. My attitude toward her is still a mixture of reverence and rhapsody. Her nobility is authentic, undeniable. Her

originality, as well. And I suspect that as time passes, she will seem braver to me, sexier, scarier, more mysterious, and more remarkable. She's a supreme figure. A hero.

I'll say this for Eve, too. Self-pity is entirely absent from her makeup. She hasn't succumbed to lethargy or depression. She remains buoyant, to an almost pathological degree. A quick illustrative anecdote:

Last March, Eve mistook a glass of lemon Pine-Sol for a glass of lemonade in the middle of the night (the glass of Pine-Sol had been left, unlabeled, in the fridge by the cleaning woman), and wound up in Cedars-Sinai. The next morning, Mirandi FaceTimed me from the hospital. I asked Eve, in an ID bracelet and one of those crinkly blue gowns, if she was okay. She turned to the lens of the camera phone, her slack features suddenly sharpening, the bleariness in her eyes falling away, and said, "It's the vacation I never knew I wanted." I gasped even as I laughed, the line as grotesque as it was funny, which, of course, made it that much funnier. The sheer heartlessness of it, the hauteur, the malice—and toward herself. Breathtaking.

And her capacity for joy is large, movingly so. She takes such pleasure in things. Food. Books. Aretha Franklin records. Getting her way.

I've already likened Eve to a femme fatale, a comparison, I believe, both instructive and apt. But there's another creature,

equally seductive, equally sociopathic, to whom she bears an even more striking resemblance—a child.

In *Eve's Hollywood*, she has an imaginary dialogue with a theoretical "they":

> "But how will you toughen up and mature?" they ask.
> "No," I say. "Who says you have to mature? I don't want to get old and die. I just want to die."
> "But . . ."
> "Why mature?"
> "But . . . you can't do that!" They are scandalized.
> "I'm doing it, though."

And is, to this day, doing it. Eve didn't fail to mature, she refused. You stick around long enough, reach a certain age, and maturity is all but unavoidable. If you don't come to it on your own, life thrusts it upon you. Yet every time life tried, Eve blocked or parried, danced away laughing. It was always boyfriends, never husbands, positively never children. Apartments, never houses. Living from assignment to assignment, book to book, taking an odd job here and there, cadging cash off a lover or an ex-lover, never a career. A cult favorite, never a mainstream success. She was beholden to nothing and no one—not a man or kids, or a piece of property, or a boss, not

even to an audience. Adulthood was a condition she simply wouldn't submit to, and that was that.

Eve is now in her mid-seventies. Her hair is no longer a silvery shade of platinum but straight-up silver. The drugs she takes are to ward off pain rather than induce psychosis and are paid for by Medicare. And yet she remains a beloved and brilliant little girl: beautiful, serenely self-absorbed, wholly without conscience or remorse, and an unending source of marvel and freshness and delight.

Epilogue, or the Four Faces of Eve

★

Eve is a product of Hollywood. And though *Hollywood* and *the movies* are not technically synonymous terms, they are de facto synonymous terms. What could be more fitting, therefore, than to end Eve's story with a montage, among the most suggestive—and poignant—gestures in the cinematic lexicon, a feat and frenzy of editing, capable of conveying an entire life in a few carefully chosen images, one dissolving into another into another.

Early on I quoted Julian Wasser, the photographer who gave us the best-known image of Eve. I'd asked him why he picked Eve as his model, and he'd said, "She had a very classic

female body." But, in fact, he'd said a good bit more than that. His response, unedited:

"You're asking me why I picked Eve to pose with Duchamp? You're really asking me that? Oh, Jesus. You have a husband, don't you? Ask him." A long pause. "Those girls I was talking about before, the ones hanging around Barney's—Eve was different. Okay, yeah, she was there to wreck relationships and steal guys, but she wasn't just a lame-o flake, an out-of-town groupie idiot who found her sexual nirvana in L.A. She had a plan. She was the real thing." A second pause, even longer. "I asked Eve because she had a very classic female body, okay? I asked her because I knew she'd blow Duchamp's mind. And you know what? She did. She blew his mind!"

There are people who don't show up in photographs. Not as vampires don't show up in mirrors. Physically, obviously, they're present. But spiritually, emotionally, they're nowhere to be seen. They regard the camera's scrutiny as an invasion and, consciously or unconsciously, guard against it, close themselves off. They flunk their screen test, in essence. Not Eve. Eve, on camera, comes across. Her intelligence, her sensitivity, her agitation, her discontent, her humor, her natural-beingness are on full display. Wasser's intuition bore out.

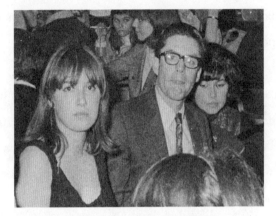

Eve Babitz, Walter Hopps, Jay DeFeo, 1963

I regard this photo, shot in January 1965 by Charles Brittin, as the companion to the Wasser-Duchamp because it features the two non-present presences in the Wasser-Duchamp: Walter Hopps and Eve's face. The background is a party, glamorously bohemian, full of smart talk and nervy, cruel-looking beauties. Eve and Hopps, in his signature G-man suit, sit at a table. He's in mid-lip-lick, and light glints off the lenses of his glasses, obscuring his eyes, making him appear a bit wary, a bit compromised. As well he might, out in public with his baby-doll mistress (he and Eve did not split after the Wasser-Duchamp, were involved for several more years). Another mistress, the woman with the high cheekbones and dark hair, chicly short—Jay DeFeo, thirty-five, an artist from San Francisco, the rare female represented by Ferus—is leaning in close to him. What suggestion or threat is she about to whisper in his ear?

It's Eve, though, who's the revelation here. She's wearing a dress, sleeveless and black, and little if any makeup. In contrast with the others, all of whom, except for Hopps, are done up in the contemporary style, she appears simple, classical, slightly out-of-time. She seems to be looking directly into the camera's eye, which is both mechanical and human, since the camera's eye is, too, the photographer's eye. Our eye, as well, and that's the magic of this extraordinary picture: the feeling of connection it gives, the electrical charge of two gazes touching across great spatial and temporal divides. And as I lose myself in Eve's face, I start to understand why she hid it with her hair when she was with Wasser and Duchamp. Not that it's ugly or strange. On the contrary, it's lovely—so lovely. But it's also so round, so soft, so pale, so unmarked, so *bare*. (As physically exposed as she is in the Wasser-Duchamp photo is as emotionally exposed as she is in the Brittin, another reason I regard the Brittin as the companion piece to the Wasser-Duchamp.) I can't stop staring.

Eve, while scarcely beyond her teens, has been assured and decisive in her actions. There was the nude chess match, of course. There was also the dropping out of college, the liaisons with married men. She'd opted for intrigue on her eighteenth birthday, the very day she reached the age of consent, refusing to be intimidated by the complexities of adult erotic life, instead immersing herself in them, jumping in with both feet. Her thoughts and feelings, however, are considerably

more delicate, nuanced, tentative. As her expression help-lessly reveals. Observe it and observe the mingling of inno-cence and experience, of hope and jealousy, of bewilderment and grief, which the romance with Hopps was no doubt caus-ing her, the romance with Hutton already had. It's rough-draft Eve you're witnessing. The Eve who would appear in that letter to Mirandi a year later. It's the Eve whose rawness and tenderness are still raw, still tender, haven't yet hardened into attitude or style, an armor to protect her from the world. The Eve who is so young she only half understands what's in store for her, though fully intuits.

Seeing Eve naked couldn't be easier. All you have to do is Google her name. The Wasser-Duchamp photo is the first image that pops up. And so much of this book has been an attempt to look past her uncovered body, which tells us one thing, and get a glimpse of her covered face, which tells us another. (The impulse is the opposite of pornographic, yet is still—someway, somehow—pornographic. It's the chaste view that becomes the forbidden.) Brittin's photo, obviously, provides such a glimpse. So does the letter to Mirandi that I just alluded to, though less obviously. And so, even less obviously, does Mirandi herself. This isn't to say that the covered face is the authentic Eve and the uncovered body the inauthentic. In spite of the contradic-tory claims face and body make, *both* are the authentic and *both* are the inauthentic. Meaning, taken individually both are the

inauthentic, but taken together both are the authentic because their authenticity depends on each other, their authenticity and their contradictions are one and the same.

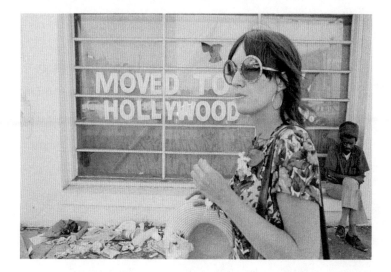

Eve Babitz, 1972

This photograph, taken by sometime girlfriend Annie Leibovitz, shows Eve at the opposite end of her twenties. She's in profile and on the move, wearing a short-sleeved print shirt and a pair of sunglasses as big and round as her hoop earrings. In her right hand, she clutches a straw hat; in her left, a set of keys. Her skin is tan and clear, her hair dark, the cut cool and vaguely rock 'n' roll (Marva's work), her body slender, supple. She's sucking on a lollipop or a toothpick. Behind her is a sign in a giant store window that reads MOVED TO HOLLYWOOD, these hopeful, glamour-struck words made ironic by

their context: the cracks in the white stucco wall; the partially smashed windowpane; the piles of debris on the sidewalk. A man who looks simultaneously down-and-out and dapper sits on the window ledge, one leg crossed loosely over the other, eyeing her as she struts past.

Eve no longer has to fake the sexual brazenness, the give-a-shit imperturbability—they're for real now. In the intervening years, she's survived, barely, life on the Sunset Strip, the birth and death of her career as an album-cover designer, Earl McGrath, Jim Morrison, the bar at the Troubadour, to become a writer with a byline in the most happening magazine of the era. She's been put through the ringer (put herself through the ringer is closer to the mark) and is the better for it. Knowledge, hard-won, has given her a confidence, a defiance. Her fears have been subsumed by the will to create. She's a tough little chickie now, and way beyond Walter Hopps and his fickle tastes.

Eve here is a dead ringer for Eve as played by Jeanne Moreau in the 1962 Joseph Losey movie *Eve*: moody, sullen, sensual, wreathed in cigarette smoke and ennui, and with an ageless quality, by which I mean she looks older than she is, only thirty-two. The loneliness, the eccentricity, the anxiety, that underlay her surface ebullience are right on top in these shots.

They were taken at the time she was with Paul and writing *Slow Days*, so the moment it was all coming together for her, the very moment, of course, it all started to fall apart. The delicate balance of liberty and restraint, passion and cunning, madness and clarity, was about to be tipped.

★ ★ ★

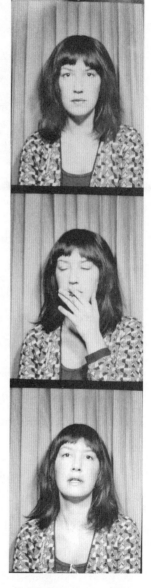

*It was difficult to determine a date for this photo strip. Eve and Mirandi were convinced by Eve's clothes that it came from a booth in New York. And Eve didn't get to New York much. A trip was taken in the spring of 1971. Except that would put her at twenty-seven or twenty-eight, and she doesn't look twenty-seven or twenty-eight to me in these pictures, an awkward observation to make, so I didn't. Finally, though, I did, and both Eve and Mirandi agreed. Eve was silent for a while, then she said, "I know! It must've been when *Ms.* flew me to their New York offices. They thought they wanted me to write for them, but they didn't. I came in wearing platform shoes and a floppy hat, and they said, 'You're obviously trying to attract men.' They hated me! And they hated me even more when I turned in a piece about how great it is to have big tits ["My Life in a 36DD Bra, or, the All-American Obsession," *Ms.*, April 1976]."

Eve Babitz times three, 1976*

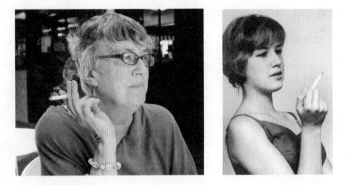

Eve Babitz at the Farmers' Market, 2011 Eve Babitz, 1957

I once asked Paul how Eve viewed herself. I meant as a writer, but he thought I meant as a woman. His answer: "When we were together, I noticed that she was always standing in front of the mirror. I used to be awestruck watching her. She was simply transfixed by her own image and truly unaware of how funny her elaborate posing was. I think that's why she wrote about herself in such glamorous terms, because she saw herself in such glamorous terms. Eve was really big on what she looked like."

The woman in this photo, taken by Lloyd Ziff in 2011, no longer cares what she looks like—her clothes are stained, her bangs greasy, her nails dirty and broken. And she certainly no longer feels the need to pose or present glamorously. Instead she sits at a table, smokes, thinks her thoughts. This, to me, is the photo that was implicit in all the other photos, just as all the other photos are implicit in it. As evidence, I'm including

a fifth photo: Eve, fourteen, sitting, smoking, thinking. The body language, the facial expression, the haircut—identical. Even the ashes on the ends of the two cigarettes are the same length. Gazing at the pictures side by side is like gazing at that famous optical illusion of the pretty girl who is also the wizened crone. Both are always present, one part of the other, the young and the old, the past and the future, the dream and the nightmare.

Ziff's photo seems the inevitable conclusion to the life. But maybe what the photo is, is the inevitable unfolding of the truth. You can see in Eve's face uncommon intelligence and character. Stoicism, as well. She understands her fate and, in this moment of calm, of Chekhovian wisdom and resignation, accepts it. She has become the simplest version of herself, another way of saying she has become the achieved version of herself.

She is Eve, distilled.

Eve Babitz and the author at a prop lot on Melrose, 2013

Acknowledgments

First of all and most of all, thank you to Eve, who picked up the phone practically every time I called, which was constantly over the past six and a half years.

And to Mirandi Babitz, Laurie Pepper, and Paul Ruscha, also on my speed dial. I'm in your eternal debt, is what it comes down to.

I want to thank my editor at Scribner, Colin Harrison. (Colin, I'm in your eternal debt, too.) And Sarah Goldberg, who is so nice that when she criticizes me I hardly notice that's what she's doing. Also, Katie Monaghan and her calm, reflective intelligence. And, of course, Nan Graham. Additionally: Kara Watson, Dan Cuddy, Jaya Miceli, Jill Putorti, and Steve Boldt—the entire Scribner team, basically. I'm wildly appreciative for your work on this book, and I love how it looks.

I want to thank, as well, Bruce Handy, Dana Brown, and Graydon Carter at *Vanity Fair*. The words "*Vanity Fair*" were

my "open sesame" as far as this book was concerned. They provided me with access to people who otherwise wouldn't have given me the time of day. Plus, the magazine took a chance on me and Eve when no one else would. And, Peter Biskind, it all started with you.

I am so grateful to my agent, Jennifer Joel at ICM, that she gets her very own paragraph.

Thank you to the following people for submitting to interviews, often multiple, either in person or on the phone or both, for the magazine piece and/or the book: Peter Alexander, Colman Andrews, Bob Asahina, Larry Bell, Billy Al Bengston, Léon Bing, Ronee Blakley, Nan Blitman, Chris Blum, Irving Blum, Lois Chiles, Ron Cooper, Dickie Davis, Laddie John Dill, Ned Doheny, Frederick Eberstadt, Michael Elias, Bret Easton Ellis, Joni Evans, Paul Fortune, David Freeman, Robert Gottlieb, Mick Haggerty, Judy Henske, Dave Hickey, Sarah Kernochan, Gerard Malanga, Steve Martin, Ralph Metzner, Bob Neuwirth, Tom Nolan, Peter Pilafian, Michelle Phillips, Fred Roos, Ed Ruscha, Erica Spellman-Silverman, J. D. Souther, Caroline Thompson, Bill Tonelli, John Van Hamersveld, Dan Wakefield, Julian Wasser, David Weddle, Carrie White, Victoria Wilson, and Lloyd Ziff.

Thank you to the following institutions for their assistance: the Getty Research Institute, the Lilly Library at Indi-

ana University Bloomington, and the Wittliff Collections at Texas State University.

Thank you to Pierre Chanteau, Annie Leibovitz, Julian Wasser, and Lloyd Ziff for contributing photographs.

Susan Haller, Hugh Kenny, Kristine McKenna, Ruth Young-Baker, John Zilliax, Karen Mulligan and Laura Cali at Leibovitz Studio—you helped, too. So did David Thomson. And Blake Bailey.

I'm sorry to say that Henry Bromell, Josh Greenfeld, and Ed Moses are no longer alive to be thanked.

And, finally, thank you to my mom and dad, Marjorie and Bill Holodnak. To my brother, John, whom Eve always preferred to me. To my sons, Ike and Archie, who only pout a little when they hear the words "Mom's working." And to my husband, Rob. He turned my initials into L.A.'s initials, just one of the many great things he's done for me.